Nineteenth-
Century
Art

A Beginner's Guide

ONEWORLD BEGINNER'S GUIDES combine an original, inventive, and engaging approach with expert analysis on subjects ranging from art and history to religion and politics, and everything in-between. Innovative and affordable, books in the series are perfect for anyone curious about the way the world works and the big ideas of our time.

Nineteenth-Century Century Art

A Beginner's Guide

Laurie Schneider Adams

ONEWORLD

A Oneworld Book

Published by Oneworld Publications, 2014

ISBN 978-1-78074-541-1
ISBN (ebook) 978-1-78074-542-8

Typeset by Siliconchips Services Ltd, UK
Printed and bound in Denmark
by Nørhaven

Oneworld Publications
10 Bloomsbury Street
London WC1B 3SR
UK

For Joseph T. Ruggiero

Contents

Contents

Acknowledgements

At Oneworld Publications, I would like to thank Mike Harpley for encouraging the publication of this book, Andrea D'Cruz for her excellent editing, Paul Nash, Laura McFarlane, and Kathleen McCully. John Adams read the entire manuscript and saved it from many errors. The anonymous reader offered several useful suggestions for which I am also grateful.

List of illustrations

Plates

Figures

Introduction

Munch's *The Scream*, Van Gogh's *Starry Night*, Rodin's *The Thinker*, Degas's dancers, Whistler's *Mother*, Monet's water lilies, English landscapes by Constable, seascapes by Turner, the Brooklyn Bridge, the Eiffel Tower. The nineteenth century has given us a wealth of artistic riches so memorable in their genius and enduring in their fame that we can picture many of them in an instant in our mind's eye. At the time, however, the revolutionary style, technique, and imagery of nineteenth-century artists meant that many were disregarded and disdained by critics and the public alike.

The groundbreaking developments in the art of the nineteenth century – which saw an unprecedented proliferation of new styles – took place in the wider context of the great philosophical, social, political, and economic changes, scientific discoveries, global exploration, and literary movements that defined the century. But none of this could have happened without the Enlightenment of the eighteenth century.

For the first time in Western history, two great upheavals – the American Revolution of 1776 and the French Revolution of 1789 – challenged the age-old idea that kings rule by divine right. This challenge was an expression of widespread anger at royal abuses perpetrated under the absolute monarchies of the seventeenth century that continued in the eighteenth century and a growing sense of the importance of individual human rights. The Enlightenment also included the notion of intellectual illumination, the primacy of reason, a new emphasis on scientific research, and a systematic approach to cataloguing knowledge. This

interest in cataloguing what was known of the world inspired the French philosopher and key Enlightenment figure Denis Diderot (1713–1784) and Jean le Rond d'Alembert (1717–1783), a philosopher and mathematician, to edit and publish a new twenty-eight-volume French *Encyclopédie*, compiling articles on science, history, ethics, and the arts. Their empirical approach to knowledge challenged many traditional non-scientific beliefs and superstitions, resulted in Diderot's imprisonment, and opened the way for much of the controversy that characterized the nineteenth century.

Although the impact of Enlightenment thinking was felt throughout Europe and the United States in the early nineteenth century, Paris was the intellectual and creative center of the Western art world, as it had been since the eighteenth century. Students came from different countries to study in the Paris art studios, and it was in Paris that new styles developed with each generation of artists. In previous centuries, it had been possible to speak of a single predominant style lasting for several generations in western Europe: one could reasonably call the sixth century Byzantine, the seventh to tenth centuries Early Medieval, the eleventh to fourteenth centuries Romanesque and Gothic, followed by the Renaissance from the fourteenth to sixteenth centuries, Mannerism in the late sixteenth century, Baroque in the seventeenth century, and Rococo in the eighteenth century. No single appellation covers nineteenth-century art. Instead, the nineteenth century witnessed a parade of styles – mainly Neoclassicism, Romanticism, Realism, Impressionism, and the diverse styles of the Post-Impressionists – with each new one creating controversy among viewers.

As the speed of stylistic change increased, the viewing public had less time to accustom itself to new, different, sometimes scandalous, artistic imagery and technique, making controversy inevitable. The French term *avant-garde*, which was originally applied to the advance guard (or vanguard) of an army marching into

battle, became current in nineteenth-century art criticism. In art, the avant-garde referred to innovative works that seemed unfamiliar, ahead of their time, possessing the capacity to shock, and in any case that took a while to become widely appreciated.

Alongside these rapid stylistic developments, the financial and institutional framework of the art world saw great shifts. During the eighteenth and nineteenth centuries, the center of the French art world migrated from the royal court at Versailles to the Paris Salon, which was a system of juried exhibitions that allowed the general public a greater exposure to new art than had previously been the case. The influence of the Salon, however, waned over the course of the nineteenth century, as did the power of the Académie Royale de Peinture et de Sculpture (the French Academy), which had been established under Louis XIV. This was in part a result of their conservatism and reluctance to embrace the new generations of artists, especially in the second half of the nineteenth century.

Critics who wrote about the new styles in the press, whether denigrating or championing them, constituted an important new influence in the art world. Europe and then America also witnessed the rise of the private art dealer and art galleries that created a new breed of collectors who were no longer limited mainly to royalty or the aristocracy. With the decline of royal and Academic patronage, artists rarely painted on commission and had to develop their own markets or find a dealer who would do so. As a result, financial problems plagued artists whose works remained unpopular for much or all of their lifetime. Although some came from wealthy families, the avant-garde artists of the nineteenth century considered themselves a group apart from bourgeois society. The notion of the Bohemian artist developed in the nineteenth century to reflect an "outsider" status.

Technological, scientific, political, and social developments during the nineteenth century went hand in hand with stylistic changes in the arts. With the Industrial Revolution, which

began in England and spread throughout Europe and America from the mid-eighteenth through the nineteenth century, large numbers of workers migrated from the countryside to the cities in search of jobs in the new factories. In France and elsewhere, the abuses of workers in these factories, and their squalid urban living conditions, fueled a series of rebellions against the restored monarchies – most significantly the revolution against the French ruler Louis Philippe in 1848, which was also the year the *Communist Manifesto* was published – but it was not until the Franco-Prussian War of 1870–1871 that France became a permanent republic. Art reflected the tumultuous political developments of the nineteenth century and was often used in the service of political ideology, whether Napoleonic, republican, or socialist. Artists of the time also captured in their work the impact of the Industrial Revolution on society and the environment.

The fact that many artists represented their own time and place in preference to the religious and historical subject matter that had been most highly valued by the Academies was a significant innovation. The French poet and critic Charles Baudelaire (1821–1867) was a major influence on the representation of contemporary subject matter. He championed the avant-garde and argued that the arts should reflect the here-and-now. He believed that modernity should be a driving force in the world of visual art, an idea that determined a great deal of what was new and revolutionary in the nineteenth century.

In addition to representing their own time and place, artists depicted the influence of contact with non-Western parts of the world. The opening up of trade with Japan in 1853, the accelerating pace of communication and travel, colonization, and the growing popularity of international exhibitions exposed artists, as well as the public at large, to the culture and art of other civilizations. In addition to the Romantic taste for Orientalism there were vogues for Chinese and Japanese art that influenced Western art. By the end of the century, with the travels of the French

artist Paul Gauguin, arts of the South Pacific had also become known in the West.

Technological and industrial advances led to the rise of photography as a medium for documentation, classification, and portraiture (although it was not until well into the twentieth century that photography would be widely accepted as an art form) and to bold new possibilities for architecture. The cost-effective practice of prefabrication allowed for premade sections of buildings to be assembled into a total structure, especially for large exhibition spaces. The advent of industrial iron and steel production facilitated new suspension bridges, including the Brooklyn Bridge, and works such as the Eiffel Tower, which was originally a source of great controversy and is now an icon of modern Paris. The use of steel frames and the invention of the elevator made it possible to construct taller buildings, which led to a proliferation of skyscrapers in the American Midwest.

This book, which is necessarily brief, focuses on the most significant Western artists and works, including painting, sculpture, photography, and architecture, of the nineteenth century. It begins with the late eighteenth century, which set the stage for the developments of the nineteenth century, and covers a range of styles in Western Europe and the United States. We begin with Neoclassicism, which, with Romanticism – the subject of the second chapter – ushered in the nineteenth century. These two styles were then superseded by Realism in the 1840s, Impressionism in the late 1860s and 1870s, and the work of the Post-Impressionists from the 1880s. Dates and periods are, of course, approximate, for earlier styles and movements persisted as new ones appeared.

1
Neoclassicism

In 1738 near Naples, in southern Italy, workers laying foundations for a summer residence for the king of Naples discovered the ruins of the ancient Roman city of Pompeii, although the presence of an old city there had been known of since the end of the sixteenth century. That same year witnessed the beginning of excavations of the ruins of the nearby Roman town of Herculaneum. The eruption of Mount Vesuvius in 79 CE had buried both cities under layers of volcanic ash, making them time capsules that preserved a view of life in the ancient world. By 1748, excavations in Pompeii and Herculaneum were well underway, sparking a new interest in antiquity, a vogue for archaeology – as seen in the Classical motifs characteristic of the English interior decoration of Robert Adam (1728–1792) – and the increasing popularity of books on Classical art. In 1765 Johann Joachim Winckelmann's (1717–1768) *Reflections on the Imitation of Greek Works in Painting and Sculpture* was translated from German into English and fueled the endeavor to recapture what the author considered to be the lost virility of ancient sculpture.

This burgeoning interest in ancient Rome – and eventually in Greek and Etruscan art and society – led to the emergence of a new style in the arts known as Neoclassical, literally "New Classical." Alongside Romanticism, Neoclassicism was to be the major art movement of the early nineteenth century but, like

Romanticism, it began during the previous century. The appeal of the style was its reaction against the frivolity of Rococo, which had been the prevailing style of eighteenth-century Europe and the Americas. Neoclassicism began as an expression of Enlightenment philosophy and the principles of democracy. Called the "True Style" in France, Neoclassicism provided a moral dimension to iconography and was inspired by a formal interest in the styles of ancient Greece and Rome. In painting and sculpture, Neoclassical artists preferred the clear edges, smooth paint handling, lifelike figures, and antique subject matter they saw in Roman art. In architecture, ancient Greek and Roman elements were revived. Such choices harked back to an age associated with more democratic societies – the Roman Republic and fifth-century BCE Athens – than the European monarchies. But despite having begun as a style of revolutionary sentiment – notably that of the French Revolution of 1789 – Neoclassicism became an imperial style under Napoleon. As such it was used to project his image as a legitimate ruler in the tradition of Roman emperors.

Architecture

In England, the eighteenth-century architectural revival of antiquity began with Palladianism, which rejected the Rococo levity of the previous century in favor of more austere Classical forms. From 1725, Lord Burlington (1694–1753) began constructing Chiswick House (**figure 1**) on the outskirts of London. Intended as a place of relaxation and entertainment, Chiswick House was inspired by Andrea Palladio's sixteenth-century Villa Rotonda in the northern Italian town of Vicenza. Burlington appropriated from Palladio the Greek portico, pedimented windows (surmounted here by a triangular element), a central dome, and a symmetrical façade. The columns on the portico are in the Corinthian order (**figure 2**), historically the latest and formally

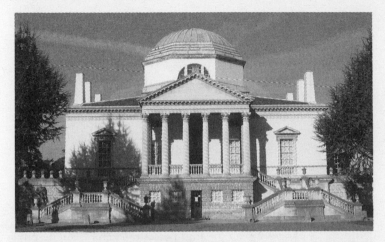

Figure 1 Richard Boyle (Earl of Burlington), Chiswick House, 1725–1729, London, UK. (Source: Wikimedia Commons)

the most ornate of the three Greek orders (Doric, Ionic, and Corinthian) – types of architecture best distinguished by the forms and arrangement of their individual parts.

In France and Germany, as in England, architects borrowed from the Greek orders to endow their buildings with a Classical flavor. The Paris church of Sainte-Geneviève (known as the Panthéon) was designed beginning in 1755 by Jacques-Germain Soufflot (1713–1780), again in the Corinthian order. It is based on a Greek-cross plan, in which the four domed "arms" of the plan are of equal length and surround a larger dome at the center. The use of the Greek-cross plan here derives from the Renaissance notion that its architectural configuration expresses the ancient Greek belief in man's centrality in the universe – that "man is the measure of all things." An interior colonnade is repeated on the portico entrance, thus unifying the two areas of the church. By continuing the Corinthian entablature (see **figure 2**) around the entire building and placing a triangular pediment at the end of

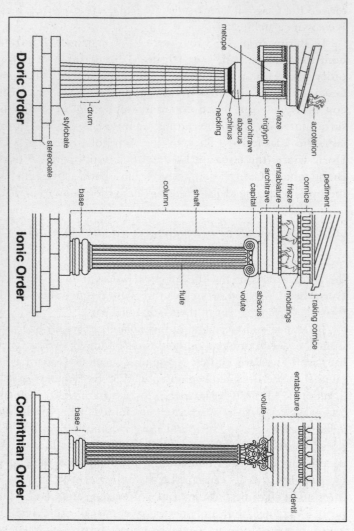

Figure 2 Labeled diagram of the three Greek orders: Doric, Ionic, and Corinthian.

each cross arm, Soufflot created a unity of form that had characterized the Classical Greek style and had been revived by Italian Renaissance architects.

In Berlin, from 1788 to 1791, Carl Langhans (1732–1808) built the Brandenburg Gate (**figure 3**) in the imposing Doric order, the earliest and sturdiest in appearance of the three Greek orders. Its overall design, flanked by smaller Doric porticos, peristyles, and fluted columns supporting an entablature surmounted by a narrow attic, is reminiscent of the Propylaea, the Classical entrance to the Acropolis in Athens. The Doric frieze (the horizontal section below the cornice) of the Brandenburg Gate is composed of alternating triglyphs and metopes, with a quadriga at the top. Like the Panthéon in Paris,

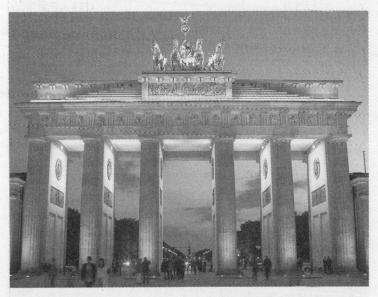

Figure 3 Carl Gotthard Langhans, Brandenburg Gate, 1788–1791 (damaged during World War II and restored 2000–2002), Berlin, Germany. (Source: Thomas Wolf, www.foto-tw.de/Wikimedia Commons)

the Brandenburg Gate was intended to evoke the grandeur of Greco-Roman antiquity.

In North America, the Federal style, which was largely the invention of Thomas Jefferson (1743–1826), was the equivalent of European Neoclassicism. Consistent with Jefferson's interest in the architecture of Republican Rome – itself derived from Greek architecture – and his commitment to democracy, the Federal style departed from the Colonial Georgian style popular in the American South, which was named for the English king, George III. Like Lord Burlington in England, Jefferson had read Palladio's *Four Books of Architecture*, which stimulated his study of Classically inspired buildings while he was ambassador to France. When, during the 1780s, Jefferson designed the Virginia State Capitol (**figure 4**), his model was the Roman temple with Corinthian columns known as the Maison Carrée, in Nîmes, in the south of France. Unlike the Maison Carrée, however, the Richmond Capitol is built in the graceful Ionic order, but it replicates the use of the portico at the entrance and the solid side walls. Whereas Roman temples typically stood on a

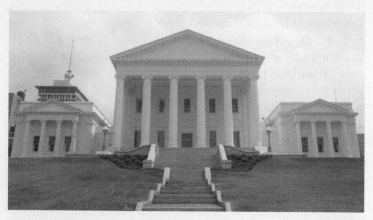

Figure 4 Thomas Jefferson, State Capitol, 1788, Richmond, Virginia. (Source: Jim Bowen/Wikimedia Commons)

podium, symbolizing the power of the emperor dominating the urban space before him, Jefferson situated the Capitol on a hill, accentuating the lofty dignity of the building. Here, the author of American democracy built a symbol of the power of citizens to govern themselves.

Jacques-Louis David and Revolutionary France

In the eighteenth century, France was the intellectual and artistic leader of Western Europe. With the violent upheaval of the French Revolution in 1789, royal patronage began to decline. But, like the French kings, the revolutionaries recognized the importance of imagery for projecting their ideology and they used it accordingly. The most significant French painter to include revolutionary allusions in his work was Jacques-Louis David (1748–1825). David's life and work mirrored the complex political situation in France before, during, and immediately after the 1789 Revolution. Born in 1748 in Paris, David grew up during the reigns of Louis XV and Louis XVI; he survived the Revolution and the period of the Napoleonic Empire (1804–1814), and died in 1825, during the Bourbon Restoration monarchy that lasted from 1814 to 1830.

While studying in Rome at the French Academy, David absorbed Neoclassical taste and developed an interest in ancient history and mythology. The widespread appeal of Classical subject matter in France was apparent in the continuing popularity of the seventeenth-century plays by Corneille and Racine. David shared the Enlightenment taste for combining antiquity with the present; the content of his paintings was often Classical, but at the same time directly linked to contemporary events. Diderot praised David's work exhibited at the Paris Salon of 1781 as the embodiment of lofty Classical ideals.

CORNEILLE AND RACINE

The leading exponents of French Classical drama, Pierre Corneille (1606–1684) and Jean Racine (1639–1699), appealed to Neoclassical taste. Corneille published a series of plays based on ancient Greek and Roman themes. Among these were works inspired by the legends of Andromeda, Medea, and Oedipus. Corneille's attraction to the theme of the power of reason over will is consistent with the ideals depicted in David's *Oath of the Horatii* (**figure 5**). Many of Racine's plays were tragedies based on Classical themes involving powerful female characters, such as Andromache and Phaedra, as well as those in Old Testament stories, notably Athaliah and Esther. His plays typically contained the Aristotelian theme of a hero or heroine, typically of noble blood, ruined by a character flaw. Known for the simplicity of his plots and the elegance of his language, Racine's reputation eventually eclipsed Corneille's and he achieved a position in French literary history similar to that of Shakespeare in England.

David's reputation as France's most important living painter was assured when he exhibited his *Oath of the Horatii* (see **figure 5**) at the Paris Salon of 1785. In that work, viewers saw an image of the Roman past that spoke directly to their contemporary situation, calling for liberty and a new moral order. David conveyed this message through a reduction of form that echoes the narrative on which he based the painting's iconography. According to the legend that had inspired Corneille's play *Horace*, Rome decided to avoid an all-out war with its ancient rival Alba Longa by substituting single combat between two sets of triplets representing each side – the Horatii for Rome and the Curiatii for Alba Longa. In David's *Oath of the Horatii*, broad gestures, determined stances, and visible muscular tension produce the stoic demeanor of the triplets, who swear allegiance to Rome as their father raises their swords. Their father, who is also committed to a Roman victory, is contrasted with his sons in a lessening of tension conveyed by his slightly bent elbows and knees. The stark simplicity of the background architecture and the sturdy Doric

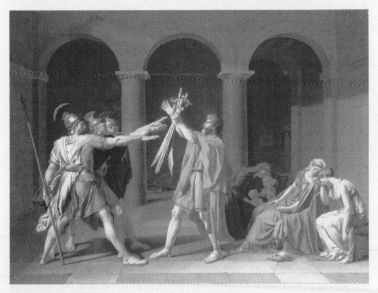

Figure 5 Jacques-Louis David, *The Oath of the Horatii*, 1784, 11 x 13 ft 11 3/8 in (3.30 x 4.25 m). Musée du Louvre, Paris, France. (Source: Wikimedia Commons)

columns supporting plain round arches echo the stoicism of the male figures. The triple-arched wall both recalls the triumphal arches of ancient Rome and frames the groups of figures.

At the right, women and children reveal their anguish at the prospect of personal loss.[1] The patriotic zeal of the Horatii triplets, willing to die for an ideal and composed of assertive diagonals, contrasts with the more realistic fatalism of the women, who are rendered in a more curvilinear manner than the men. Camilla, on the far right, is shown in a traditional pose of mourning. She is the sister of the Horatii, but is betrothed to one of the Curiatii. For her, therefore, the outcome of the combat cannot fail to end in tragedy.

In 1789, thirteen years after the American Revolution (1776), the French Revolution erupted in full force. Its impact, in Europe

as well as in America, shattered the time-honored belief in the divine right of kings and led to the establishment of the First Republic, declared in 1792. Conflict between two factions of the republican revolutionary movement – the Girondists and the more radical Jacobins – followed, culminating in the Reign of Terror from September 1793 to July 1794. Led by the Jacobin lawyer and politician Maximilien Robespierre (1758–1794), the Terror resulted in the deaths of tens of thousands of Girondists, aristocrats, and members of the clergy, who were considered enemies of the Revolution. David, himself a Jacobin and avid supporter of Robespierre, voted to guillotine the king, Louis XVI, and his queen, Marie Antoinette. Soon thereafter Robespierre was executed and the Jacobins lost their position of power, and with them David lost his. He went to jail twice for his revolutionary leanings, but he escaped execution and within a decade became an artist much admired by the emperor, Napoleon Bonaparte.

In the Salon of 1791 (see box, p.11), David exhibited his huge drawing study for a twenty-by-thirty-foot painting to be entitled *The Tennis Court Oath* (**figure 6**, p.12). Although never completed, the work remains an important historical and artistic document of revolutionary France. It was commissioned by the Jacobins to memorialize the event of June 20, 1789, when the deputies of the newly constituted National Assembly met at an indoor tennis court in Versailles and took an oath to secure the establishment of a new constitution. A pivotal revolutionary event, the oath marked the first official opposition of the French people to Louis XVI.

The broad horizontal space of the picture reveals the expansive mood of the crowd, which is unified by its single-minded devotion to a cause. Poses and gestures are reminiscent of the Horatii as they direct the viewer's gaze to the central figures. At the far right, in contrast, is the politician Joseph Martin-Dauch, who disagreed with the aims of the crowd and supported the king.

THE SALON AND THE ACADEMIES

The term *Salon* designated the official government-sponsored art exhibitions held annually in France from 1737, which attracted hundreds of thousands of visitors. Beginning in 1748, artists were selected by a jury, and the Salon became the main avenue of public exposure for an artist's work. As a result, the admission of a work to the Salon was of critical importance for his or her career. The Salon also became an outlet for writers of art criticism, a genre that began in the eighteenth century. Differing views held by critics and ensuing controversies between conservative and progressive taste notwithstanding, the critics helped to publicize new art, which had previously been confined to royal and private aristocratic collections not readily accessible to the general public.

The most important professional art societies in nineteenth-century Europe were the *Académie Royale de Peinture et de Sculpture* (the French Academy), founded in 1648, and the Royal Academy, founded in England in 1768. The Academies imposed strict standards in art and schooled artists in the Western tradition. They also awarded fellowships to young artists, the most important being the Prix de Rome established by the French Academy under Louis XIV in 1663. In London, the Royal Academy was (and still is) limited to forty members and, like the other academies across Europe, it held art exhibitions that exposed the public to contemporary art; annual exhibitions continue there today.

Although Salon juries had been relatively progressive and open to new artistic ideas in the eighteenth century, they became more conservative and restrictive, and less open to innovation, under the domination of the French Academy in the nineteenth century. One of the most constraining rules imposed by the French Academy was its so-called **hierarchy of genres**, which ranked subject matter according to its perceived importance. At the top of the hierarchy were the Christian sacraments; next came history painting (which was also highly regarded), followed by portraiture, genre (scenes of everyday life), landscape, and finally, the lowest of the categories, still life.

By the end of the nineteenth century the French government had ended its sponsorship of the Salon, new arenas for exhibiting art flourished, and the Academies, having failed to embrace the most innovative contemporary art, waned in importance.

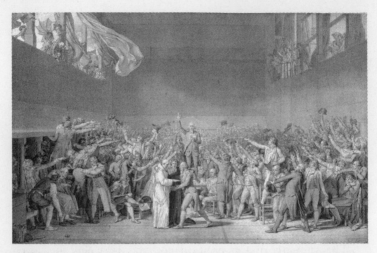

Figure 6 Jacques-Louis David, *The Tennis Court Oath*, 1789–1791, drawing study, pen and brown ink and brown wash on paper, 26 x 42 in (65.8 x 106.3 cm). Musée du Louvre, Paris, France. (Source: Wikimedia Commons)

During the Reign of Terror, Martin–Dauch was imprisoned, but was later released. In David's drawing, Martin–Dauch is a formal and psychological echo of the women in *The Oath of the Horatii*, who are distinguished from the men in not enthusiastically endorsing the cause. Aside from a few personal vignettes among the crowd – for example, the embracing men at the left and the figure trying to persuade Martin–Dauch to join the revolutionary cause – the planar thrust of the picture is toward the center. The president of the assembly, Jean Sylvain Bailly, a scientist and politician executed during the Reign of Terror, indicates his leadership role in the early days of the Revolution by standing on a table and raising his right hand in a gesture borrowed from ancient Roman oratory. On the floor below, three clergymen are shown as a unified group. To their right, differentiated from the crowd by his gesture, his hands on his heart, is Robespierre himself.

The different modes of dress worn by members of the crowd and the figures waving from the windows convey the impression that the entire spectrum of French society is in accord with Jacobin aims. The light streaming into the space, accentuated by the fluttering curtain and creating a glow above the crowd, alludes to the role of the Enlightenment in driving the Revolution. David uses the age-old symbolism of light, both as a divine force and as a sign of intellectual achievement. As in *The Oath of the Horatii*, he also uses the so-called Roman salute, in which the arm is outstretched and the palm faces down. The salute is found in ancient Roman sculpture, such as the imperial *Augustus of Prima Porta*, and became associated in France with the revolutionary spirit. David stopped work on the picture in 1792, mainly because of the tense political atmosphere.

The strength of the political conflicts between the revolutionary parties was revealed in the assassination of Jean-Paul Marat, a journalist and member of the Jacobin party, to which David also belonged. Marat's death in July 1793 at the hands of the aristocratic Girondist Charlotte Corday was memorialized by the artist in his famous painting *The Death of Marat*. Fearing the growing power of the Jacobins, Corday entered Marat's house and stabbed him as he reclined in the bath. At the side of the tub David depicted a wooden writing table inscribed with the words "To Marat, from David" and marked with the date "l'an deux" (the second year of the revolutionary calendar). Marat is idealized, for the artist does not show the skin sores that required him to spend long hours soaking in a tub. In this painting, as in *The Tennis Court Oath*, David used light to evoke the moral and intellectual virtue of his theme. David frames Marat's face with a white, haloesque head-covering and bathes him in a highlight that makes him appear to be sleeping rather than dead. As such, David portrays Marat as a living martyr to the cause of freedom.

Napoleon and Neoclassicism

Two years after David painted *The Death of Marat*, the Directory (the body that held executive power) established rule by the middle class in France. This lasted four years, from 1795 until 1799, when Napoleon Bonaparte became first consul. In 1803 the Napoleonic legal code was imposed and, a year later, Napoleon was crowned emperor of France. From 1806 Napoleon embarked on a vast building campaign in Paris that was designed to revive Classical themes and create the Neoclassical image of a new Rome with himself as its legitimate ruler.

In the course of Napoleon's rise from consul to emperor he was painted numerous times by David. Identifying with Alexander the Great, who appointed the Classical Greek artist Apelles to be his personal portraitist, Napoleon named David "First Painter" to the empire. In that role, David commemorated Napoleon's coronation at Notre Dame Cathedral on December 2, 1804, with a huge canvas measuring some twenty by thirty feet (**plate 1**). Exhibited at the Salon of 1808 (see box, p.11), this work records the transition from republic to empire in France, ironically following the revolution intended to overthrow the rule of kings. David shows the interior of the cathedral, decorated for the occasion, with massive piers and round arches recalling the grandeur of ancient Rome. The staunch verticals of the giant candlesticks at the far right signify the moral rectitude of the event. Gone are the melodramatic diagonals of *The Tennis Court Oath* and the dynamic patriotic fervor of *The Oath of the Horatii*. Instead, the vast space of Notre Dame is filled with verticals, suggesting that order and stability have been restored with Napoleon in power.

At the actual event, Napoleon revealed his grandiosity by usurping the role of the pope, Pius VII, who attended, as tradition dictated, in order to place the crown on the head of the new emperor. As we see in the painting, however, it was Napoleon, rather than the pope, who raised the crown. David shows

the pope blessing the occasion as Napoleon had instructed, an arrogant display of artistic license since in reality the pope sat through the ceremony with his hands in his lap. Perhaps to mitigate Napoleon's narcissism, David represented the moment when he crowned Josephine empress. Both emperor and empress wear the royal ermine, velvet, and gold that distinguishes them from the crowd. Josephine bows her head to receive the crown, her diagonal pose extended by her long train. Napoleon's Roman profile and laurel wreath add the authority of tradition to his role, while the gold fleurs-de-lys – symbols of French royalty – on the blue velvet pillow beside Josephine proclaim her right to be queen of France. Protesting Napoleon's conflicts with his two brothers, his mother, Mme. Mère, did not attend the coronation. But for propriety's sake she is shown in the painting importantly seated under the large arch at the left, as though she had been there.

In 1807, when David had completed his monumental painting, Étienne Delécluze, an art writer and student of David, gave an account of Napoleon's reaction. The emperor, according to Delécluze, paced up and down before the work, keeping the artist and his assistants in suspense, before finally declaring: "Well done, David. Very well done! You have correctly guessed my own intention, in representing me as a French gentleman. I am grateful to you for having given future centuries a proof of my affection for the woman with whom I share the burdens of government."[2]

With Napoleon's coronation, his patronage of the arts expanded in ways that would enhance his desired political image. He continued to commission numerous portraits of himself in traditional iconography reminiscent of ancient Rome. His sister Pauline, who had married into the wealthy, aristocratic Italian Borghese family, also used the arts to enhance her new social position. On one occasion she commissioned the Italian Neoclassical artist Antonio Canova (1757–1822) to create a marble portrait of her as a reclining *Venus Victrix*; that is, as Venus (the Roman

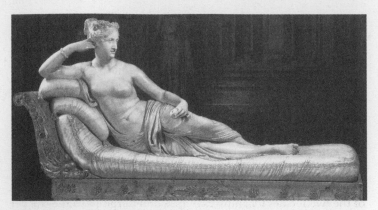

Figure 7 Antonio Canova, *Maria Paolina Borghese as Venus*, 1808, marble, 5 ft 2 1/2 in x 6 ft 3/4 in (1.6 x 2 m). Borghese Gallery, Rome, Italy. (Source: Wikimedia Commons)

counterpart to the Greek Aphrodite) victorious in a mythical beauty contest (**figure 7**). Compared with the women in David's *Oath of the Horatii*, Canova's Venus is restful, her pose and gestures relaxed. These, together with her idealized proportions and form, are consistent with Classical tradition.

Venus holds the golden apple awarded to Aphrodite by the Trojan prince Paris, designating her as the most beautiful of three goddesses (the other two contestants being Athena, the Greek counterpart to Minerva, and Hera, the Greek counterpart to Juno). The divan on which Canova's Pauline-as-Venus reclines is contemporary French Empire in style, but it is combined with an ancient Greek legend, thus merging the Classical past with the present – a hallmark of Neoclassical taste.

In contrast to his sister's private commissions, Napoleon reinforced his imperial political image with public architectural monuments throughout Paris. In 1804 he renamed the Louvre, which was the former royal palace, the Musée Napoléon, whose collection consisted largely of works plundered by his armies. In 1810, a colossal freestanding column with a statue of himself at

the top was erected in the Place Vendôme. Inspired by Trajan's Column in Rome, Napoleon's column was decorated with scenes of his 1805 military campaigns. A bronze frieze spirals upwards (as in Trajan's Column); the bronze came from melting down weapons captured by Napoleon's troops in Prussia and Austria.

In 1806, the new French ruler commissioned two triumphal arches based on the ancient Roman structures marking places of passage for victorious emperors and generals returning from war. The large, single-arched Arc de Triomphe at the Place de l'Étoile (now Place Charles de Gaulle) was derived from the Roman arch of Titus and completed only in 1836. It stood at the western end of the Avenue des Champs-Élysées, a counterpoint to the smaller triple Arc du Carrousel (completed 1808) at the other end of the boulevard, by the entrance to the Tuileries courtyard. For the Arc du Carrousel, Napoleon himself chose the sculptural program carved in relief on the surface to celebrate the French victory of 1805 at the Battle of Austerlitz.

In 1814, Napoleon abdicated and went into exile; the monarchy was restored (the Restoration) under Louis XVIII. The following year, Napoleon returned, but was defeated by the British and their allies at the Battle of Waterloo, in what is now Belgium. He died in 1821, once again in exile. The fortunes of Napoleon's First Painter resembled his own: David fell from favor under the new king, but his reputation revived with Napoleon's return in 1815. After Waterloo, David, too, was exiled from France. In 1816, he moved to Brussels, where he continued to paint and to correspond with his followers in France. He died in December 1825.

Jean-Auguste-Dominique Ingres

David's student Jean-Auguste-Dominique Ingres (1780–1867) produced political works aimed at exalting Napoleon. But he also painted many portraits, as well as mythical subject matter

and reclining nudes inspired by both antiquity and Orientalism. His *Grande Odalisque* of 1814 (**figure 8**) exemplifies this combination. The odalisque's clarity of form and reclining pose, also evident in Canova's *Venus*, are reminiscent of ancient Greek and Roman sculpture, but the figure occupies the exotic setting of a Turkish harem (*oda* being the Turkish word for harem). The materials are rich and convincing – the silk curtain, peacock-feather fan, jewels, fur, and Turkish water pipe, emitting steam at the far right. The odalisque turns to gaze at her viewers, thus drawing them into the picture space, but at the same time there is a constructed distance between her and the French viewers. The figure exemplifies Ingres' belief in the purity of line, characteristic of Classical order. "Drawing is the probity of art," he declared, whereas "Color is an ornament of painting, but it is no more than a handmaiden to it, since it does no more than render more pleasing those things which are the true perfections of art."[3]

Born in Montauban, in the south of France, the son of a local artist, Ingres was a violinist as well as a painter (the term

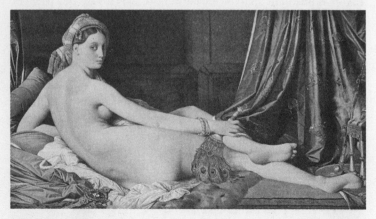

Figure 8 Jean-Auguste-Dominique Ingres, *La Grande Odalisque*, 1814, oil on canvas, approx. 2 ft 11 7/8 in x 5 ft 3 3/4 in (0.91 x 1.62 m). Musée du Louvre, Paris, France. (Source: Wikimedia Commons)

violon d'Ingres came to mean a hobby or occasional pastime in French). He believed that art and music were creative partners and that both were related to the notion of truth in nature, which became a characteristic view among nineteenth-century artists. On one occasion Ingres wrote, "If I could make you musicians, you would become better painters. In nature, all is harmony: a little more or less disturbs the key and produces a false note ... Truth of form is comparable to truth of sound."[4] Having studied art with David in Paris from the age of seventeen, Ingres worked in Florence and Rome. In 1824 he returned to Paris, where he joined the Academy in 1825. Two years later, Ingres was commissioned by the Bourbon government to work at the Louvre on an artistic program based on Neoclassical ideals. For the artist who said "I still worship Raphael, his century, the Ancients, and above all the divine Greeks,"[5] the commission seemed perfect.

Ingres' *Apotheosis of Homer* (**plate 2**) is set before an Ionic temple and echoes Raphael's quintessentially classicizing early-sixteenth-century fresco *The School of Athens* in the Vatican. The frieze is bare apart from Homer's Greek name, *OMEROS*. Enthroned on the top step is Homer himself, about to be crowned with laurel by a winged Victory in the ancient tradition of crowning poets. Ingres shows Homer as a god, reminiscent of the monumental statue of Zeus at Olympia, which had been carved in the fifth century BCE by the Classical sculptor Phidias. Ingres' Greek inscription below Homer's throne translates as: "To a commander of men and heroes." Flanking the inscription on the lower step are female personifications of the *Iliad* (in red) and of the *Odyssey* (in green). Just below these figures is another Greek inscription: "If Homer be a god, may he be worshipped among the immortals. But if he is not a god, let him be considered one." To the left and right on the lower step are, respectively, Latin quotations from Quintilian and Greek quotations from Longinus, both ancient authors known for teaching rhetoric.

There are over forty figures in *The Apotheosis of Homer*. Among them are artists (Apelles, Michelangelo, Raphael, Poussin), playwrights (Aeschylus, Sophocles, Shakespeare, Corneille, Racine, Molière), poets (Horace, Virgil, Tasso, Dante), musicians (Orpheus and Mozart), moralists (Aesop, La Fontaine), generals (Pericles, Alexander the Great), and philosophers (Plato, Socrates, Aristotle). All are depicted as descendants of Homer. Aside from Dante in the red hat and cape of a Renaissance scholar and Raphael in early sixteenth-century dress, the figures around Homer wear Classical dress. Just as Virgil had been Dante's guide through the Inferno, so Ingres' Virgil places his arm around Dante's shoulder as if to usher him – and the text he carries – before Homer. Raphael is led by Apelles (Painter to Alexander the Great), wearing a blue robe and carrying a palette with two brushes. For his part, Ingres signals his own special relationship to the classicizing seventeenth-century painter Nicolas Poussin, who is dressed in black, at the lower left. Poussin rests his arm on the block inscribed with Ingres' signature and points upward, his gesture carried formally through the long curve of Apelles' robe. By virtue of this arrangement, Ingres places himself within a pictorial genealogy of the Western Classical tradition. He identifies his august predecessors not only in the field of painting, but also in literature, philosophy, music, and politics.

The Apotheosis of Homer embodies Ingres' statement that color is the handmaiden of painting. Its rigorous symmetry, Ionic temple front, Classical subject matter, and crisp form convey a sense of structural calm and historical continuity. At the same time, there is something of David's melodrama in the diagonal gestures and the centripetal force drawing them towards the impassive, blind figure of Homer. The colors are restrained and clear; each costume is a single color, but repeated across different costumes to maintain unity and balance in the organization of the painting.

The classicizing style of Ingres prompted the French author and art critic Théophile Gautier to ally Ingres with his own apotheosis of Homer: "It is impossible," Gautier wrote on the occasion of the Paris *Exposition Universelle* (World's Fair) of 1855, "not to place him on art's summit, on that throne of gold with ivory steps on which are seated, crowned with laurel, the artists who have accomplished their glory and are ready for immortality. The epithet 'sovereign' that Dante gives to Homer fits Ingres equally well."[6]

In addition to works with classically inspired content such as *The Apotheosis of Homer*, Ingres produced many portraits of his contemporaries. One of his best known and most impressive is *Louis-François Bertin*, exhibited at the Salon of 1833. Here Ingres demonstrates his genius for revealing character. Bertin (1766–1841) was a self-made, assertive, and powerful Jacobin journalist. He is depicted as a living force, his massive bulk barely contained by a silk waistcoat as he places his hands on his knees and inclines toward the viewer. His ample chin, broad limbs, and powerful head convey a sense of immediacy. Unlike Homer, who is shown securely in the past, elevated above the viewer and his successors like a literary totem, Bertin is very much in the present.

Toward the end of his career, from the 1840s, Ingres painted a number of aristocratic women dressed in dazzling color that differs sharply from the somber, largely brown palette of Bertin's portrait. Bertin is shown as a serious *homme d'affaires*, whereas the women are clearly upper-class and dress accordingly. In those works, the color that had been subordinated to form in *The Apotheosis of Homer* and in the *Grande Odalisque* became a dominant visual and tactile force. Ingres achieved a new synthesis of color, texture, and line in these later interior portraits.

Like David, Ingres combined elements of the Classical revival with expressive gestures and political imagery. Their taste for dramatic, expansive gestures, and the attraction to the exotic East

was shared by the Romantic artists – the subject of the next chapter. Ingres' interest in color and texture can be seen as a prelude to developments that arise in Impressionism and Post-Impressionism, whose tactile qualities are conveyed by making the brushstrokes visible rather than by creating illusions of identifiable material. Whereas Ingres subordinates the medium to the content, the Impressionists would combine medium and content in a new way. With the emergence of Romanticism, we see the beginning of this new interest in the visibility of paint.

2
Romanticism

In 1757, the Irish philosopher Edmund Burke (1729–1797) published his *Philosophical Enquiry into the Origin of our Ideas of the Sublime and the Beautiful*, in which he proposed new aesthetic ideals. He described the combination of terror and elation, which he referred to as "the Sublime," experienced by the individual in relation to the vastness of nature – including human nature. For Burke, society was founded on human love and loyalty rather than on the abstract principles and revolutionary sentiments that inspired Neoclassicism. His contemporary, the Swiss-born French philosopher Jean-Jacques Rousseau (1712–1778), believed in a return to nature and advocated the importance of passion as a driving force of human existence. This, in turn, reflected a new interest in the mind as a source of hidden thought and emotion and prefigured the beginnings of modern psychology.

The ideas and interests of Burke and Rousseau fueled the art of a new movement, namely Romanticism. Like Neoclassicism, Romanticism began in the late eighteenth century, but, unlike Neoclassicism, it was not a style with clear and consistent formal qualities. It was a broad cultural movement comprising the visual arts, philosophy, music, and literature; the very term *Romanticism* was derived from a nostalgia for medieval, chivalric literature written in the Romance languages. Efforts to characterize Romantic art have focused on its themes – the primacy

of emotion over reason, the psychological and the imaginative, the mysteries of landscape and dreams, a commitment to social justice and political freedom, and an attraction to bygone eras and distant, exotic locales – rather than on principles of composition or paint handling. Nevertheless, in general the paint handling by Romantic painters is broader and often more textured than that of the Neoclassical artists, and therefore lends itself more to the expression of dynamic moods.

Romanticism embraced antiquity, but placed greater emphasis on the role of the individual than did Neoclassicism. The Romantic revival of antiquity stressed the social self and the natural self as facets of individual expression. The social self was embodied in Enlightenment ideas that drove the American and French Revolutions, including Rousseau's advocacy of the "rights of man" and the concept of a "social contract" between the governed and those who govern. The interest in the natural self, in humankind's relationship to nature, led to the depiction in nineteenth-century painting of landscape as a vast space that engulfs humanity. Other key aspects of the human condition that influenced Romanticism were the inner self – as expressed in moods, dreams, fantasy, religion, and superstition. The Romantic interest in childhood was also inspired by Rousseau, especially his autobiographical *Confessions*, in which he detailed the most intimate events of his youth.

Romanticism and architecture

Romantic themes inspired several revival styles in architecture, such as the Neo-Gothic Houses of Parliament in London and the Indian Gothic style of the Brighton Pavilion on England's south coast. The former expressed the architect Augustus Pugin's conviction that architecture should convey the morality of a lost Christian era, whereas the latter, designed by John Nash, was a place of entertainment and relaxation for the Prince Regent.

ROMANTIC LITERATURE

Germany: The eighteenth-century *Sturm und Drang* (Storm and Stress) movement prefigured Romanticism. It emphasized the primacy of feeling and imagination over the reason and order espoused by Academic classicism. The main German exponents of *Sturm und Drang* were Johann Wolfgang von Goethe (1749–1832) (*Faust* and *The Sorrows of Young Werther*), Friedrich Schiller (1759–1805) (*On Naïve and Sentimental Poetry*), and Johann Gottfried Herder (1744–1803) (*Treatise on the Origin of Language*).

England: The leading Romantic poets were William Wordsworth (1770–1850) and Samuel Taylor Coleridge (1772–1834). Their *Lyrical Ballads*, published in 1798, can be considered a manifesto of the Romantic movement. Their poetry conveyed the Romantic appeal of nature and of distant, exotic locales. The work of Lord Byron (1788–1824) (*Don Juan*), John Keats (1795–1821) (*La Belle Dame Sans Merci*), and Percy Bysshe Shelley (1792–1822) (*Ozymandias*) expressed the Romantic nostalgia for past and ruined civilizations, a passion for political and social justice (Byron: *The Isles of Greece*), and the combined attraction of beauty and terror (Shelley: *On the Medusa of Leonardo da Vinci in the Florentine Gallery*).

France: The most important French precursor of Romanticism was François-René de Chateaubriand (1768–1848), who evoked the medieval spirit in his *Génie du christianisme* of 1802. Among the major French Romantic poets in the nineteenth century are Alfred de Musset (1810–1857), Gérard de Nerval (1808–1855), Alphonse de Lamartine (1790–1869), and Théophile Gautier (1811–1872). Victor Hugo (1802–1885) was the leader of Romanticism in nineteenth-century France, and believed literary freedom to be as important as political and social freedom.

United States: The novels of James Fenimore Cooper (1789–1851) (*The Last of the Mohicans*) expressed the notion – espoused by Jean-Jacques Rousseau – of the "noble savage," especially in his fictionalized histories of Native Americans. The haunting Gothic tales of Nathaniel Hawthorne (1804–1864) (*The Scarlet Letter*) and Washington Irving (1783–1859) (*Tales of the Alhambra*) convey the taste for a medieval past and share with Edgar Allan Poe (1809–1849) (*The Raven*) a penchant for the macabre and the supernatural.

As such, the Brighton Pavilion has a whimsical, playful quality enhanced by its onion domes and elaborate tracery inspired by Islamic ornamentation. The Houses of Parliament, in contrast,

are imposing and forceful, combining Pugin's vision of England's medieval past with the requirements of the contemporary British government.

Fuseli's *The Nightmare*

Burke's notion of the "sublime," as well as explicitly psychological themes, informs *The Nightmare* of 1781 (**figure 9**) by the Swiss painter Henry Fuseli (1741–1825). In this work, Fuseli evokes the sublime by showing the dreamer and the dream simultaneously, so that the viewer, along with the painted dreamer, experiences the terrors of a nightmare. The painting also mirrors the belief current among Enlightenment thinkers that dreams are intimate and internal phenomena rather than supernatural visions sent by an outside force.

Fuseli's dreamer is portrayed with Neoclassical proportions and idealized form, but her pose and the theme of the picture are Romantic. She is dramatically stretched across a couch, her eyes are closed, and she seems not to see the monstrous little incubus sitting on her, although he is clearly part of her dream. She does, however, *feel* his presence, because he presses on her chest and causes the panicked breathing that typically accompanies the anxiety of a nightmare. At the same time, the dreamer's calm expression and slightly parted lips, along with her pose, betray the underlying eroticism stimulating her dream. The rich reds of the curtain and the curvilinear, flowing drapery below the couch reinforce this effect. Also accentuating the erotic character of this particular nightmare is the resemblance of the incubus to a satyr in its stunted proportions, goat-like legs, pointed ears, and subhuman head. The incubus represents mysterious forces of the unconscious mind that erupt in dreams and nightmares. He is childlike in his small size, which reflects the fact that dreams are formed when a childhood memory connects with an event or thought

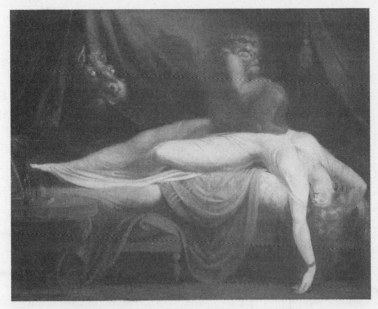

Figure 9 Henry Fuseli, *The Nightmare*, 1781, oil on canvas, 39 3/4 x 49 1/2 in (101 x 127 cm). Detroit Institute of Arts, Detroit, Michigan. (Source: Wikimedia Commons)

from the previous day. Since dreams are overdetermined – that is, they are caused by multiple layers of experience – they have multiple meanings. In this context, the painting has been read on a political level as having implications related to contemporary tensions between conservative and liberal factions in England and the United States. The image was widely disseminated in prints and one popular caricature of it showed an aristocrat (in place of the horse) frightened at the prospect of revolution.[1]

Another, more psychological reading of Fuseli's dream concerns its emphasis on the power of the gaze. In contrast to the closed eyes of the dreamer, those of the incubus are wide open. They stare out of the picture, engaging the gaze of the

viewer. Likewise, the bulging eyes of the surprised horse peering around the curtain lead our gaze to the dreamer herself, at whom the horse is staring. In its role as intruder, the horse is like a child unexpectedly encountering adult sexual activity (called the "primal scene" in psychoanalysis), but it is also, like us, coming face to face with the anxiety of a forbidden erotic nightmare.[2] The psychological implications of *The Nightmare* are highlighted by the fact that a reproduction of it hung for years in Freud's consulting room.

William Blake and the myth of Albion

The work of the English visionary William Blake (1757–1827) embodies the Romantic view that imagination is foremost. He shared a sense of the sublime with Burke and Fuseli, who was his close friend, and he imbued his work with religious imagery. Blake was not an active revolutionary, but he identified with the Jacobins in France and championed the views espoused by Thomas Paine (1737–1809), the revolutionary political activist, in *The Age of Reason*. He belonged to the Lunar Society of Birmingham, England (see box), a testament to his liberal views and commitment to social justice.

Blake's opposition to tyranny is evident in a watercolor of 1795 showing the Neo-Babylonian king Nebuchadnezzar II as a fallen tyrant. Blake depicted Nebuchadnezzar as a metaphor for the notion that a king who breaks his "contract" with his subjects (and with God) turns reason inside out and perverts the rights of man. In the Bible, God casts down Nebuchadnezzar for his grandiosity in building the Tower of Babel and invading the heavens. Blake's God drives Nebuchadnezzar mad, just as in revolution the mobs overturn the established order of society. Blake's Nebuchadnezzar stood for contemporary rulers such as Louis XVI of France and George III of England.

THE LUNAR SOCIETY

The Lunar Society began as an informal group of liberals in eighteenth-century Birmingham; its aim was to promote progress in science and industry. Members of the society included merchants, industrialists, scientists, artists, and writers dedicated to experimentation and the primacy of science over religion. The Lunar Society supported the American and French Revolutions and opposed slavery. In the nineteenth century, members began keeping records of their meetings, which were held on the Monday evenings closest to the full moon (hence the name). This enabled members to find their way home by moonlight. Influential in matters of politics and economic philosophy, the Lunar Society helped to shape the progress of industry in the English Midlands.

In addition to his political liberalism and interest in science, Blake believed in the timeless nature of the human soul, which endowed his imagery with a visionary quality and a longing for England's Christian past. He also believed in the arts as a kind of hymn to his own Christianity, a view he expressed in 1820 as follows:

A Poet, a Painter, a Musician, an Architect: the Man or Woman who is not one of these is not a Christian.
You must leave Fathers and Mothers and Houses and Lands if they stand in the way of Art.
Prayer is the study of Art.
Prayer is the Practice of Art[3]

Blake's training as an engraver left an imprint of sharp edges and clear lines on his pictorial style, which can be seen in the frontispiece for *Jerusalem: The Emanation of the Giant Albion* (**figure 10**), the best and longest of Blake's "prophetic books," a series of poetic works expressing his personal mythology. The iconographic "text" of the frontispiece is the so-called myth of Albion – the

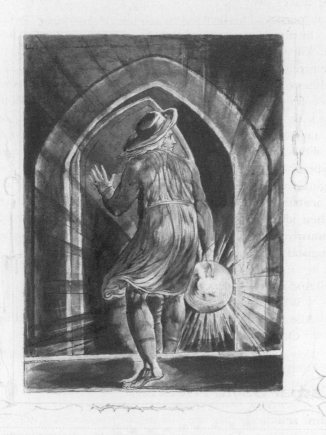

Figure 10 William Blake, Frontispiece of *Jerusalem: The Emanation of the Giant Albion*, 1804–1820, hand-colored etching, 8 3/4 x 6 6/8 in (22 x 16 cm). (Source: Wikimedia Commons)

belief in a primal man (Albion), a kind of Adamic "first man" who inhabited England after losing contact with Jerusalem. A metaphor for Blake's own spiritual voyage, the poem *Jerusalem* relates the epic journey of his hero through death and redemption in Christ.

In the engraving, a giant Albion carrying a lamp steps into blackness. He turns his head and raises his left hand as if apprehensively confronting the abyss. The sharp contrast between the whites of Albion's costume and the murky darkness he is about to enter enhances the dramatic character of the image. With his back to the viewer, he makes us identify with his own dread. A ray of hope is implied in the haloesque, circular lamp that embodies both the interests of the Lunar Society in scientific experiments with electricity and the Christian symbolism of light. Blake hoped that a new synthesis of industry, science, and Christian spirituality would form a New Jerusalem in England. These ideas recur in Blake's famous poem *Jerusalem* (different but similarly named), in which he refers to the myth that Jesus visited England during his lifetime:

> And did those feet, in ancient time
> Walk upon England's mountains green?
> And was the holy Lamb of God
> On England's pleasant pastures seen?

Caspar David Friedrich

Time and timelessness are prominent themes in Romantic landscape painting. To some degree, the Romantic landscape was a refuge from the growing pollution of industry, the spread of urban slums, and the abuse of workers. At the same time, however, landscape for its own sake conveyed a vision of the sublime, a sense that humanity can lose itself in nature, and this, like Fuseli's *The Nightmare*, led to a fusion of beauty and terror. Nature, being

infinite and timeless, was a constant reminder of the finite time granted to human beings and confronted people with their own mortality.

In Germany, the Romantic pantheistic spirit was expressed by Goethe, who saw revolution and industry as harbingers of world destruction. He believed that mind and matter merge in nature and that science and reason are secondary to feeling and nature's changing moods. Echoes of these views can be seen in the work of Caspar David Friedrich (1774–1840). He was born in Greifswald, a Swedish–Pomeranian town on the Baltic Sea, and studied art first in Copenhagen and later in Dresden. He was bothered by seeing groups of pictures exhibited together in great numbers, which interfered with his ability to contemplate each one in sufficient, meditative isolation. This, he felt, lessened the impact of the individual work.

A self-portrait of 1810 conveys the intensity of Friedrich's identification with Romanticism. He leans forward and gazes from the picture beneath arched brows and wavy hair. His thick sideburns create a dynamic form around his face and seem to merge into the folds of his cloak. Here, he depicts himself as a passionate Romantic with a powerful, moody inner life. "A painter should not merely paint what he sees in front of him," he declared, "he ought to paint what he sees within himself."[4]

The same intense feelings characterize Friedrich's landscapes. He believed in spirituality, which he conveyed in his landscapes, although they are rendered with historical accuracy. Friedrich's *The Stages of Life* (**figure 11**) is a late painting of 1834 to 1835, which combines autobiography with a landscape devoid of allusions to industry. On one level, the work is an allegory of time – from childhood to old age. The human figures are finite in time and space; they occupy a low foreground promontory delineated with grass and rocks, whereas a limitless sea seems to stretch into the distance. The sky, consisting of flattened grays and yellows, meets the sea in a straight edge, past which is infinity.

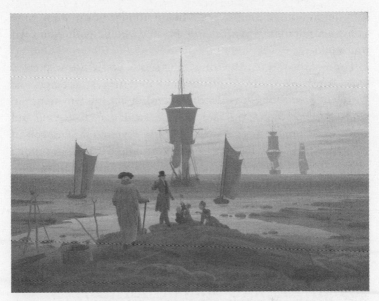

Figure 11 Caspar David Friedrich, *The Stages of Life*, 1834–1835, oil on canvas, 28 1/2 x 37 in (72.5 x 94 cm). Museum der bildenden Künste, Leipzig, Germany. (Source: Wikimedia Commons)

Friedrich confronts viewers with the notion that nature, in the words of Coleridge, is "measureless to man" and thus beyond our comprehension.

The figures in the painting reveal its autobiographical content. They have been identified as Friedrich's three children, Gustav Adolf, Agnes and Emma, his nephew (in the top hat), and himself (the older man with a walking stick). The absence of his wife reflects his obsessive (and almost certainly unfounded) belief in her infidelity – he has literally painted her out of the picture. Echoing the five family members are five sailing ships, the three in the foreground carrying tiny figures. The boats also signify time, through space, scale, and diminishing clarity, rather than by chronological age. They are signs of a pre-industrial past, idyllic

relics of a nostalgic fantasy just as the myth of a utopian childhood is suggested by the playful, carefree character of Gustav Adolf and Agnes. As the boats come into view, they, like the grassy mound, become visible in detail. However, the two distant boats are gray silhouettes, flattened and ghostly. The overturned, wrecked, and cadaverous hull of a boat in the foreground begins to sink into the earth. It occupies the same diagonal as the sunken rocks and is a metaphor for the future of the artist, toward whom it directs our gaze. Friedrich, like his painted sky, has arrived at the sunset of life. Because he is shown in back view, his own viewpoint, like that of Blake's Albion, is the same as ours. We identify with him as he gazes on human time juxtaposed with the eternal vastness of nature. Like Friedrich, we are on the shore; we are finite and transitory, whereas nature is infinite and unknowable.

Joseph Mallord William Turner

In contrast to the clarity and stillness of Friedrich's landscapes, those by the English artist Joseph Mallord William Turner (1775–1851) confront viewers with nature as a force in continual motion. Even when Turner's scenes technically recede into the far distance, his paint remains a powerful presence on the surface of the picture. His loose brushwork and visible paint texture that were contrary to the Neoclassical aesthetic drew negative reviews, but he was championed by John Ruskin (1819–1900), then England's greatest living art critic. For Ruskin, Turner's landscapes were, above all, truthful. "Of one thing I am certain," Ruskin wrote, "Turner never drew anything that could be *seen*, without having seen it."[5]

Turner's genius was recognized early in his career, especially in his drawings and book illustrations, and his productive life lasted over sixty years. From the age of fourteen he took long walks and sketched the countryside. He developed an expertise

JOHN RUSKIN

John Ruskin (1819–1900) was the son of a wealthy wine merchant and thus had the means and leisure to travel and write without having to earn a living. His genius as an art critic lay in his passionate commitment to truth and beauty as well as in his ability to produce literary equivalents of paintings. He championed Turner, whose work motivated him to write the first volume of *Modern Painters*, published in 1843. Six years later, he produced *The Seven Lamps of Architecture*, his major work of architectural philosophy, followed by *The Stones of Venice* in 1851–1853. Ruskin also wrote on geology, botany, ecology, economics, and politics, and published a children's book entitled *The King of the Golden River*. In 1869 he became the first Slade Professor of Art at Oxford, his own *alma mater*. Ruskin was himself a talented draughtsman and watercolorist. He drew many works of architecture in the hope that by doing so he would preserve them for future generations.

Ruskin's odd relationships with women have been the subject of numerous studies. His notorious marriage to his cousin, Effie Gray, which was apparently unconsummated, ended in a scandalous separation, and was followed by obsessions with images of sleeping or dead girls – notably the sleeping Saint Ursula in Carpaccio's *Dream of Saint Ursula* in the Venice Accademia and Jacopo della Quercia's marble tomb statue of Ilaria del Carretto in Lucca, Italy. After her divorce from Ruskin, Effie married the artist John Everett Millais and had eight children.

Ruskin's autobiography, *Praeterita* (1885–1889), describes his bizarre upbringing, the insanity in his family, and his own contradictory nature. He was a victim of periodic bouts of psychosis and carefully recorded his delusions and nightmares. Ten years before his death, he succumbed to complete madness.

in topography and by the time he was twenty-seven he was a full member of the Royal Academy in London, where some five years later he was appointed Professor of Perspective. Many of his early landscapes are structured through architecture, but in his signature style the architecture is opened up, distanced, and absorbed into a dynamic, ever-changing nature. Turner's interest in the sublime quality of the Neolithic cromlech (circle of stones) at Stonehenge,

for example, was expressed in pencil studies and watercolors that depict the stones at different times of day and in different weather conditions. This practice reflects his interest in light and color, which would later influence the Impressionists, who strove to convey immediate sensations. Turner shows the fleeting character of nature in contrast to the stones that have lasted for over 2,000 years. By blending his medium (materials), especially the fluid character of watercolor, with the content of the images, Turner created slightly blurred form that suggests uncertainty.

In *The Fighting Temeraire Tugged to Her Last Berth to Be Broken Up* of 1838 (**plate 3**), Turner created an epic in light and color. Its rich surface results from intense primary hues (reds, yellows, and blues) and a build-up of glazes; Turner has placed thin, transparent layers of paint on top of each other to increase depth and modify the colors without mixing them. The brushstrokes seem to transform themselves into elements of nature before our eyes. At the right, the yellow of the setting sun nestles between blues and reds, creating a fiery sky that is reflected in the sea and perhaps symbolizes the end of an era in British naval history. The blues, purples, and whites at the left are calm and muted, implying that the ship has outlived its usefulness.

In sharp contrast to the fading Temeraire, which played an important role in the Battle of Trafalgar in 1805 and whose very name evokes the daring bravery of its naval victories, the tugboat, with rich red and yellow flames spewing forth from its black smokestack, is energized. This ugly little boat heralds the industrial future, its engine capable of leading the much larger, proud and elegant sailing ship to its final resting place. Turner's painting is thus about the end of an era as well as the end of a ship. His depiction of the Temeraire can be read as a Romantic metaphor for the state of nineteenth-century England. As such, the work evokes nostalgia for the past and shows us the change from one period of history to the next.

When Turner exhibited *The Fighting Temeraire* at the Royal Academy in 1839, he was criticized by the author William

Makepeace Thackeray for making "mad exaggerations" of nature and for "daubing it with some absurd antics and fard of his own." Thackeray objected to Turner's "pea-green skies, crimson-lake trees, and orange and purple grass ... shake them well up," he wrote, "and you will have an idea of a fancy picture by Turner."[6] Ruskin, however, considered Turner a presenter of truth and argued that he, unlike previous painters, had depicted the truth of the sea. "The sea up to that time," Ruskin wrote, "had been generally regarded by painters as a liquidly comprised, level-seeking consistent thing with a smooth surface ... But Turner found ... that the sea was *not* this: that it was, on the contrary, a very incalculable and unhorizontal thing."[7] In this description, Ruskin identifies Turner's genius for capturing the changing moods of nature and the dynamic brushwork that produced the intense shifting color of *The Fighting Temeraire*.

Turner's characteristic translucent "veil" seems to place a scrim between the viewer and the artist's vision of nature. This brings a quality of mystery to the images by suggesting hidden dynamic forces constantly in flux beneath a dazzling surface. Turner's colors are a subject in their own right and impinge directly on our experience of the image. They are independent of the boundaries and structure required by narrative content, but they are also conveyors of that content. In Ruskin's view, this new presentation of color and light (and, one might add, of darkness) brought new meaning to the picture's surface. In so doing, it also implies what might lie below the surface of the picture and thus stimulates the viewer's imagination.

John Constable

England's other leading Romantic landscape painter, John Constable (1776–1837), had his own vision of "truth" in nature. Less interested in the sublime effects of Friedrich or the vigorous paint handling of Turner, Constable produced images to which

he had become attached as a child. His "truth" was the truth of his childhood, and his landscapes were a window onto his personal past. They are endowed with a quiet, pastoral atmosphere that, like Friedrich's, seems oblivious to the growth of industry and its effects on the countryside. As such, Constable's landscapes have a utopian quality associated in the nineteenth century with an idealized vision of childhood.

Constable was born in the valley of the River Stour in Suffolk, where his father was a wealthy mill-owner. He began painting during his late adolescence and decided not to enter his father's business. Rather than profiting from producing agricultural goods, Constable painted the land that produced them. In typical Romantic spirit, Constable compared painting to feeling and said that he associated his "'careless boyhood' with all that lies on the banks of the Stour; those scenes made me a painter."[8] His career, far less meteoric than Turner's, did not flourish until his marriage in 1816, when he began painting large-scale landscapes. During the ten-year period by which his future in-laws delayed the marriage, because he could not provide financially for a wife, Constable supported himself by painting portraits. Small sketches made during that time were used as studies for his later monumental landscapes.

Constable studied in the Academic tradition of London's Royal Academy, but did not become a full member until the age of fifty-three. Landscape painting was not lucrative, even though it was his natural subject, but it expressed his firm attachment to his native environment and the sway in which it held him. Constable's vision of landscape included the sky, in which he took a scientific interest. He studied the effects of weather and seasons on cloud formations and, from 1821 to 1822, entered a period that he referred to as "skying." At that time, he produced many sketches and oil studies of clouds, which exemplified the Romantic interest in the shifting moods and transitory, changing character of nature. For Constable, the sky was the light

source of nature and a necessary aspect of landscape painting. "The landscape painter," he wrote, "who does not make his skies a very material part of his composition neglects to avail himself of one of his greatest aids."[9]

The beginning of Constable's period of "skying" coincided with the production of his best-known painting, *The Hay Wain* (**figure 12**). This is a scene of harvesting late in summer as viewed from Flatford Mill at the edge of the River Stour in Suffolk. A wagon (the hay wain) crosses a river, a house stands to the left, an elusive figure is barely visible in front of the house, and another, apparently mooring a row boat, appears in the thicket of bushes at the right. In the distance, tiny farmers in white shirts tend to the harvest. Unlike the broad sweeps of Turner's brushstrokes and his notion of nature as constantly moving, Constable's *Hay Wain* is calm, structured, and closely observed. Only a few intense reds

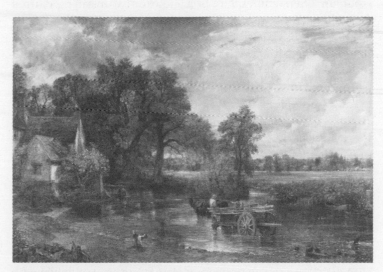

Figure 12 John Constable, *The Hay Wain*, 1821, oil on canvas, 51 1/4 x 73 in (1.30 x 1.85 m). National Gallery, London, UK. (Source: Wikimedia Commons)

(on the horses) and occasional patches of white stand out from the predominant deep browns and dark greens.

Constable's original title for the work, *Landscape: Noon*, identifies the time of day. The sky is heavy with clouds that lighten as the threat of a storm gives way to blue. In contrast to the density of the land, Constable's sky has the potential to open up space, relieving the weight and solidity of the land. Only his sky, animated by cloud formations, seems capable of change. The land, like his memories of childhood, seems eternal. The flux of Constable's nature is in the changing weather and in the leisurely motion of the hay wain, as it is pulled through the river by the horses.

A surviving preliminary study for *The Hay Wain* offers some insight into the deeper meaning of the picture. The artist organized the original lights and darks as they are retained in the final work. In one significant respect, however, Constable departed from the study, which shows a man and a dog standing at the edge of the river watching the unremarkable passage of the cart. In the final version, the man is eliminated and the dog is interrupted in his stroll along the river bank as if suddenly riveted by the sight of the hay wain. By eliminating the adult bystander, Constable elevates the hay wain's passage from a narrative, picturesque image to a more general mythic one, hence the fame of this painting. The myth in question involves the universal quest of children for their origins.

The Hudson River School

In nineteenth-century America there developed an image of the land that shows a distinct affinity with European Romanticism. Rousseau's view of the pure state of nature, combined with the moral conviction of God's presence in nature, was advanced in America by the authors Emerson and Thoreau. This led to a

TRANSCENDENTALISM: EMERSON AND THOREAU

In the United States, Ralph Waldo Emerson (1803–1882), who met Wordsworth while traveling in England, was, with Henry David Thoreau (1817–1862), the leading exponent of Transcendental philosophy. In 1836, Emerson wrote that, when surrounded by nature, he became an all-seeing eye; he joined with God, who was revealed in nature. This, for Emerson, endowed the contemplation of nature with both moral and aesthetic value. He believed that society had become inflicted with consumerism and conformity, preferring spontaneity and the virtues of nature over so-called civilization. These ideas were set out in a series of essays entitled *Nature* that Emerson published in 1836. In a two-year experiment, Thoreau lived alone in the woods by Walden Pond, a lake near Concord, Massachusetts. He set out to prove that moral and spiritual development was enriched by solitary communion with nature. In 1854, he memorialized his experiences in *Walden: or Life in the Woods.*

vision of landscape consistent with a new world, where nature is untouched by human intrusion. The major group of artists influenced by these ideas was the Hudson River School of Painters, so named because they worked mainly around the Hudson River Valley in New York State.

The foundations of American landscape painting were laid by the Hudson River painter Thomas Cole (1801–1848), who also wrote Romantic poems on man's communion with nature. In 1835 he composed a poem revealing his attraction to stormy weather:

> I sigh not for a stormless clime,
> Where drowsy quiet ever dwells,
> Where purling waters changeless chime
> Through soft and green unwintered dells –
>
> For storms bring beauty in their train;
> The hills that roar'd beneath the blast,

> The woods that welter'd in the rain
> Rejoice, whene'er the tempest's past.

Cole's paintings depict the sense of nature's overwhelming power and the inability of humanity to control its forces. In the course of his career, he had to navigate between his personal inclinations, which gave priority to imagination over reality, and those of his patrons, who preferred scenes of recognizable locales.

Cole painted a series of four monumental pictures entitled *The Course of Empire*, which combine vast space and architecture to convey the contrast between primordial nature and the grandeur of civilization. Imbued with the imaginative quality that Cole idealized, *Desolation* of 1836 (**figure 13**) is the last of the series and depicts civilization's decline. In *Desolation*, Cole shows an ancient Classical temple overgrown with foliage and a broken aqueduct bridge that once spanned a river. The moon's

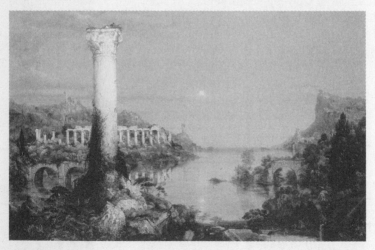

Figure 13 Thomas Cole, *The Course of Empire: Desolation*, 1836, oil on canvas, 39 1/4 x 63 1/4 in (100 x 160 cm). New York Historical Society, New York, New York. (Source: Wikimedia Commons)

reflection implies that with night comes the end of civilization. A single Corinthian column stands alone, no longer the supporting element of a temple dedicated to a pagan god; now its only function is to house a nest of birds. Fragments of broken marble moldings, the remnants of its former glory, are strewn on the ground. Cole's *Desolation* is thus a poetic allegory: its message is that moral corruption destroys humanity. Nature, on the other hand, persists in time and place. Formally, Cole's message is conveyed by softly textured brushstrokes; compared with those of Turner, Cole's forms, especially the architecture, tend to have more structure. Emphasizing this contrast, Cole criticized Turner's late landscapes for rocks that "look like sugar candy" and "ground like jelly."[10]

Cole's friend and correspondent Asher Brown Durand (1796– 1886) also became a leading figure of the Hudson River School. In 1837 he traveled with Cole in the Catskill Mountains of New York State and went to Europe three years later. In 1845 the two artists founded the National Academy of Design in New York City. Stylistically, Durand differed from Cole in his preference for accurate portrayals over imagination. He studied details of rocks and foliage, and the properties of light and color as they were affected by time and weather. Nevertheless, his paintings retain qualities of feeling and mood, as can be seen in *Kindred Spirits* of 1849 (**figure 14**), a double portrait of Cole and the poet William Cullen Bryant overlooking Kaaterskill Clove in the Catskills. In that work, the two men are depicted as individuals and are a strong presence even though surrounded by nature. The painter carries an easel and wears a hat, whereas the poet has removed his hat and leans on a walking stick. They seem to be conversing, possibly a metaphor for the on-going Romantic "conversation" between the arts. The poet and painter have arrived at a stopping point; only their shadows venture past the edge of the rocky platform before them. Unable to proceed, they are enveloped but not engulfed by nature. They retain their identity and, like

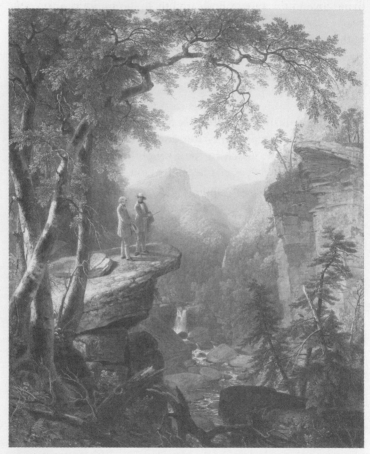

Figure 14 Asher B. Durand, *Kindred Spirits*, 1849, oil on canvas, 3 ft 8 in x 3 ft (1.12 x 0.91 m). Crystal Bridges Museum of American Art, Benton-ville, Arkansas. (Source: Wikimedia Commons)

us, are aware of the sudden drop to the rushing stream and the cascading mountains receding toward the horizon. Three birds flying toward the foreground accentuate the transition from the nearby dark rocks and broken trees to the blue-gray mountains in the far distance.

Luminism

The mystical qualities discerned in the luminous quality of nature and captured in certain American landscape paintings gave rise to the term *luminism*, which in the twentieth century was applied retrospectively to a style that developed out of the Hudson River School. With Luminism, landscape in America evolved from its Romantic literary underpinnings in Europe to a new kind of abstraction. Luminist iconography emphasizes dramatic natural light and vast space over narrative. It was in tune with the Transcendental philosophy of nature espoused by Emerson and Thoreau that emphasized the spiritual qualities of nature and the sense of a divine presence within it. The germs of Luminism can be seen in Durand's use of light and smooth paint handling. But, unlike Durand, Luminists preferred the absence of the artist and indeed of humanity in general, so that the viewer contemplates nature directly. Instead of juxtaposing figures with the vastness of nature, Luminists expressed the sublime by painting nature's vast spaces devoid of people.

With increasing exploration and settlement of the New World, an awareness of the American landscape as a potential subject of art extended beyond New England to the Far West and parts of South America. Albert Bierstadt (1830–1902) was born in Germany but raised in Massachusetts. His *Sunrise: Yosemite Valley* (**plate 4**) was painted sometime after 1863, during a trip to Yosemite, California. The work exemplifies the clarity and immobility characteristic of Luminist scenes. Its dramatic yellow

sky pervades the entire picture, casting a veiled atmosphere on the huge rock formations of the American West and providing a backdrop against which the foreground trees are silhouetted. Bierstadt deploys a sequence of light across the picture's surface, beginning with the brilliant yellow of the rising sun at the center. Its brightness outshines and engulfs the edge of the mountain, and continues through a series of yellows alternating with grays at the left and merging with the darker tones of the forest in the right foreground, where a lone bear, undisturbed by human intruders, is barely visible. Nestled in the valley is a river, reflecting and condensing the shapes and lights towering over it and creating a natural visual transition from one side of the valley to the other.

Francisco de Goya y Lucientes

In contrast to the landscape painters, the work of three of the most significant Romantic artists of the nineteenth century – Goya in Spain and Géricault and Delacroix in France – depicts large-scale figures passionately engaged in contemporary politics. The intensity of the Romantic commitment to social justice and political freedom is evident in the sometimes harsh, satirical imagery of Goya and in the dynamic, painterly energy of Géricault and Delacroix. All three of these artists, who are the focus of the rest of this chapter, stood for psychological, political, social, and artistic freedom. Their breadth of subject matter and depth of insight are consistent with the spirit of the Enlightenment.

Francisco de Goya y Lucientes (1746–1828) spent nearly all of his life in Spain. He was born near Saragossa in the Aragón region, where he studied painting. His father was a goldsmith and his mother a member of the aristocracy. He moved in Spanish intellectual circles, which were conversant with the

writings of the French Enlightenment authors. In 1770, he went to Italy and studied Classical and Baroque art; but the major influence on his style was that of the Spanish Baroque painter Velázquez. In 1774 Goya was hired to work in Madrid, designing tapestries for the king. He continued to do so until 1792, but considered it beneath his talents as a painter. In 1786, Goya was appointed Painter to King Charles III of Spain, and in 1789 he was named Court Painter to Charles IV, a position similar to that held by Velázquez at the seventeenth-century court of Philip IV.

Members of the royal family were apparently oblivious to the negative light in which Goya often portrayed them. His many portraits of the royal family chronicled the decadence and decline of the Spanish monarchy. But his public commissions were only one aspect of his prodigious output, which included portraits of the upper classes that insured him a successful and prosperous career. He also produced private, uncommissioned works, in which he expressed the hidden terrors of the mind. His main themes are represented in a series of eighty etchings and aquatints entitled *Los Caprichos* (*Caprices*), published in 1799 in a Madrid newspaper. They included delving into the inner reaches of imagination and mercilessly exposing the hypocrisy of the principle that kings rule by divine right. He also attacked the Catholic Church, satirized popular superstitions, and laid bare the horrors of war.

Duendecitos (*Hobgoblins*) from *Los Caprichos* is a satirical depiction of the clergy (**figure 15**). Hobgoblins were creatures believed to have joined with Lucifer when he was expelled from Heaven; but rather than descend to Hell as Lucifer had, they inhabited the human world. They were tricksters, who frightened people and stole from them. In Spain, the term *duendecitos* was popularly applied to friars, especially when they were depicted in a derogatory light. In Goya's etching, three members of the clergy occupy a room illuminated by a window in the back wall. Their stunted appearance and suggestive, ambiguous

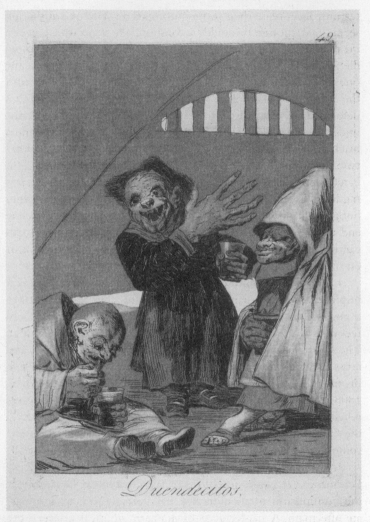

Figure 15 Francisco de Goya y Lucientes, *Duendecitos (Hobgoblins)*, from *Los Caprichos,* 1797–1798, plate 49 of first edition of 1799, etching and burnished aquatint, 8 3/8 x 6 in (21.2 x 15.2 cm). Metropolitan Museum of Art, New York, New York. (Source: Wikimedia Commons)

features accentuate their grotesque character. The one at the left seems bald, though he could be tonsured. He sucks on a piece of bread that he has dipped in a glass of wine, which has two possible iconographic meanings: an allusion to the Eucharist on the one hand, and a betrayal of his greed on the other. At the right, the hobgoblin wearing sandals and a tall cowl, endowed with a deformed jaw and jutting nose, tries to hide another glass of wine under his cloak. The central figure resembles a priest, wearing a black cassock and buckled shoes. Even more so than the other two, the priest-like figure is shown as a subhuman monster, his bared teeth reminiscent of fangs and his enlarged hand extending long fingers. He, too, holds a glass of wine, joining the other hobgoblins in secret drinking. The grotesque quality of this scene and the character of the figures imply that a greedy clergy was cannibalizing Spain at a time when the Church was the wealthiest institution in the country.

One of Goya's most eloquent condemnations of war was inspired when the armies of Napoleon overran Spain in 1808, a conflict known as the Peninsular War (see box, p.50). Goya recorded the war in a second series of eighty etchings entitled *The Disasters of War*, which were not made public until after the artist's death. Their message, however, is clearly foreshadowed in his famous *The Executions of May 3, 1808* (**plate 5**). On May 2, 1808, in the Puerta del Sol square in Madrid, a group of Spaniards rebelled against the French invasion. The following day, May 3, the French army executed, without a trial, every Madrileño (citizen of Madrid) suspected of having participated in the uprising.

In 1814, after the French were ousted from Spain and King Ferdinand VII was restored to the Spanish throne, Goya sought the commission to memorialize the uprising and its immediate aftermath. A masterpiece of dramatic political imagery, the painting's powerful impact is enhanced by allusions to traditional Christian symbolism. The viewer identifies with the illuminated Christ-like figure at the left who raises his arms, echoing the

THE PENINSULAR WAR

The Peninsular War began in 1808 with Napoleon's invasion of Spain and Portugal (the Iberian Peninsula). That same year, Napoleon installed his brother, Joseph, on the Spanish throne, thereby inciting fierce rebellion throughout Spain. The British commander Sir Arthur Wellesley fought for Spain and defeated the French in Portugal in 1808 and 1809. In 1812, Wellesley (who was by then Viscount Wellington) was victorious at Salamanca. He occupied Madrid and drove the French from southern Spain. Three years later, Wellington forced the French from Spain entirely and, in 1814, invaded southern France. The following year he defeated Napoleon at the Battle of Waterloo. Goya commemorated Wellington's victories on behalf of Spain by painting his equestrian portrait.

Crucifixion, in a gesture of helpless surrender and vigorous protest. He thrusts his head forward, confronting his own annihilation with wide-eyed horror. Lying before him on the ground, their blood mingling with the Spanish soil, are his predecessors in death. The foremost of these extends his arms in a gesture also reminiscent of the Crucifixion. Other Madrileños awaiting execution cover their faces or shake their fists. Their formal arrangement as a semi-circle around the illuminated figure echoes the semi-circular apse of a church in which the crucifix is placed on an altar.[11] The dimmed church building in the background reinforces this association; its faded appearance, combined with the black sky, refers to the tradition that the sky turned dark when Christ died.

The large square lantern illuminating the victims silhouettes the French firing squad, which is represented as a dark, faceless, and relentless force of soldiers. They form an orderly line, similarly posed, with their legs and swords forming harmonious diagonals. Their neat military dress creates a sharp contrast with the disheveled clothing of the unarmed Spanish rebels. Whereas

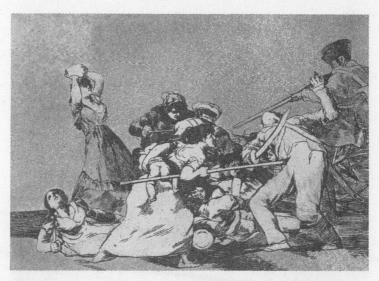

Figure 16 Francisco de Goya y Lucientes, *Y son fieras (And They Are Wild Beasts), Fatal consequences of the bloody war in Spain with Bonaparte, Disasters of War*, plate 5. Working proof 1810–1820, 6 1/8 x 8 1/8 in (15.6 x 20.8 cm). Museum of Fine Arts, Boston, Massachusetts. (Source: Wikimedia Commons)

the French are shown as an anonymous force, the Spaniards are individualized and their faces are clearly visible. As the French take aim, their pointed rifles direct the viewer's gaze toward their victims, creating a visual tension that echoes the political tension between the conquerors and the conquered. In this work, Goya has emphasized themes of seeing and not seeing, of being seen and not being seen. We see the Spanish faces, but not those of the French – an echo of the tradition of masking the face of an executioner. Likewise, the Spanish either confront their destiny directly or refuse to look and hide their eyes. The French, meanwhile, are unified in focusing on their Spanish victims.

Goya's etching from *The Disasters of War* entitled *And They Are Wild Beasts* (**figure 16**) further illustrates his opposition to war

and the fortitude of the Spanish in resisting the French. Inspired by the 1808 Siege of Saragossa, the image shows Napoleon's troops fighting Spanish women who went to the barricades and fought with bricks and stones. The title of the print was taken from contemporary accounts of the battle that likened the resisting Spaniards to wild animals defending their homes and young. Rage and maternal determination are embodied in the woman at the far left, who prepares to hurl a large rock at the soldiers. She leans back, forming a diagonal away from the central group as her gesture leads our gaze to the right. The reclining woman leaning toward the left occupies a pose reminiscent of dying Classical and Romantic heroes and heroines. She grasps a knife and looks to the sky as if imploring God.

The power of this etching lies not only in its depiction of a fierce battle between armed troops and unarmed women. As with *The Executions of May 3, 1808*, Goya has embedded traditional Christian symbolism in a contemporary event. He highlights the woman in the foreground and the contorted, falling soldier she has impaled with a long pike. Countering the thrust of the pike is the diagonal of the rifle aimed into the crowd. The woman with the pike carries a bare-bottomed infant under her arm, a clear allusion to the biblical Massacre of the Innocents. For Goya and the Spanish resistance, the soldiers of King Herod were reborn in Napoleon's army. As in traditional scenes of the biblical massacre, Goya's resisting women are compressed together. The French officer at the right bears down on them as he, like the firing squad in *The Executions of May 3, 1808*, sights them along his rifle. Although there is a quality of panic in the clashing figures and weapons, a sense of maternal ferocity dominates the scene.

Toward the end of his life, Goya produced many pictures in which black predominates. Several were self-portraits that perhaps echoed his own "black" mood. In one, painted at the age of seventy, the artist is highlighted in light and seems to emerge

from the enveloping silence of a black background, representing his isolation from the world of sound; Goya was left permanently deaf at age forty-six, after a serious illness. There is nothing in his self-portrait at age seventy to identify a time or place occupied by the artist, who seems adrift in blacks and browns.

Théodore Géricault

In France, the short career of Théodore Géricault (1791–1824) was to have a profound influence on subsequent nineteenth-century art, especially the interest in visible brushwork and in the depiction of contemporary reality that would be taken up by the Realists, the Impressionists, and the Post-Impressionists. Géricault was born in Rouen, in northern France. His family was wealthy, which exempted him from having to earn a living for most of his restless life. He moved with his family to Paris before his tenth birthday and, against his father's wishes, decided to study art. He had some formal training, but essentially taught himself to draw. Attracted to the exuberant, painterly qualities of the seventeenth-century Baroque artist Peter Paul Rubens, especially his scenes of horses, Géricault joined the French cavalry in 1814. Two years later, he went to Rome, where he developed a taste for the powerful, contorted forms of Michelangelo. In 1818, Géricault returned to Paris, where he started an affair with the wife of his mother's brother, by whom he had a son. This was only one such episode in a life largely devoted to self-destructive behavior. The dynamic energy and tension evident in his paintings is perhaps a mirror of his own character and lifestyle.

Géricault's most famous painting combines the universality of myth with a detailed study of individual human character and expression. His *Raft of the Medusa* (**figure 17**) exemplifies this thematic combination, for it was inspired by a real event, which Géricault elevated to the grandeur of an epic tragedy. The picture

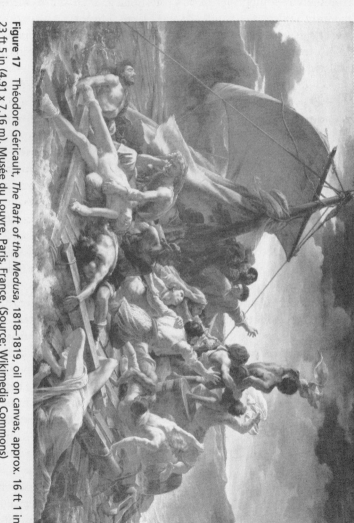

Figure 17 Théodore Géricault, *The Raft of the Medusa*, 1818–1819, oil on canvas, approx. 16 ft 1 in x 23 ft 5 in (4.91 x 7.16 m). Musée du Louvre, Paris, France. (Source: Wikimedia Commons)

represents a moment of simultaneous hope and despair in one of the most notorious episodes of French naval history.

The frigate *Méduse* (Medusa) was heading for the French colony of Senegal, in West Africa, carrying settlers and colonists as well as a crew. On July 2, 1816, the ship ran aground off the African coast. The six lifeboats could accommodate only about 250 of the 400 people on board the ship. For three days the captain and his crew struggled to keep the *Méduse* afloat, before abandoning the effort. A raft was hastily built and 150 people, mainly colonists and the lower ranks of the crew, were ordered onto it and assured that the captain would tow them to safety. The higher-ranking members of the crew, including the captain, remained on the lifeboats. Soon afterwards the captain broke his promise, severed the cables connecting the raft to the lifeboats, and cast it adrift. After six days on the raft only twenty-eight of the original 150 passengers were still alive. They decided, partly on humanitarian grounds and partly in their own interest, to throw overboard the sick and dying. This left fifteen survivors. Altogether, the journey lasted thirteen days, during which time the survivors resorted to murder and cannibalism, with some becoming insane. At last, a distant ship was sighted. The survivors signaled it, but it disappeared; two days later it reappeared and rescued the raft. An additional five people died after the rescue, leaving a final tally of ten survivors and 140 dead. For obvious reasons, the entire incident was played down by the French government. But in November, 1817, two of the survivors, a surgeon and an engineer, published an account of the events. The captain, it was revealed, owed his commission to connections with the Bourbon monarchy rather than to merit.

Géricault depicts the moment when the rescue ship is first sighted. He tilted the raft upwards, placing four diagonal cadavers at the bottom of the picture. This draws us into the crowded raft, and our gaze follows a progression of hopeful gestures as the figures, like suppliants, reach upward toward the distant,

barely visible craft. At the far end of the progression, survivors still able to stand signal in vain. In the foreground, a man, who is the only living figure turned toward the viewer, grieves for his dead son. He echoes the seated, mourning figure enveloped in shadow at the left. We are also made aware of the raft's precarious position on the swelling waves and of the gathering storm clouds. The billowing of the single, flimsy sail and the rags in the hands of the men waving at the ship indicate the direction of a rising wind. One aspect of the work's genius is the unity that the artist creates between humankind and nature, for the writhing figures – dead and dying, despairing and hopeful – rise and fall like the waves.

Géricault produced many small painting studies and drawings in preparation for *The Raft of the Medusa*. He observed the ocean and made a studio model of the raft filled with wax figures. The artist's commitment to revealing the injustice of the events surrounding the shipwreck is evident in his study of the dismembered body.[12] He visited hospitals and morgues to study the dead and dying. Among the results of these preparations were images of severed heads and limbs that reflect Géricault's detailed observation of reality.

The Raft of the Medusa, Géricault's only heroic work on a monumental scale, was exhibited at the Salon on August 25, 1819, the third Salon after the Restoration of the Bourbons to the French throne following Napoleon's abdication. Not surprisingly, given the work's exposure of official corruption and its challenge to, rather than celebration of, national pride, reactions were mixed. Géricault himself complained bitterly about the comments of French critics, with liberals praising the work and conservatives accusing him of a lack of patriotism. He wrote to a friend pointing this out and noted that "The wretches who write such rubbish have certainly never had to go without food for two weeks on end. If they had, they would perhaps realize that

neither poetry nor painting could ever fully render the horror and anguish endured by the men on the raft."[13] The following year, the *Raft* was shown in London to great critical acclaim.

Géricault then spent two years in London, during which time he learned lithography (a technique invented in late eighteenth-century Germany in which prints are made by impressing paper onto engraved and inked stone plates) and made images of every-day life. These, like the *Raft*, documented reality and expressed the artist's sympathy for the downtrodden elements of society and his Romantic commitment to social justice. On returning to Paris, Géricault resumed his old ways, squandering his wealth in careless speculation.

In 1822, for the first time in his life, Géricault had to earn a living. That year he was commissioned by a progressively minded psychiatrist, Dr Étienne Georget of Paris, to paint ten portraits of his mental patients. The five surviving works from this series represent delusional or obsessive personalities as bust-length figures with illuminated faces isolated against dark backgrounds. Géricault's *Portrait of a Kleptomaniac* (**figure 18**) shows the artist's ability to transform careful observation of physiognomy and character into paint. He reveals the patient's insanity in several ways, including his unkempt beard and disheveled hair. By focus-ing light on the face, emphasized by a bandage-like white cloth around his neck, Géricault accentuates individual features. Particu-larly striking are the forceful eyes and raised brows, evoking the regressive wide-eyed stare of a child who is riveted by what he wants but cannot have. He seems to be on the outside of some-thing looking in, replicating the perpetual envy of unsatisfied children.[14]

With this series of portraits Géricault's short life was drawing to a close. In 1823 he suffered a worsening of spinal tubercu-losis and died the following year, having reached the youthful "Romantic" age of thirty-two.

Figure 18 Théodore Géricault, *Portrait of a Kleptomaniac*, c.1822, oil on canvas, 24 1/8 x 19 3/4 in (61.2 x 50.1 cm). Ghent Museum, Ghent, Belgium. (Source: Wikimedia Commons)

Eugène Delacroix

In contrast to Géricault, Eugène Delacroix (1798–1863) lived a long and productive life. His range of subject matter was considerable, including scenes of intense erotic and physical violence, quiet harem interiors, and political, mythological, and Christian pictures. His dynamic style was marked by a fitful energy and a restlessness that seems consistent with his first journal entry describing himself as "unstable" and declaring his artistic and psychological relationship to Michelangelo.

THE JOURNAL OF EUGENE DELACROIX AND THE ARTIST'S RELATIONSHIP TO MICHELANGELO

In 1822, at the age of twenty-four, Delacroix began keeping a journal, which is one of the great literary self-portraits of an artist. It records Delacroix's life, including his tastes in art, working methods, use of pigments and brushes, excerpts from what he read, and notes on his travel. He opens the journal with the words "I AM beginning my Journal: the Journal I have so often planned to write. My keenest wish is to remember that I am writing only for myself; this will keep me truthful, I hope, and it will do me good. These pages will reproach me for my instability. I am beginning in good spirits."[15]

The first artist mentioned in the journal is Michelangelo, who had a profound influence on Delacroix's range of human portrayal. Delacroix, however, never traveled to Italy to see Michelangelo's work in the original – most likely a manifestation of his fear of its inhibiting effect on him. On May 9, 1853, Delacroix wrote: "Michelangelo astounds us and fills us with a sense of awe (which is one kind of admiration), but before long we notice disturbing incongruities caused in his case by hasty work, either because he attacked it with so much passion, or because of the weariness that must have overcome him at the end of an impossible task."[16] Delacroix attributes Michelangelo's well-documented failure to complete a number of works (referred to as his *non-finito*) to a failure of talent, rather than to a genius who "stopped short before he was satisfied."[17] In this notion, Delacroix reveals himself more than he reveals Michelangelo. At first struck by a sense of awe upon confronting Michelangelo's work, Delacroix denies its power by claiming that it was hastily executed.

Energetic brushwork, contorted poses that reveal his control of form and space, and a passion for the effect of vivid color characterize Delacroix's style. His thick brushstrokes, like those of Goya and Géricault, are strikingly different from the smooth surfaces of Neoclassical style and were calculated to make the paint itself into content. He was drawn to the rich color of Venetian painting, particularly that of Giorgione, Titian, and Veronese, and considered color a basic principle of painting, because it creates the

impression of life. In Delacroix's view, color, especially brilliant color, enhanced by energetic, sensuous lines and forms, could be a direct conveyor of emotion. His belief in the power of line and vivid color, as well as his sometimes exuberant visible brushwork and taste for spontaneity, would influence the Impressionists and Post-Impressionists later in the nineteenth century. Baudelaire championed Delacroix's work in reviews of the 1845 and 1846 Salons, and called him the last great Renaissance artist and the first modern artist.

Delacroix was born near Paris, seven years after Géricault. His father was an ambassador and his mother came from an artistic family. It is almost certain that Delacroix was the illegitimate son of Talleyrand, the French statesman who became Minister of Foreign Affairs under Napoleon. After his Bonapartist parents died and Napoleon abdicated, Delacroix had no means of support other than his paintings. His early successes at the Salon helped establish his reputation and in 1826, at the age of twenty-eight, he received his first government commission.

Like Géricault, Delacroix knew from a young age that he wanted to be a painter and, aside from brief periods in various art studios, most of his early training consisted of studying the Old Masters in the Louvre. Despite not travelling to Italy, the influence of the Italian High Renaissance, notably the work of Raphael and Titian in addition to Michelangelo, is readily apparent. For his famous lion hunts, on the other hand, Delacroix turned to the Baroque painter Rubens for inspiration. In 1825, Delacroix visited London, where he was impressed by the plays of Shakespeare and English Romantic poetry. His literary interests are apparent in much of his early subject matter. For example, *The Massacre at Chios* – in which the Turks are shown about to massacre a group of Greeks whom they have captured – alludes to the Greek struggle for independence from Turkish rule, a cause for which Byron himself died. Delacroix's *Barque of Dante* reflects the Romantic revival of interest in the *Inferno*, and

his *Death of Sardanapalus* is derived from Byron's play about the Assyrian king.

Delacroix's self-image as a Romantic is evident in a self-portrait of around 1837, where he depicted himself as an attractive, somewhat aristocratic, Byronic figure with unruly dark hair and the affectation of a single lock falling over his forehead. The sharp angle of the mustache, upturned nose, and slight tilt of the head that seems pushed up by the dark cravat convey an air of aloof determination. But the penetrating eyes gazing off to the right (his left) are those of a painter who sees intensely and is in contact with the world around him. The artist is elegantly dressed in a brown coat with a velvet collar and a green silk waistcoat. The background is a medley of browns, textured by visible traces of brushstrokes so that the figure appears to emerge through the use of light and contour.

Despite his aristocratic origins, Delacroix was committed to social justice and opposed to tyranny. In 1830, he created a memorable image combining his Romantic inclinations with close observation of reality; the result became an art-historical icon – *Liberty Leading the People* of 1830 (**plate 6**). Based on the July Revolution of the same year, the work commemorates the downfall of the Bourbon Restoration monarchy and the ascent to the throne of Louis Philippe, Duke of Orléans. The new July Monarchy was more congenial to Delacroix, who celebrates it in his depiction of the French *tricolore* – the revolutionary flag – at the apex of the figural triangle. That the *tricolore* is cropped by the top edge of the painting accentuates the impression of its height and thus of its role as a symbol of freedom, the ideal to which the revolutionaries aspired.

The personification of Liberty is symbolic as well. She is a political, maternal, Classical, and contemporary ideal. Although she is clearly derived from ancient Victories, who were usually represented as winged females, her flag has replaced the wings of Greek myth. She has the power of a goddess, rising above the

other figures, some of whom have died for the cause of freedom. Insofar as Liberty herself embodies an intellectual ideal, she is a political muse, metaphorically leading the citizens of Paris in their fight against the Bourbons. But she also behaves like a real leader, setting an example to her followers and striding force-fully forward while looking back to rally her troops. Her advance within the picture, like her height, has formal and symbolic significance. In her left hand she carries a bayoneted musket, whose silhouette against the smoke of battle reminds us that she is an actual fighter on the barricades, as well as a mythical figure.

In 1831, the German Romantic poet Heinrich Heine (1797–1856) described Delacroix's figure of Liberty as a bold young woman "with a red Phrygian cap on her head, a gun in one hand, and in the other a tricolor flag … naked to the hips, a beautiful impetuous body, the face a bold profile, an air of insolent suffer-ing in the features – a strange blending of Phryne [a famous Greek courtesan], fish wife, and goddess of Liberty."[18]

Liberty's charismatic effect on the crowd is evident in the boy beside her, who echoes her pose and gestures as he brandishes two pistols. Her formal and psychological centrality is shown by the gradual progression of figures leading our gaze in her direction. This pictorial structure suggests that Delacroix was influenced by the design of Géricault's *Raft of the Medusa*, and that Liberty's flag has a meaning similar to the cloth waved at the distant rescue ship. As with Géricault's *Raft*, Delacroix's *Liberty* is grounded in observation, for he watched from the sidelines the three days of fighting, from July 27 to 29, 1830, in the streets of Paris.

We are drawn into the picture space by the corpses at the lower edge of the painting. The blue stocking carries our gaze to the blue shirt of the dying worker rising from the ground to gaze at Liberty. On the other side of him kneels a well-dressed young man wearing a top hat and carrying a musket that forms one side of an implied triangle leading toward the flag. Echoing the thrust of the musket is the saber of the man behind him at

the far left. Beneath this figure, a soldier, whose eyes are glazed over as if in anticipation of his own death, grasps a rock to hurl at the enemy.

In contrast to *The Raft of the Medusa*, the visual thrust of *Liberty Leading the People* is toward the foreground and the viewer. The people's victory lies in front of them and is within their reach – in the future of a new government – whereas the rescue of Géricault's raft rests with the distant ship and is far beyond the control of the helpless passengers. There is no equivalent to Delacroix's Liberty in the painting of the raft, whose power lies partly in the absence of allegory. For the viewers of *Liberty*, rescue is embodied in the person of a superwoman; her nourishing maternal power is conveyed by her full, bare breasts. Her drapery folds are reminiscent of ancient Greek statuary, produced by a civilization in which citizens had a say in how they were governed. Her hold on her followers and on viewers depends on Delacroix's formal, psychological, and historical synthesis of real and imagined sources of female power.

Delacroix orchestrated the poses and gestures of his crowd to emphasize their unity of purpose. Similarly, his organization of color is a source of formal unity. Small areas of red are scattered throughout the image, with the blues concentrated at the center. Reds, blues, and whites that are diffused in the smoke of battle, through which the buildings of Paris are barely visible, converge and are emphasized in the flag. By this concentration of color in the *tricolore*, Delacroix makes it stand for the very concept of liberty that drives the image, as it drove the uprising. Underscoring the artist's sympathy for the cause is his signature and the date painted in red on the fallen timbers at the right.

Liberty Leading the People was exhibited in the Salon of 1831. It won Delacroix the Legion of Honor and was purchased by the king. Thereafter it was removed from public view until 1848, possibly because its glorification of revolution was deemed too inflammatory. The irony is that the July Revolution succeeded

only in replacing one form of monarchy with another; France had to wait another eighteen years for a republican government.

In 1832, Delacroix accompanied the French ambassador to Cadiz and Seville, in Spain, and also to North Africa, where he visited, among others, the sultan of Morocco. The trip lasted seven months and sparked in the artist a Romantic passion for "Oriental" subject matter, including perfumed harems, Moorish settings and costumes, Jewish women, and Arab horsemen. During the trip Delacroix made many watercolors and drawings that would later be used as studies for large paintings. His fascination with exotic "otherness" reflected a view, prevalent among his Romantic contemporaries, of the Orient as a kind of rediscovered antiquity. He believed that he had found an ancient civilization that had survived into the present and, in a letter of 1832, he compared the robed Arabs to toga-clad Roman senators and to Greeks attending feasts in honor of Athena.

Delacroix applied his natural inclination to record his observations, in his paintings and his journal, to these new subjects. Describing Jewish women in North Africa, Delacroix wrote of "women in the shadow near the door; many reflections. In the evening: Costume of the Jewish girl. The shape of her pointed cap ... Beautiful eyes."[19] Of fighting Arab horsemen in North Africa he wrote from Tangier on January 29, 1832:

> They reared up and fought with a fury that made me tremble for their riders, but magnificent for painting ... the gray got his head over the other horse's neck ... Mornay [the ambassador travelling with Delacroix] managed to dismount. While he was holding it by the head, the black reared up furiously. The other went on fiercely biting him from behind."[20]

In a small etching of Arab horsemen, Delacroix illustrated another journal entry. He depicts two horses crashing into each other as their Arab riders struggle to control them. They rear

up dangerously, appearing as two intertwined ancient equestrian monuments transformed by their Moorish setting. Their forelegs wave furiously, their necks twist, and their riders seem barely able to hold on. The predominance of diagonal thrusts, rapid shifts from light to dark, and contrasting textures rendered with different degrees of shading animate the surface and accentuate the fury of the horses. They have been literally "stopped in their tracks," conveying an impression of frustrated energy. The horses are placed in a landscape setting, whereas he represented Jewish women in moments of quiet stasis, reinforced by architectural enclosures. With the women, there is little motion, and they are as confined by internal tensions as by their enclosed space. The etching *Jewish Woman of Tangier* shows a seated Jewish bride and a reclining black servant and was inspired by a wedding the artist had attended in Tangier. He was impressed by the exotic nature of the ceremony and created a series of related etchings in 1832, in Tangier.

Delacroix was also drawn to the power of the lion. He painted many pictures of lions that reveal his genius for multivalent character depictions. In his *Lion of the Atlas* (**figure 19**), the piercing gaze of a recumbent lion betrays its designs on a rabbit caught between its paws. The lion appears to caress the rabbit, although it is poised to devour it. The domination of the lion is complete, reinforced by the rocks and its lair. It projects an image of quiet, unquestioned authority, always prepared to assert its royal prerogatives. For Delacroix, the lion pictures, like those of the Arab horses, express pure animal passion, obedient only to the law of the jungle. Unlike the horse, however, the lion is not tamed by man; it is man's traditional adversary, whether hunted by kings, battling gladiators, or preying on a helpless rabbit.

Delacroix's lion hunts can be seen as a culmination of several themes that dominated his work over the course of his career. Above all, as Baudelaire said of him, "Delacroix was passionately in love with passion."[21] This can be seen in his political paintings

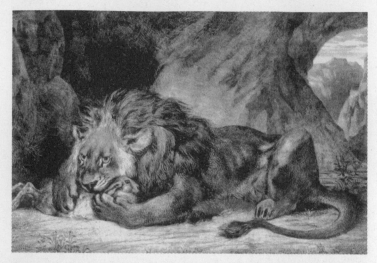

Figure 19 Eugène Delacroix, *Lion of the Atlas, c.*1829, lithograph on wove paper, 12.9 x 18 in (32.8 x 45.8 cm). Brooklyn Museum, New York, New York. (Source: Wikimedia Commons)

advocating freedom, such as *Liberty Leading the People*, as well as in his depictions of animals. Even death and dying have a flamboyance in Delacroix that is lacking in the more sober, darkly chromatic works of Géricault.

The mythic proportions of certain nineteenth-century Romantic painters and the idyllic and sublime qualities of their landscapes differ strikingly from the next major nineteenth-century style, namely Realism. But like Romanticism, Realism was not so much identifiable by formal elements of style as by a way of thinking about representing the world.

3
Realism

When Jean-François Millet (1814–1875) exhibited *The Gleaners* (**figure 20**) at the Salon in 1857, it drew immediate criticism from the French middle and upper classes. They were alarmed by its apparent sympathy with and even glorification of lower-class rural workers, whom they associated with the rising tide of socialism. The painting – Millet's most famous – depicts three women gathering (gleaning) what remains after a field has been harvested. Their activity, which was a privilege accorded to the poor in nineteenth-century France, emphasizes their poverty. The distant farm, in contrast, is highlighted in a soft yellow light and stacks of the abundant harvest are clearly visible. On the one hand the gleaners are shown in relative darkness; on the other, they are monumentalized and placed in the foreground, inviting the viewer to identify with them.

The work is a key example of Realism, a movement that began in France after the 1848 Revolution. Realism did not mean "real" in the Platonic sense of mimesis (imitation) or *trompe l'oeil* illusionism. Rather, it was a bold attempt by artists to produce imagery according to a "truth" derived from their own experiences and observation of the contemporary world. In searching for an art that would mirror their time and place, Realists expanded subject matter to include everyday experience and represented it directly rather than through the idealizing

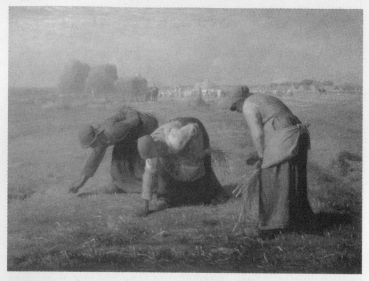

Figure 20 Jean-François Millet, *The Gleaners*, 1857, oil on canvas, 33 x 44 in (83.8 x 111.8 cm). Musée d'Orsay, Paris, France. (Source: Wikimedia Commons)

lens of myth, allegory, or history, as was typical of Neoclassicism and Romanticism. Everyday life in the nineteenth century was marked by the Industrial Revolution, which, among other changes, brought increased urban crowding as more country dwellers migrated to the cities in search of work. Realist artists began to focus on the broad panorama of urban society and to approach life from a social or class-conscious point of view. Like the Romantic artists, some Realists took on social and political causes and produced work with implicit subversive content that portrayed the lower classes in a sympathetic light. This aroused controversy and artists – like Millet – were sometimes accused of harboring radical political views. When they painted landscape, Realists depicted the details of nature outdoors, where they could observe it empirically.

VERISMO OPERA

Verismo (Italian for "realism") became a dominant style in late nineteenth-century opera. Composers portrayed the "realistic," sometimes sordid, aspects of everyday life and rejected the historical and mythological subject matter of Romanticism. In France, Georges Bizet's *Carmen* (1875) told the story of a Spanish gypsy whose intense emotions and free-wheeling attitudes to love led to her destruction. In Italy, Giacomo Puccini's *verismo* took audiences into the everyday life of the lower as well as the upper classes. In *La Bohème* (1896), Puccini deals with artists living the Bohemian life in Paris and a heroine who dies of tuberculosis. This new emphasis on an expanding view of society was a reflection of the Enlightenment to the degree that ordinary citizens and everyday themes could be elevated to subjects of high art.

The work of Realist artists was mirrored and inspired by that of their literary counterparts. Realist authors such as Honoré de Balzac, Émile Zola, and Gustave Flaubert in France, Charles Dickens in England, and Henrik Ibsen in Norway all espoused social and political causes and made them part of their work. In opera, as well, storylines addressed Realist themes.

Realism in the visual arts flourished mainly in France from the 1840s to around 1880, with the painter Gustave Courbet being the best-known proponent of the style. But, as with Romanticism, painters in other countries worked in related styles – notably the Pre-Raphaelites in England, Wilhelm Leibl in Germany, and, in the United States, William Sidney Mount, Winslow Homer, and Thomas Eakins. Realist imperatives were expressed in other art forms as well as painting. Realist sculptors, such as the American William Rimmer, conveyed anatomically accurate – rather than idealized – images of the human body. Photographers used their medium for portraiture, as well as for documentation (for example, Mathew Brady's American Civil War pictures). Jacob Riis hoped his photographs would

draw attention to the need to improve social conditions for the poor, especially in New York. Architects associated with Realism answered to new social and economic needs, building structures – including the first skyscrapers in the American Midwest – whose criteria were mainly practical and utilitarian. These buildings were designed to be used by large numbers of people at costs they could afford. In this endeavor, architects were assisted by new technologies such as the manufacture of steel, prefabrication, and the invention of the elevator. Suspension bridges using steel cables addressed the need to travel long distances, especially in the United States.

Realism in France

To a considerable extent, Realism in France was driven by efforts to shake off the tyranny of the Academy, the strictures imposed by its hierarchy of genres, and the taste for stale, often mannered, classicism. Artists such as William-Adolphe Bouguereau (1825–1905) exemplified Academic taste. In contrast to the Neoclassical style, which used antiquity as a model and a metaphor for contemporary events, Bouguereau painted subjects such as nymphs frolicking in idyllic settings, which had little or no relevance to nineteenth-century life. The forms and poses were derived from Greek statuary, and the clear contours of the figures harked back to classicizing artists such as Raphael. But compared with the sensuous odalisques of Ingres and the forceful political iconography of David, Bouguereau's nymphs seem trivial and frivolous.

The Revolution of July 1830 ended the Restoration monarchy of Charles X, who was succeeded by Louis Philippe. He was called the "Citizen King" to indicate that he ruled because he was popular with the people rather than by divine right. His rule, known as the July Monarchy, lasted until 1848. During

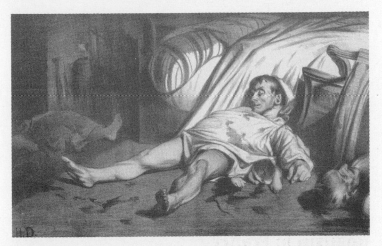

Figure 21 Honoré Daumier, *Rue Transnonain, April 15, 1834*, 1834, lithograph, 11 x 17 in (29 x 44.5 cm). Private collection. (Source: Wikimedia Commons)

the eighteen years of his reign, middle-class influence in France expanded. The consequent rise in popular culture was accompanied by a rise in literacy. Visual literacy also increased, in part because of lithography, the printing process invented in 1799 in Germany that made imagery more accessible through the popular press. Using the new printing techniques, newspapers published cartoons and caricatures of political figures, the monarchy, and the professions.

The caricaturist and painter Honoré Daumier (1808–1879) protested the abuses of Louis Philippe in several prints that were published in the press. His famous print of July 1834 entitled *Rue Transnonain, April 15, 1834* (**figure 21**) was a response to a particularly outrageous injustice committed under Louis Philippe and was calculated to inflame viewers against this abuse. Republican and socialist workers were agitating against the monarchy, when the king ordered his soldiers to respond. One officer was shot,

after which the king's troops killed some twenty innocent people, including entire families living in a working-class building in Rue Transnonain.

Daumier's image aroused sympathy for the dead by focusing on the family of an individual worker living at 12, Rue Transnonain. The father lies dead in his nightshirt, his foreshortened pose reminiscent of Andrea Mantegna's Renaissance painting of the dead Christ. By highlighting the father, Daumier associates him with the death of Christ, a metaphor for the senseless destruction of innocent people by an abusive ruler. Beneath the father's corpse, we can see his son, whose blood, like that of his father, stains the wooden floor. An old man lies dead at the right, although we see only part of his head. At the left, in shadow, the corpse of the boy's mother is visible. An entire family has perished – martyred, Daumier seems to be saying, by the unreasonable rage of the king. The subversive message of Daumier's print was not lost on Louis Philippe, who imposed censorship on imagery in the press.

Realism became associated with socialist ideas, which spread with the increased abuse of workers in newly minted factories and rising poverty in rural areas. During the 1840s, middle-class intellectuals and workers agitated for more representation in government. In 1848 the *Communist Manifesto* was published in London, and that same year in France a revolution erupted, fueled by Louis Philippe's disregard for the lower classes. This latest upheaval was, in large part, a reprise of the revolution of 1789, with people demanding some of the same rights, including free speech and suffrage for all male citizens.

The rule of the Citizen King ended with his abdication after four days of fighting – from June 23 to June 26, 1848. The aftermath of this conflict was memorialized in a small-scale painting by Jean-Louis-Ernest Meissonier (1815–1891) entitled *Memory of Civil War*, also called *The Barricade, Rue de la Mortellerie, June 1848* (**figure 22**). Meissonier's portrayal is Realist rather than Romantic and, as such, is very different from Delacroix's *Liberty Leading*

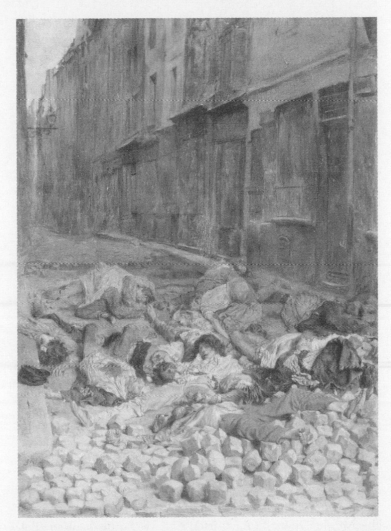

Figure 22 Jean-Louis-Ernest Meissonier, *Memory of Civil War* (also known as *The Barricade, Rue de la Mortellerie, June 1848*), c.1848–1850, oil on canvas, 11 x 8 in (29 x 22 cm). Musée du Louvre, Paris, France. (Source: Wikimedia Commons)

the People. First exhibited at the Salon of 1850–1851, *The Barricade* shows the dead lying in an otherwise deserted Paris street, amid the rubble of the barricade. All told, some 15,000 rebels died and 12,000 were arrested. In Meissonier's painting, a row of houses at the right recedes into the distance, still standing after the fighting. The silent, shuttered houses that signify the absence of the inhabitants form a stark contrast to the dead bodies strewn on the street and the remnants of the fallen, makeshift barricades. Blood-stained clothes, contorted limbs, grimacing expressions, and dead bodies lying where they fell occupy the foreground and confront the viewer directly. Meissonier's blues and reds, in contrast to the *tricolore* that Delacroix's idealized Victory carries above the fray of battle, are literally "ground into" the predominant browns and intense oranges of the street. They are no longer the colors of a triumphantly held flag, but are part of a more "realistic" image of the torn clothing and blood of the dead after battle.

Over twenty years later, in 1877, Meissonier painted another Realist work inspired by political upheaval, namely *The Ruins of the Tuileries Palace after the Commune of 1871*. A socialist uprising against the French state, the Commune established autonomous rule by workers in Paris, lasting from March 18 to May 28, 1871. Following the defeat of France by Germany in February 1871, workers feared that the peace, negotiated by royalists in control of the National Assembly, would end in a restoration of the monarchy. Like Meissonier's *Memory of Civil War*, *The Ruins of the Tuileries Palace* focuses on destruction, but this work is devoid of human figures. The picture space is structured with ruined walls and stone fragments filling the street. The closed-in area between the walls opens up at the far end into three spaces, through which sky and the silhouetted quadriga on the attic of the Arc de Triomphe du Carrousel is visible (perhaps an allusion to the Roman past and the former glory of Paris). In the foreground we see the rubble that was the Salon des Maréchaux

and a block of stone inscribed with the names of the Battles of Marengo and Austerlitz.

Baudelaire had advised painters to portray everyday life as it was lived at the time – that is, to paint modern society and contemporary events instead of ancient history and myth. He expressed his views most notably in two venues: a review of the 1846 Salon and his famous essay of 1863, "The Painter of Modern Life." Gustave Courbet (1819–1877), Baudelaire's good friend from the late 1840s, obliged. He agreed with Baudelaire that artists should depict only their own time and place. He also believed that beauty and truth lie in nature, which he considered superior artistic content to history, allegory, and nude figures derived from the Classical tradition. Courbet argued that painters are born and cannot be taught how to become artists. Hence, he believed that there are painters but no schools of art. It is only the artist's talent for perception that can lead to the expression of beauty. In one often-cited exchange, Courbet made it clear that in order to paint an angel he would first have to see one. On one occasion he asked a contemporary: "Angels! Madonnas! Have you ever seen any?"

"*Non, monsieur*," came the reply.

"Me neither," said the artist. "The first time you see one, don't forget to let me know."[1]

From 1849 to 1850, Courbet produced a monumental painting that embodied Realist ideals. Entitled *A Burial at Ornans* (**figure 23**), this work records a specific moment in a contemporary setting and it caused a scandal when it was first exhibited at the 1850–1851 Salon. It confronted Parisian viewers with the dull sameness of bourgeois life in the provinces and reminded them that France was composed of more than Paris intellectuals and the lively art world. The mainstay of the nation, Courbet seems to be saying, is Catholic, conservative, and unimaginative – and these are the people who, following the rebellions of

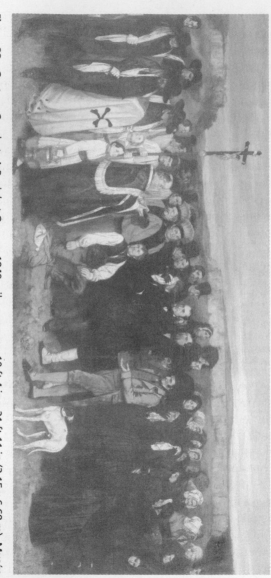

Figure 23 Gustave Courbet, *A Burial at Ornans*, 1849, oil on canvas, 10 ft 4 in x 21 ft 11 in (3.15 x 6.68 m). Musée d'Orsay, Paris, France. (Source: Wikimedia Commons)

1830 and 1848, had the power to vote and be heard. The *Burial* was, to paraphrase Baudelaire, of its period, and formally as well as psychologically it offered no relief of distance with regard to either time or place.

Over twenty-one feet wide, the *Burial* is composed of a panoramic frieze of figures, including the artist's sister, living in Ornans – Courbet's native village in the Franche-Comté region of eastern France. A group of middle-class bourgeois mourners is framed by the gradually rising hills in the distance, which ties them to the land. Towering over the figures and piercing the sky is a lone crucifix held aloft by a prelate. At the right, the women mourners wearing black and white repeat the blacks and whites of the religious figures at the left. In the foreground, a dog turns sharply to stare at the women. The dreary palette is relieved only by the reds of the beadles, the boy at the left, and the man in blue. Standing to the left of the gravedigger are the mayor of Ornans, a justice of the peace, and two choir boys. The horizontal layering of the figures beneath the dull brown and gray sky is a metaphor for the monotony of life in the French provinces.

Several years after being exhibited at the Salon, *A Burial at Ornans* was rejected for the 1855 Paris World's Fair, which angered Courbet and led him to remove eleven works that the jury had accepted and to mount a separate one-man exhibition. Courbet wrote the introduction to the catalogue for the exhibition in which he laid out the principles of Realism, producing what has been called a Realist Manifesto. Courbet's unusual act in removing the eleven works met with praise as well as outrage. Some called it a daring appeal to the public and others claimed it was a form of anarchy, in which he dragged art through the mud.

Courbet's *Stonebreakers* of 1849 to 1850 (**figure 24**), which was destroyed during World War II, is known only through photographs. The painting confronted the artist's contemporaries with the unrelenting monotony of repetitive, manual work. Its

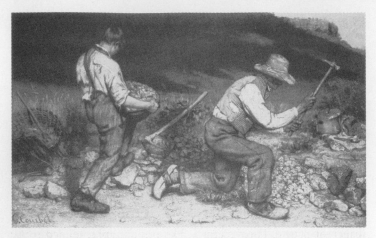

Figure 24 Gustave Courbet, *The Stonebreakers*, 1849–1850, oil on canvas, 5 ft 3 in x 8 ft 6 in (1.6 x 2.6 m). Destroyed during World War II, formerly in the Gemäldegalerie, Dresden, Germany. (Source: Wikimedia Commons)

large scale – over eight feet wide – monumentalizes two men who are absorbed in breaking stones and do not communicate with each other or with the viewer. They perform tasks requiring physical strength, but little intellect. Their surroundings are dry, the foreground is filled with stones, and the colors of the landscape are repeated in the ragged clothing of the workers. Here, too, Courbet has created a formal unity between the figures and their setting, and the alignment of diagonal picks with the workers identifies the figures with their labor. Courbet made a distinction between an older stonebreaker wearing a hat whitened with dust and a younger one straining to lift a boulder. As with the *Burial*, the *Stonebreakers* was staged to make a social point consistent with Realism. For the working poor, Courbet implied, there was little or no economic or professional progress from one generation to the next. The old worker can be read as an image of the young man's future, indicating that the passage of

time would not improve the lot of impoverished French citizens as long as society remained as it was.

Several critics, both pro and con, called Courbet a socialist because of his sympathy for everyday life and the working classes. One loyal critic, Jules Antoine Castagnary (1830–1888), declared Courbet the first socialist painter.

In 1868, Castagnary defined three schools of painting: the Classical school (i.e. Neoclassicism), which held that nature should be idealized; the Romantic school (Romanticism), which advocated social, political, and artistic freedom, and imagination over reality; and Naturalism, a form of Realism that focused on the lower classes and the details of nature. Like the Realists, Naturalists believed that art should depict all aspects of life and the reality of nature. Their pictures, like photographs, tended to be more static than those of the Realists. The Classicists, according to Castagnary, produced purity in French art; the Romantics, with their appeal to imagination, led art into a state of anarchy and encouraged the commodification of art; and the Naturalists put the artist into his contemporary world, uniting man and nature and depicting urban and rural life as they are lived. Castagnary praised them for producing a French art that was no longer an art of "dead peoples; that describes its own appearances and customs and no longer those of vanished civilizations; that, finally, in all its aspects, bears the imprint of its own luminous grace, and lucid, penetrating, clear spirit."[2]

Courbet's contemporary, Rosa Bonheur (1822–1899), was raised in an environment attuned to the aims of Realism. Her father was a Saint-Simon socialist and, as such, he believed in a utopian form of socialism based on the Golden Rule – love thy neighbor as thyself. In his ideal society there would be no poverty, wealth would be shared, and women would have the same rights as men. Bonheur became a leading artist of her generation and was the first woman to be awarded the French Legion of Honor. Her iconography deals mainly with animals, which she sketched

in slaughterhouses; for this she obtained the right to wear men's clothing, which was illegal for women in Paris unless they had a police permit to do so.

Bonheur's interest in the power and energy of animals is evident in her large painting *Plowing in the Nivernais: The Dressing of the Vines* of 1849 (**figure 25**), first exhibited in the Salon of 1850–1851. The scene, like Courbet's *A Burial at Ornans*, takes place in the French countryside, but its color is livelier. In contrast to Courbet's dark, heavy sky and the gravitas of his figures, Bonheur paints a clear blue sky and farmers hard at work driving their oxen. Nonetheless, her ploughed field is composed of repetitive patterns and her oxen trudge ponderously up the hill pulling their burdens behind them. The human figures, rather than dominating the picture space as they do in the *Burial*, are dwarfed by the powerful animals, which are aligned in a frieze-like manner. Whereas Courbet's painting focuses on the inevitability of death, and its figures are relatively static, Bonheur depicts the physical effort of cultivating the land that leads to future growth. Her Realism is shown both in her attention to details such as the upturned earth and the folds of the oxen's skin, and in her ability to evoke the struggle for survival. Bonheur's personal identification with the animals is evident in the attention she lavishes on them here and in the time she spent observing and sketching them.

In the village of Barbizon, near Fontainebleau, thirty-five miles southeast of Paris, an art movement developed that was related to Realism but is also associated with Naturalism in advocating a close, empirical study of nature. Jean-François Millet was one of the founders of the Barbizon school; he had left Paris to live in the village. His work, with its sympathetic depictions of workers, had its roots in the Romantic ennobling of French peasants. Millet's paintings of monumentalized workers – such as *The Gleaners* – show them as giants of the earth who are at one with the land and also distinct from it. His workers, especially

Figure 25 Rosa Bonheur, *Plowing in the Nivernais: The Dressing of the Vines*, 1869, oil on canvas, 5 ft 9 in x 8 ft 8 in (1.75 x 2.63 m). Musée National du Château de Fontainebleau, Fontainebleau, France. (Source: Wikimedia Commons)

figures sowing in the fields, unlike Courbet's stonebreakers, stride energetically across the land. Like Bonheur's oxen, Millet's sowers point toward a potential future prosperity.

The leading Barbizon painter, Jean-Baptiste-Camille Corot (1796–1875), considered landscape to be a subject in its own right, rather than a setting for the working classes, as it was for Millet. Corot's vision of nature conforms to the Realist demand for the observation and depiction of the here-and-now as experienced by the artist, and also exemplifies the Naturalist emphasis on nature. Corot traveled to Italy and sketched landscapes, coming under the sway of more classically inclined seventeenth-century landscape artists such as Nicolas Poussin and Claude Lorrain. Like his predecessors in the seventeenth century, Corot focused on the shifting lights and darks of the countryside and its idyllic, atmospheric qualities. But his brushwork has more visible texture than theirs, a characteristic that foreshadows the textured paint surfaces of the Impressionists. Also typical of Impressionism was Corot's spontaneity in capturing his first impressions on canvas. "Whatever the site, whatever the object," he said, "the artist should submit his first impression."[3] His human figures are small, often inspired by biblical and mythological figures as well as contemporary peasants; they are immersed in nature and enveloped by it.

The many landscapes of Corot were significant for the development of the genre in France, especially for those painted outdoors. In *Ville d'Avray* of about 1867 (**figure 26**), which illustrates a scene from the village where his parents had a country house, we can see his taste for muted color and soft textures illuminated by a clear, light blue sky. A large central foreground tree filters the light, creating a silver sheen on the leaves. The painting is divided horizontally by a quiet river, reflecting houses on the far side of the scene, in which a few tiny figures are visible. Corot's interest in Naturalism and Realism led him to consider the artistic possibilities of photography, which he applied to

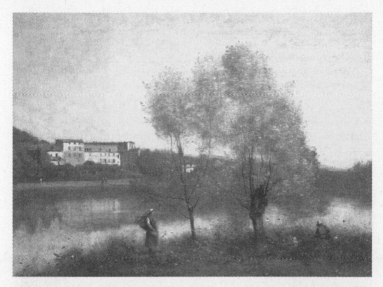

Figure 26 Camille Corot, *Ville d'Avray*, oil on canvas, c.1867, 19 3/8 x 25 3/4 in (49.3 x 65.5 cm). National Gallery of Art, Washington, D.C. (Source: Wikimedia Commons)

representations of nature in a series of works known as *cliché-verres* (see box, p. 84). By developing this technique, Corot was able to create the same shimmering effects of filmy gray light filtering through softly textured leaves as those in *Ville d'Avray*.

Édouard Manet (1832–1883), one of the most radical proponents of Realism in France, produced major works during the 1860s that caused enormous controversy and for which he was severely criticized by his contemporaries. In 1863 he produced *Luncheon on the Grass*, which provoked outrage for its depiction of a nude woman picnicking in a public park with two clothed men. A lightly clad woman bathes in a stream in the background, and the remains of the picnic are strewn in the foreground. Although inspired by a Renaissance painting, the *Fête Champêtre*, attributed variously to Giorgione and Titian, and an engraving by

THE *CLICHÉ-VERRE*

The *cliché-verre*, literally a "glass negative," allowed artists to represent the tones and values of light and dark in nature. The technique involves covering a glass plate (or other transparent surface) with an opaque material such as paint. The artist draws through the material with a sharp instrument. The plate is then used as a negative and a contact print is made on light-sensitive photographic paper, resulting in an image composed of dark lines on a light ground. An alternative method involves drawing with paint or another medium on uncoated glass, which, when used as a negative, produces an image with white lines on a dark background. *Cliché-verres* tend to have a quality of "impressionistic" surface texture structured by precise outlines.

Raimondi based on Raphael's *Judgment of Paris*, Manet's *Luncheon* eliminates the mythic, idealized, and idyllic quality of the Renaissance works and locates his image in the present. In place of the unidentified Renaissance figures bathed in soft yellow light and their dream-like setting, Manet depicted identifiable contemporaries – his model Victorine Meurent, his brother, and his future brother-in-law – leaving viewers with no escape into the past or the distance.

Critics were shocked by the unidealized, lumpy proportions of the nude and the prominently displayed sole of her foot. The author Émile Zola, who was a defender of Manet's work, wryly noted the controversy that the painting aroused: "The public was scandalized by this nude, which was all it saw in the painting. 'Good heavens! How indecent! A woman without a stitch on alongside two clothed men.' Such a thing had never been seen before! But that was a gross mistake, for in the Louvre there are more than fifty canvases in which both clothed and nude figures occur. But no one goes to the Louvre to be shocked."[4]

The Salon of 1863 rejected the painting, but agreed in 1865 to display another work that once again shocked viewers. *Olympia* (**figure 27**) was inspired by another Renaissance picture, Titian's

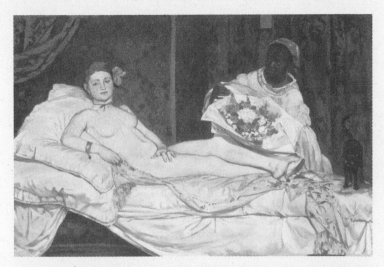

Figure 27 Édouard Manet, *Olympia*, 1865, oil on canvas, 4 ft 3 in x 6 ft 3 in (1.3 x 1.9 m). Musée d'Orsay, Paris, France. (Source: Wikimedia Commons)

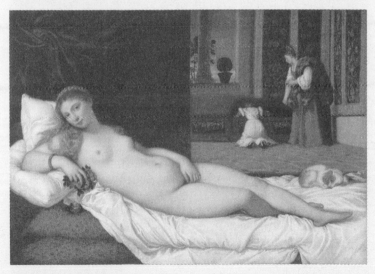

Figure 28 Titian, *Venus of Urbino*, c.1538, oil on canvas, 3 ft 11 in x 5 ft 5 in (1.19 x 1.65 m). Galleria degli Uffizi, Florence, Italy. (Source: Wikimedia Commons)

Venus of Urbino (**figure 28**), a resemblance that no one at the time seemed to notice. Manet's figure of Olympia, the same model he used in the *Luncheon on the Grass*, is harshly illuminated and clearly identified as a prostitute. She is accompanied by a cat at the foot of her bed and by a black servant bringing flowers from a client. In contrast to Titian's Venus, Olympia is not idealized and there is no use of Renaissance linear perspective to draw viewers into the distance. Her sheets are rumpled and her shoes have a fetishistic quality; they are at once unnecessary in her present context and an allusion to "street-walking." She herself seems to be soliciting a male viewer; her sexuality is simultaneously hidden and highlighted by the gesture of her left hand, and displaced onto the flower in her hair, the bouquet sent by her client, and the floral patterns on the silk bedspread.

Olympia's gaze lacks the flirtatious quality of Titian's Venus and meets ours with an air of directness bordering on defiance. Although Titian's Venus is sensual and provocative, her languid character contrasts with Olympia's rigid pose. Venus (possibly the mistress of Titian's patron) occupies an upper-class Venetian house; in the background two servants tend to a marriage chest by an open window. The very name *Olympia* in nineteenth-century Paris denoted not the mythic heights inhabited by the Greek gods, but rather prostitution (at the time, Olympia was a popular term for street-walkers). Manet confronted his contemporaries with an implied allusion to venereal disease, which was rife at the time, especially among prostitutes, and aroused age-old fears of contagion. He also played on the ambivalent male reaction to female seduction.

Olympia shocked the general public and art critics alike; even Courbet disliked it, finding the painting too flat and too stark. Some critics were scathing in their remarks. One accused Manet of being ignorant of the basic rules of drawing, as well as vulgar and scandalous in presenting visitors with "this ludicrous creature called *Olympia*."[5] Another called him a painter of "mockeries.

What is this Odalisque with a yellow stomach, a base model picked up I know not where, who represents Olympia? Olympia? Olympia? What Olympia? A courtesan no doubt. Manet cannot be accused of idealizing the foolish virgins, he who makes them vulgar virgins."[6] But Zola declared that *Olympia* would be a lasting testament to Manet at the height of his talent.

The Pre-Raphaelite Brotherhood

In England, some of the ideals of Realism were taken up by a group of artists known as the Pre-Raphaelites – because they believed that the only art that was "truthful" predated Raphael, who died in 1520. In their view, by close observation and careful attention to nature they would be able to depict "truth" in their paintings. Their work is characterized by rich, pure color on a white ground (a combination which enhances brightness), meticulous detail, and clear forms.

In 1848, the year that Louis Philippe abdicated in France and Marx and Engels published the *Communist Manifesto* in London, the Pre-Raphaelite Brotherhood (PRB) was formed. The original group was composed of young artists and poets protesting the decline of art and the conservative taste advocated by the Royal Academy; its three founders were William Holman Hunt (1827–1910), Dante Gabriel Rossetti (1828–1882), and John Everett Millais (1829–1896), who were soon joined by four more artists. In 1849 the Pre-Raphaelites had their first public exhibition.

By 1848, John Ruskin had published the first two volumes of his five-volume *Modern Painters*. He too advocated "truth to nature," a quality for which he praised Turner; he also defended the Pre-Raphaelites against their critics. But if we compare Turner's work (see **plate 3**) with that of the Pre-Raphaelites, we see that the notion of truth can appear very different in the styles

of different artists. In contrast to Turner's expansive use of paint and dynamic depiction of landscape, the Pre-Raphaelite style is precise, linear, and crowded with details.

The Pre-Raphaelites often turned to literature for their iconographic sources – notably Shakespeare, the Arthurian legends, and the Bible. The latter inspired John Everett Millais' *Christ in the House of His Parents* of 1850 (**figure 29**), which combines Realist details with symbolic Christian allusions. The scene takes place in the carpentry shop of Joseph, the earthly father of Jesus. It is filled with tools, slats of wood, and a large work table; wood shavings are strewn about on the floor. Details such as the grain of wood, folds and patterns of clothing, and physiognomy are depicted with precision. An old woman (who could be Mary's first cousin, Elizabeth, or her mother, Saint Anne), a balding Joseph with ringlets typical of his Jewish sect, and a young man

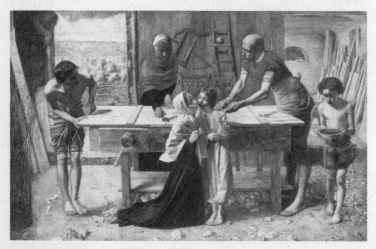

Figure 29 John Everett Millais, *Christ in the House of His Parents*, 1850, oil on canvas, 33 1/2 in x 54 in (56.5 x 84.8 cm). Tate Britain, London, UK. (Source: Wikimedia Commons)

in a vaguely Middle-Eastern cloth seem to be assisting in the shop. In the center foreground Mary kneels before the young Jesus, who wears a white robe.

Jesus has accidently pierced his palm with a nail, prefiguring his death on the Cross. At the right, his second cousin, John the Baptist, carries a bowl of water, foreshadowing his role as the one who baptizes Jesus. John steps gingerly over the wood shavings to avoid spilling the water and gazes sadly into the bowl, also a prefiguration of his early death. Seemingly incidental objects carrying symbolic significance include the ladder, which alludes to taking Jesus down from the Cross (the Deposition), and the white dove perched on it, denoting the Holy Ghost. Next to the ladder, the carpenter's triangle is a reference to the Trinity and is echoed formally in the triangular arrangement of Jesus and Mary, and in the space between Joseph and Elizabeth (or Saint Anne), who are chromatically linked by the rich reds of their costume. The sheep outside refer to Jesus as the Good Shepherd. The bright red flower recalls the blood of Jesus and his rebirth as the Christ through resurrection. The predominance of wood throughout the painting refers to the wood of the Cross, which became associated with the Tree of Life.

Christ in the House of His Parents was first exhibited in 1850 and, like many other Realist works, provoked harsh criticism. Charles Dickens did not mince words, declaring Jesus to be "a hideous, wry-necked, blubbering, red-haired boy in a night-gown" and the Virgin "so horrible in her ugliness that (supposing it were possible for any human creature to exist for a moment with that dislocated throat) she would stand out from the rest of the company as a monster in the vilest cabaret in France or in the lowest gin shop in England."[7] A review in *The Times* of London, objecting to the depiction of poverty, called the work "disgusting." The reviewer described Jesus as an ugly, spoiled cry-baby and the Virgin as hideous. Ruskin, however, praised the empirical

observation of nature in Pre-Raphaelite style and applauded the aspersions cast on Academic taste. Of course, as is often the case in the art world, all the negative reviews had an effect that was the reverse of that intended by the critics, and catapulted the style into public prominence.

Although, in contrast to Realism, much Pre-Raphaelite painting depicted Christian and Shakespearean subjects, as well as medieval themes, some represented contemporary issues, including unemployment and prostitution, usually with a moralizing gloss. William Holman Hunt, for example, painted *The Awakening Conscience* (**figure 30**), which shows a prostitute suddenly realizing the immorality of her lifestyle. The canvas is filled with an abundance of rich material details, juxtaposing the crowded Victorian interior with a brighter natural outdoors reflected in the background mirror. A man plays the piano with his left hand (a motif traditionally associated with sexual seduction) and extends his right hand in front of the prostitute. She rises suddenly from his lap, gazing out of a window onto nature, which has a redeeming, spiritual quality in contrast to the materialistic interior. Critics who disapproved of the painting reacted to the eroticism of its content rather than to the moralizing character of the iconography.

Ford Madox Brown (1821–1893) was born in Calais and studied in Antwerp, Rome, and Paris before settling in London. He was closely related to the Pre-Raphaelites through his friendship with Rossetti, but not an official member of the group. Brown shared the Pre-Raphaelites' painstaking attention to detail and the French Realist interest in depicting contemporary subject matter and focusing on different strata of society, especially the working class. In his last and most important painting, *Work*, begun in 1852, Brown represented a panorama of social classes in Victorian England. Eleven years in the making, *Work* includes figures from every walk of life, from laborers in

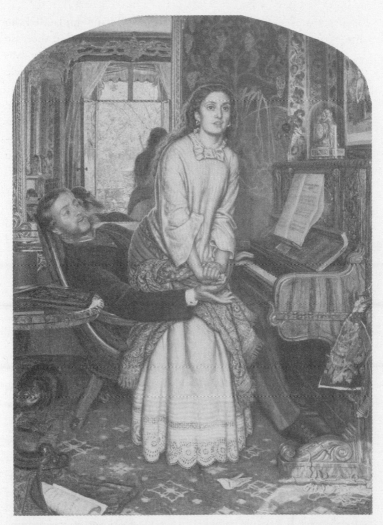

Figure 30 William Holman Hunt, *The Awakening Conscience*, 1853–1854, oil on canvas, 30 x 22 in (76.2 x 55.9 cm). Tate Britain, London, UK. (Source: Wikimedia Commons)

Figure 31 Ford Madox Brown, *The Last of England*, 1852–1855, oil on panel, oval 32 1/2 x 29 1/2 in (82.5 x 75 cm). Birmingham Museums and Art Gallery, Birmingham, UK. (Source: Wikimedia Commons)

the center foreground, digging up a London street to install a sewage line, to a wealthy Member of Parliament and his daughter on horseback in the distance.

In *The Last of England* (**figure 31**) Brown takes up the contemporary issue of emigration; in 1852, over 350,000 people left England to settle elsewhere. Two main figures occupy the foreground, a mother protecting her infant beneath her cloak as her husband in turn tries to protect her. They appear to be middle class and are joined in their departure by figures from other walks of life crowded into the boat behind them. A blond child eats an apple and a man smokes a long-stemmed pipe. The

provisions in the foreground indicate that they are leaving for a long period of time, if not for good. The bright pink ribbon uniting the foreground couple and the fact that they are holding hands reinforce the impression of their commitment to each other. The gray rainy day is typical of the cold weather conditions that Brown liked to paint and echoes the sad, subdued mood of the émigrés.

The Arts and Crafts Movement

In England, the socialist aims of Realism influenced the decorative arts, particularly the Arts and Crafts Movement led by William Morris (1834–1896). He studied painting with the Pre-Raphaelites, but soon turned to interior decoration. He established a business that produced furniture, wallpaper, stained glass, and other objects inspired by the Middle Ages. Although some of his products were expensive and unique, others conformed to socialist values and were handmade for the mass market. In the face of industrialization and pollution, Morris believed that crafts would create satisfaction for the worker who made them and an aesthetic environment for the consumer. By making art and design available to everyone, he hoped to contribute to the development of a classless society.

Realism in Germany

The Realist trend in nineteenth-century Germany resulted in part from the influence of Courbet, who visited Munich in 1869. He admired the work of the young German artist Wilhelm Leibl (1844–1900), whose *Village Politicians* of 1876–1877 combines several Realist features (**figure 32**). Leibl shows five local politicians poring over a newspaper, searching for election news.

Figure 32 Wilhelm Leibl, *Village Politicians*, 1876–1877, oil on canvas, 29 3/4 x 38 1/8 in (75.3 x 96.5 cm). Museum Oskar Reinhart am Stadtgarten, Winterthur, Switzerland. (Source: Wikicommons Media)

This imagery reflects the proliferation of newspapers in the late nineteenth century, which both fueled and resulted from the increasing literacy of the population in Europe and a growing awareness of contemporary events.

Three coarsely rendered men that demonstrate Leibl's aim to represent "reality" are silhouetted against the wall on the right as light enters the space from the cropped window at the left. They fill the picture, focusing their attention on the news. Their individual physiognomy and clothing reveal Leibl's close study of detail, which he depicts in accordance with the ideals of Realism. Each figure reacts in his own way, forming a progression of age, with the youngest at the left, and the oldest at the right. A man leaning on a stick, draws back and seems surprised by something, while his companion at the far right leans forward

as if eagerly awaiting information. He clasps his hands as his heels rise from his clogs, revealing torn socks and a bit of flesh. His craggy, lined face and pursed lips reinforce the impression of anticipation. The realism of this painting accords well with Leibl's pleasure at having his pictures admired by peasants rather than by painters who are considered sophisticated or by so-called art lovers. In 1879, Leibl wrote to his mother, noting his pleasure in the reaction of a peasant who called one of his pictures the work of a master.

Realist trends in America

In nineteenth-century America, Realist artists shared the concerns of European Realism. Some adapted the style to the American context, while others represented Classical subjects. William Sidney Mount (1807–1868) applied Realism to genre painting (scenes of everyday life). Winslow Homer (1836–1910), sent by *Harper's Weekly* to record the Civil War, produced gripping images of the conflict and its aftermath. William Rimmer (1816–1879) transformed Classical iconography with Realist rather than idealized depictions of human and animal form. And Thomas Eakins (1844–1916), in his *Gross Clinic*, took a Realist approach to the subject of surgery as practiced in America.

William Sidney Mount was a student of mathematics, which he believed would assist him in seeking the "truth in painting." He also studied nature, made notes on color, and kept a journal on perspective. In Mount's view, every aspect of contemporary life was fodder for art, a notion expressed in his assertion that "A painter's studio should be everywhere; ... In the blacksmith's shop. In the shoe makers – The tailors – the Church – The tavern – or Hotel, the Market – and into the dens of poverty and dissipation, high life and low life ... An artist should have the industry of a reporter."[8]

Figure 33 William Sidney Mount, *California News*, 1850, oil on canvas, 21 1/8 x 20 1/4 in (53.4 x 51.2 cm). Long Island Museum, Stony Brook, New York. (Source: Wikimedia Commons)

Mount's *California News* of 1850 (**figure 33**), like Leibl's *Village Politicians*, depicts the contemporary role of newspapers, but with a different emphasis. Mount's picture is set in a New York post office, where a man is reading the *New York Daily Tribune*. The figures are excited by news from California, where gold has been discovered. Like trains and other industrial forms of communication, printed newspapers connect remote geographic areas and remind viewers that there are vast distances in America. One man has already bought a train ticket, and on the back wall posters announce the departure of ships. The fact that the source of the excitement is gold alludes to the American dream of wealth and success.

Mount depicts a variety of ages and social groups – young and old, black and white, male and female. Their reactions to the news are revealed through a series of animated poses and gestures and the alertness of their expressions. The structure of the painting reveals Mount's study of perspective, combining a Realist approach to three-dimensional space with figures who respond with immediacy to contemporary events.

Winslow Homer's *Prisoners from the Front* of 1866 is one of his many Civil War pictures (**figure 34**). Here, too, there is a range of age, and the difference between the bedraggled Confederate prisoners and the elegantly uniformed Union officer is typical of Realism. The shined boots and polished sword of the Union officer echo the rifles on the ground that have been surrendered by the defeated Confederates and reinforce distinctions in rank as well as those between the conquered and the conqueror. As in Courbet's *A Burial at Ornans*, there is a predominant horizontal plane formed

Figure 34 Winslow Homer, *Prisoners from the Front*, 1866, oil on canvas, 24 x 38 in (61 x 96.5 cm). Metropolitan Museum of Art, New York, New York. (Source: Wikimedia Commons)

by the sky and landscape, creating a frieze of foreground figures. But Homer's work differs from the *Burial*, as there is a greater sense of distance provided by the background soldiers and horses. Homer shows us the dignity of the prisoners through their upright poses. The staunch vertical of the rifle carried by the Union soldier guarding the prisoners echoes the Ornans crucifix piercing the sky. The fierce struggle of a war that has ended is encapsulated in the confrontation between the Union officer in blue at the far right and the Confederate soldier in gray. Their stances mirror each other and signify the much wider conflict that killed thousands of men on both sides. By the physical space that separates them, Homer indicates that the sentiments that sparked the Civil War persist. In so doing, he captures an aspect of American history that still resonates today.

William Rimmer, an American Realist sculptor, was born in Liverpool, but came to the United States as a child. He was a self-taught artist, whose study of medicine influenced his Realist approach to human anatomy. Unrecognized as an artist for most of his life, he made his living by teaching drawing. His use of Classical and mythological content was unusual among Realists, though he imbued his figures with careful study of bone and muscle structure, and mastered the portrayal of inner tension and relaxation. These qualities appear in his *Dying Centaur* of 1871 (**figure 35**), an image drawn from Greek myth. A slow death is conveyed in the centaur's gradual loss of life. Rimmer shows the transition from life to death as a process rather than a static pose. The centaur's torso is tense with muscles struggling against his fate, but he is relaxed from the waist down, as if death is overtaking him from back to front. The centaur also seems to be protesting his fate by extending his right arm and raising his torso as if resisting the march of death. His truncated arm accentuates the power of the gesture, just as Géricault's studies of severed limbs exude power by the very fact of their fragmentation.

The study of medicine also informed *The Gross Clinic* (**figure 36**) of 1875 by Thomas Eakins. Its iconography shows

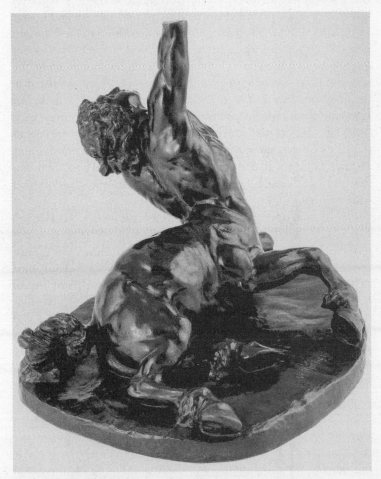

Figure 35 William Rimmer, *The Dying Centaur*, 1871, plaster cast in bronze, 25 x 21 1/2 x 19 in (63.5 x 54.6 x 48.3 cm). Metropolitan Museum of Art, New York, New York. (Source: Wikimedia Commons)

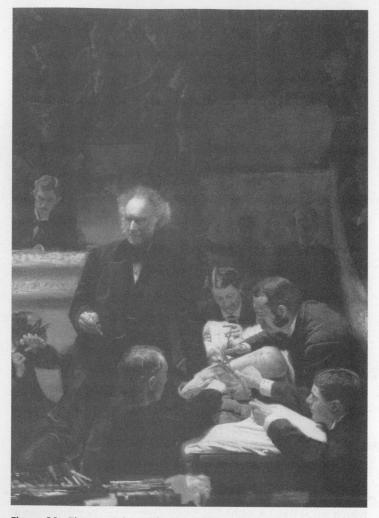

Figure 36 Thomas Eakins, *The Gross Clinic*, 1875, oil on canvas, 8 ft x 6 ft 6 in (243.8 x 198.1 cm). Philadelphia Museum of Art, USA. (Source: Wikimedia Commons)

Realism's relationship to anatomically accurate depictions, as Eakins represents a well-known contemporary surgeon, Dr Samuel Gross, lecturing to students at the Jefferson Medical School in Philadelphia. A team of surgeons performs an operation, as the patient's mother hides her eyes. Eakins does not spare details of the incision in the leg, the blood, or the instruments cutting into flesh and muscle. He was clearly influenced by Rembrandt's seventeenth-century *Anatomy Lesson of Dr Tulp* and, like Rembrandt, Eakins highlights the physicians; the light on Dr Gross's forehead denotes his superior intellect. Although there are echoes of Rembrandt, the content and style of *The Gross Clinic* are consistent with Baudelaire's assertion that artists should paint modern life.

Realism and photography

Black-and-white photography, a technique for recording nature that had been known in a preliminary form for centuries, developed at an accelerating rate in the nineteenth century. As photographers learned to make images permanent and exposure time shorter, it became possible to use the camera for portraiture, calling cards, scientific cataloguing of the natural world, reportage and social documentation, and various industrial applications. But it was not until well into the twentieth century, after initial controversy over its aesthetic possibilities and status, that photography was acknowledged as an art form in its own right.

During the 1820s, in France, Joseph Nicéphore Niépce (1765–1833) learned to fix (make permanent) photographic images, which until then would fade over time. Niépce's process, which required an eight-hour exposure time, lasted until the following decade, when another Frenchman, Louis Daguerre (1787–1851), invented the daguerreotype, which reduced the

exposure time to fifteen minutes. Daguerre's image could be printed on metal (usually silver) plates, but yielded only a single print that could not be reproduced. By 1842, the exposure time had been reduced to only a few seconds, making it easier for subjects, who no longer had to sit for hours on end. In 1839 Daguerre produced his famous photograph of shells and fossils, an example of the Enlightenment interest in classifying nature. Photography was also a new way of observing and recording nature and, as such, was aligned with the interests of the Realists.

In the mid nineteenth century, the English scientist William Henry Fox Talbot (1800–1877) invented the calotype, an image printed on paper that could be made in multiples. Daguerreotypes, on the other hand, were unique. Around 1845, Fox Talbot published his celebrated work on photography entitled *The Pencil of Nature*, containing twenty-four calotypes. He argued that photography is an art rather than a craft – an assertion that became a matter of controversy and remained so for several generations.

Gaspard-Félix Tournachon, known as Nadar (1820–1910), produced a classic example of portrait photography in nineteenth-century France – a portrait of Daumier made in 1856, one of four he made of the artist. He captures Daumier's discerning expression and intense gaze. The forehead is creased, suggesting that Daumier is thinking about some new aspect of hypocrisy, which he satirized in the Paris press along with the failures and abuses of the government. His slightly disheveled hair frames his face and his short beard indicates less concern for his appearance than for whatever has caught his attention.

The role of photography in documentation and journalism originated in the nineteenth century and was rooted in the conviction that the efficacy of the medium lies in its powers of persuasion. The photograph was considered a witness to reality. In 1848, William Edward Kilburn (1818–1891) recorded an important historical event in his photograph *The Great Chartist Meeting*

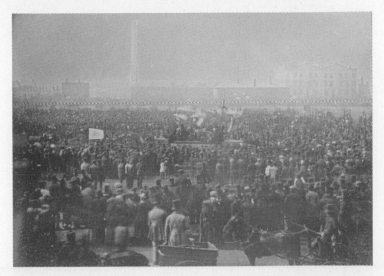

Figure 37 William Edward Kilburn, *The Great Chartist Meeting on Kennington Common, April 10, 1848,* 1848, daguerreotype, 4 1/4 in x 5 3/4 in (10.7 x 14.7 cm). Windsor Castle, Windsor, UK. (Source: Wikimedia Commons)

on Kennington Common, April 10, 1848 (**figure 37**). Chartism was the first major political movement of the British working class, and the government feared that the meeting would incite civil unrest. Over a million participants had been expected, but in the end only 20,000 to 30,000 attended. The army was on hand in case of disturbances, the Duke of Wellington was summoned out of retirement to assist the army in defending the city, and Queen Victoria repaired to the Isle of Wight for safety.

In its documentary quality and in the nature of its political content, Kilburn's photograph conforms to the ideals of Realism. It was the first known photograph of a crowd, and appears to record an actual event with complete fidelity and to capture a moment in history. The distant viewpoint, from behind the crowd of figures, and the slight blurring of form convey motion

CHARTISM

Chartism was a radical democratic movement in England that was composed mainly of the working classes and lasted from around 1838 to 1850. It concerned the rules of the "People's Charter," a petition of 1837 drawn up by popular demand but rejected by Parliament. Inspired by the Enlightenment views of the previous century, the charter called for wider male suffrage, equality of electoral districts, voting by secret ballot, elimination of property-ownership as a qualification for becoming a Member of Parliament, granting salaries for MPs so that working-class men could afford to run for political office, and annual elections. A second petition presented in 1841 was also rejected. A final effort to revive the movement, which was fueled by the 1847 recession and rebellions on the Continent, also came to nothing. Many of its goals were eventually achieved, but only after Chartism had died out.

and make the image appear candid and straightforward. But a photographer, like a painter, makes choices that carry messages and create impressions. In this case, the horse-drawn carriages in the foreground and the men in top hats gazing down at the workers reflect English class distinctions and the conflict between those for and against granting the privileges of the Charter to the working classes. Rows of houses and factories dimmed in the distance by a clouded atmosphere indicate the polluting effects of industry on urban England.

During the American Civil War (1861–1865), Mathew Brady (1822–1896) documented the conflict in photographs. But his photographs also transcend pure documentation and are now considered works of art as well as of reportage. Along with many other photographs produced in the nineteenth century, they exemplify the combined aesthetic and persuasive possibilities of the medium. Similarly, Jacob Riis (1849–1914), who moved from Denmark to New York City in 1870, hoped to use photography for political as well as aesthetic purposes. His book *How the*

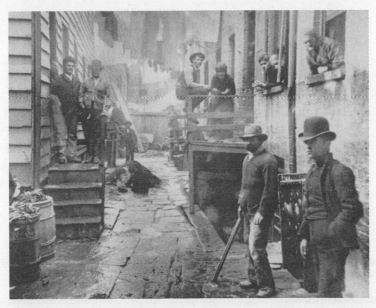

Figure 38 Jacob Riis, *Bandits' Roost, Mulberry Street, New York*, c.1888, photograph, 15 1/2 x 19 3/16 in (39.4 x 48.7 cm). Museum of the City of New York, New York. (Source: Wikimedia Commons)

Other Half Lives, published in 1890, recorded the poverty and dangerous living conditions of exploited immigrant workers. His photograph entitled *Bandits' Roost, Mulberry Street, New York* of around 1888 shows men in back alleys and people leaning out of tenement windows (**figure 38**). Open garbage is visible, laundry hangs from buildings, and stray animals roam the street. The perspective of the scene carries our eye into a haze that confirms the bad air quality and squalid lifestyle of Manhattan's Lower East Side. Riis went beyond documentation, visiting the lower classes and exploring their neighborhoods, with the intention of creating an awareness of social injustice and of the gap between rich and poor in New York.

Realism and architecture

Architecture can be said to be related to Realism insofar as it provides social and economic benefits for large numbers of people. As with Realist painters and photographers, architects developed a new awareness of the environment and explored ways to improve it for different social classes. Architects became aware of the benefits of new industrial technology and materials, especially iron and steel, for certain types of buildings. Prefabrication was developed; elevators made buildings many stories high a practical reality; increased travel led to improvements in bridge construction and the proliferation of railway stations; and the trend toward urban shopping inspired the construction of department stores.

In 1851, Joseph Paxton (1803–1865) constructed the Crystal Palace in London of cast iron, wrought iron, and cast plate glass, which was less expensive and larger than previous glass panes. The structure was to be an exposition space for the Great Exhibition of the Works of Industry of All Nations to showcase new developments in international industry and culture. Exhibits ranged from the Koh-i-Noor diamond to a fire engine. With the Crystal Palace Paxton pioneered prefabrication on a large scale; the building enclosed an area of some eighteen acres and housed 10,000 exhibits of crafts and technology from around the world. For nine months Paxton supervised the prefabrication of individual sections of the building, which were then brought to London by train and assembled on site in Hyde Park. After the exhibition, the structure was moved to a site near Sydenham Hill in South London. Paxton produced a cost-effective design, but unfortunately the conviction that iron and glass are fireproof turned out to be mistaken. The Crystal Palace burned down in 1936. Ruskin for his part disapproved of prefabrication, preferring that architects use masonry rather than glass, on the grounds that stone was imbued with traces of history.

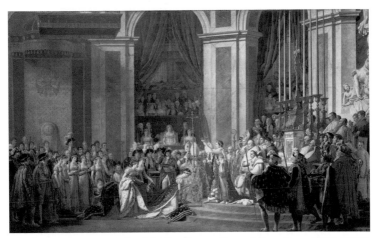

Plate 1 Jacques-Louis David, *The Coronation of Napoleon*, 1805–1807, oil on canvas, 20 ft x 32 ft (6.21 x 9.79 m). Musée du Louvre, Paris, France. (Source: Wikimedia Commons)

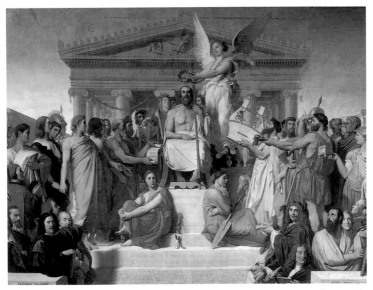

Plate 2 Jean-Auguste-Dominique Ingres, *The Apotheosis of Homer*, 1827, oil on canvas, 12 ft 8 in x 16 ft 10 in (3.8 x 5.1 m). Musée du Louvre, Paris, France. (Source: Wikimedia Commons)

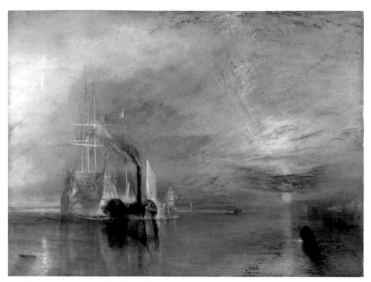

Plate 3 James Mallord William Turner, *The Fighting Temeraire Tugged to Her Last Berth to Be Broken Up, 1838*, 1838 oil on canvas, 35 3/4 x 47 7/8 in (90.7 x 121.6 cm). National Gallery, London, UK. (Source: Wikimedia Commons)

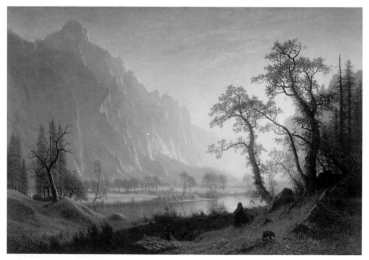

Plate 4 Albert Bierstadt, *Sunrise, Yosemite Valley*, c.1870, oil on canvas, 36 1/2 x 52 3/8 in (92.7 x 133 cm). Amon Carter Museum of American Art, Fort Worth, Texas. (Source: Amon Carter Museum of American Art, 1966.1)

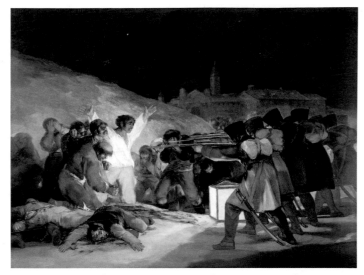

Plate 5 Francisco de Goya y Lucientes, *The Executions of May 3, 1808*, 1814, oil on canvas, 8 ft 9 1/2 in x 11 ft 3 7/8 in (2.68 x 3.47 m). Prado, Madrid, Spain. (Source: Wikimedia Commons)

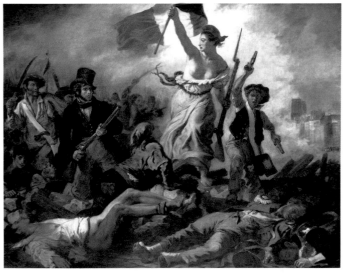

Plate 6 Eugène Delacroix, *Liberty Leading the People*, 1830, oil on canvas, 8 ft 6 3/8 in x 10 ft 8 in (2.60 x 3.25 m). Musée du Louvre, Paris, France. (Source: Wikimedia Commons)

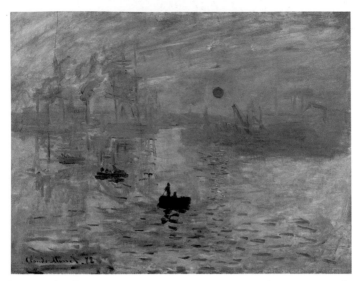

Plate 7 Claude Monet, *Impression, Sunrise*, 1872, oil on canvas, 1 ft 7 1/2 x 2 ft 1/2 in (49.5 x 64.8 cm). Musée Marmottan, Paris, France. (Source: Wikimedia Commons)

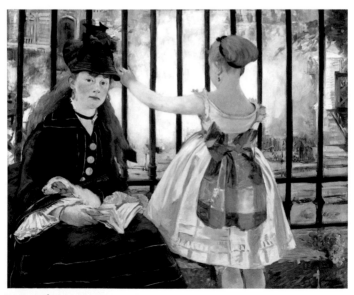

Plate 8 Édouard Manet, *The Railway*, 1872–1873, oil on canvas, 36 3/4 x 43 7/8 in (93.3 x 111.5 cm). National Gallery of Art, Washington, D.C. (Source: Wikimedia Commons)

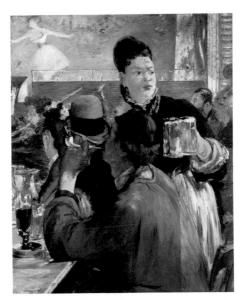

Plate 9 Édouard Manet, *Corner of a Café-Concert*, 1879, oil on canvas, 38 1/4 x 30 1/2 in (97.1 x 77.5 cm). National Gallery, London, UK. (Source: WikiPaintings)

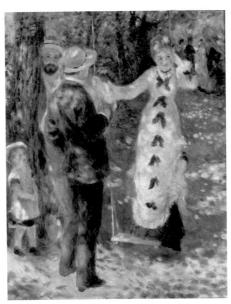

Plate 10 Pierre-Auguste Renoir, *The Swing*, 1876, oil on canvas, 36 x 28 in (92 x 73 cm). Musée d'Orsay, Paris, France. (Source: Wikimedia Commons)

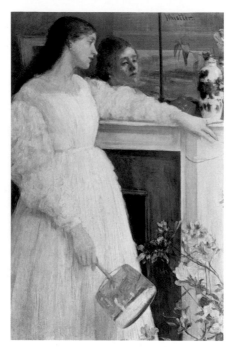

Plate 11 James McNeill Whistler, *Symphony in White No. 2: The Little White Girl*, 1864, 30 x 20 in (75.9 x 50.6 cm). Tate Gallery, London, UK. (Source: Wikimedia Commons)

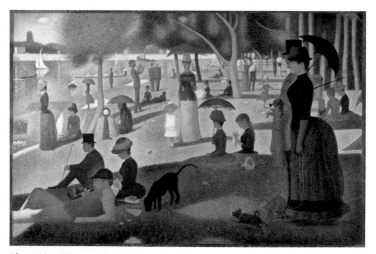

Plate 12 Georges Seurat, *Sunday Afternoon on the Island of the Grande Jatte*, 1884–1886, oil on canvas, 6 ft 9 3/4 in x 10 ft 1 1/4 in (2.08 x 3.08 m). Art Institute of Chicago, Chicago, Illinois. (Source: Wikimedia Commons)

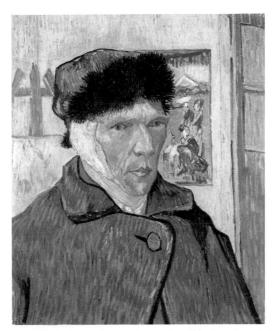

Plate 13 Vincent van Gogh, *Self-Portrait with Bandaged Ear, Arles, January 1889*, 1889, oil on canvas, 23 5/8 x 19 1/4 in (60 x 49 cm). Courtauld Gallery, London, UK. (Source: Wikimedia Commons)

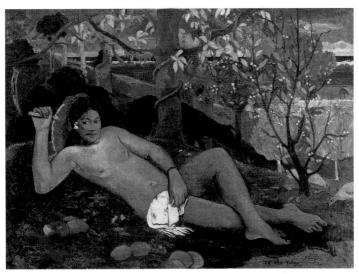

Plate 14 Paul Gauguin, *Te Arii Vahine*, 1896, oil on canvas, 38.2 x 51.2 in (97 x 130 cm). Pushkin State Museum of Fine Arts, Moscow, Russia. (Source: Wikimedia Commons)

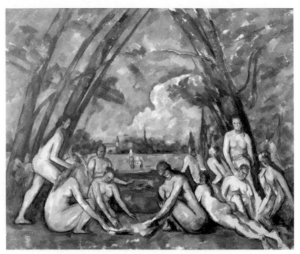

Plate 15 Paul Cézanne, *Large Bathers*, c.1905–1906, oil on canvas, 6 ft 10 7/8 in x 8 ft 2 3/4 in (210.5 x 250.8 cm). Philadelphia Museum of Art, Philadelphia, Pennsylvania. (Source: Wikimedia Commons)

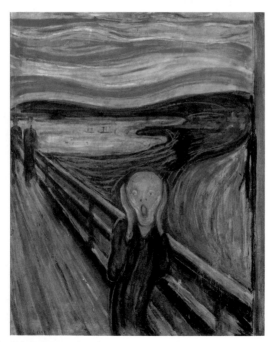

Plate 16 Edvard Munch, *The Scream*, 1893, oil, pastel, and casein on cardboard, 35 3/4 x 29 in (90.8 x 73.7 cm). National Gallery, Oslo, Norway. (Source: Wikimedia Commons)

In Paris, the Eiffel Tower, huge railway stations, and department stores used the new industrial materials and could accommodate large urban crowds. The façade of the Gare de l'Est, built between 1847 and 1852, was composed of a long horizontal arcade of round arches connecting two sturdy, block-like wings at each end. A large stone triangular pediment pierced by a lunette-shaped window dominated the center. The many openings of the station seemed to beckon travelers; it marked a place of passage from Paris to regions beyond, a response to the increasing demand for travel for business as well as pleasure in the nineteenth century.

Alexandre Gustave Eiffel's (1832–1923) Eiffel Tower, dating to 1887–1889, is a metal truss construction of wrought iron on a reinforced concrete base. It was built for the temporary Universal Exposition of 1889 to celebrate the centenary of the French Revolution. The Tower was considered an eyesore not only by the general public, but also by authors and art critics. There were numerous protests against it and a citywide petition demanded the Tower's demolition. It was allowed to remain standing, however, because of its usefulness as a radio tower. Today the Eiffel Tower is a majestic and iconic symbol of Paris – another example of how profoundly tastes in the world of art and architecture can change. The open latticework lightens the space and includes the sky, visible through the openings, in its aesthetic impact; below, the surrounding trees and buildings also enhance its appearance. Like other tall structures, the Eiffel Tower benefited from the elevator, which was invented by the American industrialist Elisha Otis. Until 1932, when the Empire State Building was erected in New York, the Eiffel Tower was the world's tallest building.

In the United States, the suspension bridge made of stone and flexible steel-wire cables came into use during the second half of the nineteenth century (previous suspension bridges had been made of non-industrial materials). From 1869 to 1883, the

Roeblings (father and son) built the Brooklyn Bridge, spanning the East River, which separates Manhattan from Brooklyn. Like the Gare de l'Est in Paris, the Brooklyn Bridge was constructed of traditional elements and materials as well as newer ones. The two large stone piers are pierced by pointed Gothic arches that open up a vista of the skyline and lighten the impression of the structure. In the steel cables, there is a combination of solidity and gracefulness that carries the eye up and down in a series of curves, rising and falling in a motion echoing that of the river itself.

In the American Midwest, architects responded to the need for residential and commercial buildings that would make economic sense as people increasingly moved westward and cities expanded. The solution came in the latter decades of the nine-teenth century in the form of skyscrapers, which used steel and reinforced concrete for increased tensile strength. This allowed for taller buildings that could accommodate offices and apart-ments and were less expensive because they occupied less land than would a shorter building of the same square footage.

Following the Great Fire of 1871, the Midwestern city of Chicago became the site of increased building activity, using new industrial materials and new techniques. William Le Baron Jenney's (1832–1907) ten-story Home Insurance Building, constructed in 1884, was the first tall building to be supported by a metal frame. After the Great Fire, which made room for the construction of new buildings, other Chicago architects also benefited from the lighter, stronger quality of the material. The upper floors had a frame of iron and steel sheathed with terracotta (clay-based earthenware) and brick. Jenney's structure contained traditional elements that concealed the steel skeleton. The masonry of the two lower stories was heavily rusticated (cut and shaped with a textured appearance) and the central entrance, two stories high, was flanked by Corinthian columns

and pedestals supporting an architrave (see **figure** 2). Projecting balconies on the third and fourth floors further accentuated the entrances. The corners were reinforced by thick pilasters (square columns), repeated above the entrance area and continuing to the top of the building. The upper-story windows had round arches, and the building was "finished" with a horizontal frieze that continued on all four sides. In 1931 the Home Insurance Building was demolished to make room for another skyscraper.

From 1890 to 1891, the American architect Louis Sullivan (1856–1924), often referred to as the father of the skyscraper, built the Wainwright Building in Saint Louis, Missouri (**figure 39**). Ten stories high like Jenney's Home Insurance Building, and concealing a steel frame, the Wainwright Building consisted of horizontal and vertical girders joined to form a grid. This permitted Sullivan to use a red granite, brick, and terracotta exterior consisting of Classical elements such as pilasters and a projecting cornice (see **figure 2**), which enhanced the aesthetic appearance of the structure. Both architects had studied in Paris, which may explain the details derived from the Greek orders that appear in their buildings.

Skyscrapers such as Jenney's and Sullivan's, and others springing up around Chicago, conformed to Sullivan's often-cited Realist architectural principle that "form follows function," meaning that the formal quality of a building is determined by its purpose. In addition, according to Sullivan, the function of a building should be readily apparent from its form. This notion of functionality was consistent with the nineteenth-century attention to social and economic conditions that was at the forefront of on-going political movements beginning with the American and French Revolutions of the late eighteenth century. Sullivan also believed that the height of an office building should be an assertion of pride and achievement; it should be aesthetically pleasing, imposing, and practical.

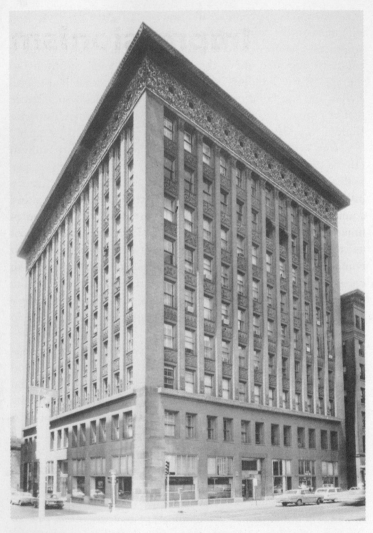

Figure 39 Louis Sullivan, Wainwright Building, 1890–1891, St Louis, Missouri. (Source: Wikimedia Commons)

4

Impressionism

Impressionism began in Paris, and drew artists from other countries, including the United States, to study, work, and sometimes to live permanently in the city. In its origins and much of its content, Impressionism is primarily a French style, although France at the time was inhospitable to the new movement and many French critics were scathing in their reaction to it. The very term *Impressionism*, coined in Paris in 1874, was intended as an insult. The critic Louis Leroy, writing in the satirical French publication *Le Charivari*, used the term to make fun of Claude Monet's (1840–1926) *Impression, Sunrise*, painted two years earlier (**plate 7**). "Impression," he declared, "– I was certain of it. I was just telling myself that, since I was impressed, there had to be some impression in it … And what freedom, what ease of workmanship! Wallpaper in its embryonic state is more finished than that seascape."[1]

Terms that have been applied to Impressionism include "sensation," "effect," "cropped viewpoint," and "fleeting moment." These suggest the artists' efforts to capture a passing impression of reality (as a photograph appears to do) and to "fix" it on a flat surface. Their aim was to make the viewer aware of the passage of time and of the shifting, fugitive character of nature. One way they achieved this was by using new techniques to apply paint,

making the brushstrokes and their arrangement a visible and prominent aspect of a picture's content.

Unable to gain admittance to the Salon, Monet showed *Impression, Sunrise* in 1874 alongside the work of like-minded artists in what would later become known as the First Impressionist Exhibition. The exhibition was organized by the Anonymous Society of Painters, Sculptors, Engravers, Etc., founded in December 1873. From 1874 to 1886, the organization mounted eight group shows – the so-called Impressionist Exhibitions. Most of the painters who exhibited there were relatively unknown at the time, but would become masters of the style – Camille Pissarro (1830–1903), Édouard Manet (1832–1883), Edgar Degas (1834–1917), Pierre-Auguste Renoir (1841–1919), Berthe Morisot (1841–1895), Mary Cassatt (1844–1926), and Gustave Caillebotte (1848–1894), in addition to Monet and several others.

The First Impressionist Exhibition provoked negative responses from a number of critics. In addition to mocking Monet, Leroy wrote that Degas painted dancers' legs as if they were made of cotton, and complained that Pissarro must have been wearing dirty glasses when painting landscapes. To a greater or lesser degree, because of the widespread negative reaction to Impressionism, all the artists had difficulty during their lifetime in finding buyers for their work, only for it to sell for millions of dollars during the twentieth and twenty-first centuries.

The Impressionists were a mixed group socially and economically, themselves a spectrum of contemporary society. Some, such as Degas, Manet, and Cassatt, were financially comfortable; others had to struggle for buyers and had difficulty supporting themselves. Around five years prior to the founding of the Anonymous Society, the Impressionists began gathering at the Café Guerbois, then on the Grande Rue des Batignolles (now Avenue de Clichy), to discuss art and art theory. Young artists in their twenties and thirties, they were known as the *Groupe des Batignolles*. Berthe Morisot declined to join these meetings since

it was considered improper for unmarried women to appear in public with men. Degas, who was a bachelor and the loner of the group, nevertheless befriended Mary Cassatt, who was also single, and they remained lifelong friends.

Although the Impressionists were a committed group sharing a new approach to painting, there were major differences among them. Manet, as we have seen, was a Realist in the 1860s but in the 1870s became an Impressionist. Degas' forms are often rendered more clearly than those of Monet, Renoir, Pissarro, Cassatt, and Morisot, whose brushwork is visible. At the same time, their joint commitment to modernity was unwavering. They shared new ways of depicting the outdoors, landscape as well as seascape, and the urban environment. They strove to paint what was visible to the eye, and to capture the "reality" of sensory perception. This approach is embedded in the very meaning of the terms *impression* and *impressionism*, which connote impermanence. We speak of "first impressions" as rapidly arrived at and subject to change.

One expression of the Impressionist attraction to the outdoors, especially in an urban setting, was the theme of the *flâneur*, a man who strolls through the city, observing and experiencing life around him. For Baudelaire, in his essay on the Painter of Modern Life, the *flâneur* is a product of "modernity" – a man whose promenade allowed him to record and be recorded in the present. The *flâneur* is both a camera, witnessing and capturing the urban scene, and a captive of the painter who depicts him.

Some nineteenth-century critics considered Impressionist subject matter – landscape, genre, and scenes of modern urban life, as well as portraiture – beneath the dignity of traditional Christian and history painting. According to its detractors, Impressionist technique lacked preparation and "finish." Furthermore, the artists often painted outdoors – hence the term *plein air* painting – rather than in a studio, as had been the traditional Academic practice. Even though a number of Realists advocated painting directly from nature, they did not do so

with the Impressionist aim of achieving optical reality, that is, a visual "truth" – what the eye actually sees. Impressionist artists were less interested in social and political "truth" than were the Realists, but, like the Realists, the Impressionists believed that they were conveying "truth in painting." When Realists such as Courbet painted figures, they placed more explicit emphasis on social class, a theme that appears in Impressionism, but in a more subdued way and one that is subordinate to the new effects of light, color, and paint texture.

With the rise of a new generation of painters, Paris began to witness the decline of the Salon. Outmoded by its conservatism, the Salon rejected over 3,000 works submitted by the Impressionists, who were opposed to the "official art" of the Academy. However, some, notably Manet, did exhibit there on occasion. In 1863, when thousands of examples of the new style were rejected by the Salon, Napoleon III established the *Salon des Refusés* (Salon of the Rejects). This provided a venue for young, generally misunderstood artists who were committed to the new style. In addition to Monet's *Impression, Sunrise*, works rejected by the Salon and then shown in the *Salon des Refusés* included Manet's *Luncheon on the Grass* and Whistler's *White Girl No. 1*. Subsequent *Salons des Refusés* were mounted in 1874, 1875, and 1876. As well as rejecting the avant-garde, the Salon saw a decline in its patronage, which led to a new crop of dealers, galleries, and exhibitions. Often the artists themselves organized and raised financing for the Impressionist exhibitions.

Politics and money

The 1870s were a period of political turmoil in Western Europe. On July 19, 1870, France declared war on Prussia; Napoleon III surrendered in September following a decisive Prussian victory at the Battle of Sedan, and the Prussians set siege to Paris. As a

result, Napoleon, Bonaparte's nephew – the last French monarch – who had been installed as emperor in December 1852, was exiled to England. The Third Republic was established. In January, 1871, Paris surrendered; this concluded the Franco–Prussian War, and in March the Paris Commune was formed to establish a socialist government. Despite the political and social upheaval of the 1870s, the subject matter of Impressionism generally avoided allusions to contemporary historical events. Some of the artists had strong political views: Manet was a republican who opposed Napoleon III; Pissarro was an anarchist; Renoir favored restoring the monarchy, hoping that it would stabilize the government. With the exception of Manet, who produced a few overtly political pictures, and Degas, who painted historical subjects such as *Spartans Exercising*, *Semiramis Building Babylon*, and *Alexander and Bucephalus* early in his career and whose anti-Semitism became evident in some of the figures with obviously Jewish features that he painted around the time of the Dreyfus Affair, Impressionist

THE DREYFUS AFFAIR

In 1894, Captain Alfred Dreyfus, an Alsatian Jew in the French army, was accused of passing French military secrets to the Germans. He was convicted of treason and sentenced to life in prison on Devil's Island, in French Guiana. In 1896, the real traitor, Ferdinand Walsin Esterhazy, was discovered, but the evidence against him was suppressed. The case became a huge political scandal and divided the country into two staunch opposing factions – the anticlerical, pro-republican Dreyfusards and the pro-army, mostly conservative Catholic anti-Dreyfusards. Vigorous opinions on the case were expressed by all walks of French society, including artists and writers. In 1898, the popular author Émile Zola made his Dreyfusard sentiments clear when he published *J'accuse* ("I Accuse"), an open letter supporting Dreyfus, in the Paris newspaper *L'Aurore*. Among the artists, Monet, Pissarro, and Cassatt supported Dreyfus, whereas Degas, Rodin, and Cézanne were anti-Dreyfusards. Renoir inclined toward the latter position, but tried to appear neutral.

allusions to politics and history are subliminal at best. What they did paint, however, were manifestations of social and technological change.

In 1853, partly for political and partly for aesthetic reasons, Napoleon III commissioned Baron Georges-Eugène Haussmann to redesign Paris in a large-scale modernization program. His grand boulevards and radiating streets, the emperor hoped, would be widely admired and quell the rebellious spirit that had festered in the overcrowded medieval slums. The boulevards would also help maintain public order by virtue of being harder to barricade and making it easier for the royal troops to maneuver around the city. These changes in the appearance of Paris became characteristic of Impressionist iconography. In addition to the broad panoramas of Haussmann's newly designed Paris, however, artists depicted factories, peasants and workers, landscape, and the bourgeoisie at leisure.

The Franco-Prussian War, brief though it was, helped the Impressionists in one respect. Some of the artists, escaping the war, moved to England where more people would see their work. The Paris art dealer Paul Durand-Ruel – the son of an art dealer who had previously championed the Barbizon painters, especially Corot – became an advocate of Impressionism and introduced the style to the English art world. He was one of the few people at the time to recognize the value of Impressionism, and he included examples of the new style at his London art gallery at 168 New Bond Street. By the end of 1871, the dealer and his artists were back in Paris, meeting at the Café Guerbois. When financial problems resurfaced in Paris from 1872 to 1873, Durand-Ruel again exhibited the Impressionists in London; all in all, he had ten exhibitions in London that included French artists. In 1886 the American Art Association invited him to mount an exhibit of Impressionists in New York, which was a critical success. Eventually he played a leading role in expanding the reputation of the style in Western Europe as well as in London and the United

States. From 1870 until his death in 1922, Durand-Ruel bought almost 12,000 Impressionist paintings. These included over 1,000 by Monet, 1,500 by Renoir, 400 by Degas and Sisley together, around 600 by Pissarro, and 400 by Cassatt.

Two of the artists, Mary Cassatt and Gustave Caillebotte, also played an important role in promoting Impressionism. Both came from wealthy families, Cassatt's in Pennsylvania and Caillebotte's in Paris. Cassatt persuaded her relatives to buy from the artists, and Caillebotte, who was himself a collector of their work, contributed to the expense of mounting exhibitions and paid the rent on Monet's studio. He bequeathed his considerable art collection to France, but the government refused to display the work in major museums. Eventually most of Caillebotte's pictures were bought by the American collector Dr Albert C. Barnes, and form part of the famous Barnes collection, originally located in Merion, Pennsylvania, and now in Philadelphia.

Gustave Caillebotte

Caillebotte (1848–1894) can be seen as a transitional artist, bridging the gap between tradition and the avant-garde. Though he was a member of the Impressionist group, his style is somewhat less innovative because of its clarity of form and relatively precise brushwork. One critic, intending a compliment, assured the public that the artist was not an Impressionist. Although Caillebotte was not as avant-garde as some of his contemporaries, his canvases have many Impressionist qualities. His daring viewpoints, his use of cropping and silhouettes showing the influence of photography, and his urban scenes, some of which illustrate the theme of the *flâneur*, are characteristic of Impressionist style and iconography.

Caillebotte came from an upper-class family. His father, a judge, inherited a military textile business, which kept his family

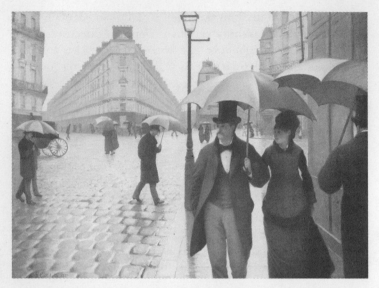

Figure 40 Gustave Caillebotte, *Rue de Paris: Temps de Pluie (Paris Street: A Rainy Day)*, 1877, oil on canvas, 6 ft 10 3/4 x 8 ft 11 5/8 in (2.12 x 2.70 m). The Art Institute of Chicago, Chicago, Illinois. (Source: Wikimedia Commons)

in relative financial comfort. Caillebotte himself became a lawyer in 1868 and also trained as an engineer. After a stint in the Franco-Prussian War, he turned to painting. In the Impressionist Exhibition of 1876, he showed eight pictures, having had a painting of workers scraping a wooden floor rejected by the Salon on the grounds that the subject was vulgar. Caillebotte's typical subjects include portraits, domestic interiors, country and urban scenes, scenes of leisure, nudes, and still lifes.

Caillebotte's *Rue de Paris: Temps de Pluie (Paris Street: A Rainy Day)* of 1877 (**figure 40**) juxtaposes near and far in the radical viewpoint of the perspectival building in the background and the flattened, silhouetted couple in the foreground. They seem distracted; they approach the viewer, but their attention has been

caught by something off to the left that we do not see. A cropped figure, strolling down the street in the opposite direction, enters the picture at the right. The rain-soaked street seems to open up and expand in the distance as pedestrians carrying umbrellas venture outdoors. As in a candid camera view, we have the impression that we are observing without being seen ourselves; the artist, like us, appears to have caught his subjects unawares. He has presented us with a *flâneur* and he invites us to share his experience of modern life.

In *Rue de Paris*, Caillebotte produces a sharp contrast between silhouetted form and the muted, gray light caused by rain and fog. Meanwhile, the cobblestones and the pavement glisten, creating the appearance of a wet surface. In these features, Caillebotte shares the Impressionist interest in the effects of weather on color, light, and shadow.

Claude Monet

Monet's *Impression, Sunrise* (see **plate 7**) embodies many of the qualities associated with Impressionist style. He painted it outdoors, apparently at a single sitting. The work is both an image of a fleeting time of day – sunrise – and, in the gray factories emitting smoke into a pink and purple sky, a depiction of industry. These two themes – transitory time, defined with visible brushstrokes, and social change – would become characteristic of Impressionism.

Formally as well as contextually Impressionism is a style of contrast and juxtaposition, as we saw in Caillebotte's *Rue de Paris*. In *Impression, Sunrise* Monet juxtaposes the bright red-orange sun, a solid enclosed circle in the sky, with its component colors – red, orange, and yellow – which are "broken" into horizontals that convey the effect of fluid motion in the water below. As the water approaches the foreground, the sun's reflection disperses

and the spaces between the reflective brushstrokes increase. In 1878, the journalist and critic Théodore Duret, echoing Ruskin's opinion of Turner, called Monet "above all the painter of water." Duret noted that previous landscape painters had depicted water in "a fixed and regular way with its 'color of water,' like a simple mirror for reflecting objects ... In the work of Monet ... it is clear, opaque, calm, agitated, running, or still, depending upon the momentary appearance that the artist finds in the sheet of water before which he sets up his easel."[2] Thus, the black silhouettes of the foreground and middle-ground boats produce reflections in the water that are composed of black horizontals interrupted by the grays and purples of the reflected sky and factories.

Monet also juxtaposes factory buildings, steel smokestacks, cranes, and large ships with small boats. We, as viewers, tend to identify with the two figures in the foreground row boat. They are not only nearest to us, but they also observe the industrial forms from our vantage point. Despite being in the foreground, they are small compared with the more distant ships and buildings. We can imagine these figures being somewhat awed by the looming gray shapes before them.

Impression, Sunrise can be considered from an autobiographical point of view, for the harbor represented is Le Havre, in Normandy, where Monet spent his childhood, growing up in a middle-class family. He was born in Paris, but his family relocated to Le Havre in 1845. The transitory moment and the passage of time in *Impression, Sunrise* allude to the artist's past and to the hazy character of early memory. As in a dream, this painting merges a present-day theme with the artist's past to create a memorable impression. Unlike a dream, however, Monet's impression has been transposed into a work of art with wide and lasting appeal. He has transformed his fleeting impressions of childhood into an image of contemporary social change that is affecting the world in which he lives. The lasting impact of *Impression, Sunrise* is a tribute to the artist's genius for merging past with present, and

alluding to the future – in imagination, in style, in content, and in technique.

Monet's father intended that he take over his grocery business in Le Havre, but to no avail – Monet declined and decided to become an artist instead. He began drawing at the age of eleven, and, as an adolescent, became known in Le Havre for his caricatures. He entered a local art school, but moved back to Paris in 1859. There he came into contact with the Barbizon painters and was inspired by their interest in nature and the outdoors. In 1861 Monet fought in Algeria, where he contracted typhoid; his father was then able to buy him out of the army, a practice not unheard-of in France at the time. In 1862, he began studying at the studio of the Swiss Academic painter Marc-Charles-Gabriel Gleyre. Later, in an interview of 1900, Monet expressed his reservations about his teacher. He recalled an incident in which Gleyre admitted that Monet was not bad as a young student, but complained that he had painted the large feet of his model as they were, instead of altering them after antique (meaning idealized) taste. "Nature, my friend," Gleyre admonished his student, "is all right as an element of study, but it offers no interest. Style, you see, style is everything." To which Monet reacted and commented years later: "I saw it all. Truth, life, nature, all that which moved me, all that which constituted in my eyes the very essence, the only *raison d'être* of art, did not exist for this man."[3]

Monet exhibited at the Paris Salon in 1865; but when he joined the group of artists who met regularly at the Café Guerbois, he began to be rejected by the Salon. When the Franco-Prussian War broke out in 1870, Monet moved to England and was exposed to the landscapes of Turner and Constable, which inspired his interest in the effects of outdoor light on color. In London he was also rejected for an exhibition, this time at the Royal Academy.

Throughout his career Monet painted several series of pictures depicting the same subject at different times of day and

in different seasons and weather conditions. In 1877 he exhibited three versions of the *Gare Saint-Lazare* in Paris, eventually adding another nine to the series. All show the interior of the station with trains entering or leaving, emitting smoke that absorbs the light and color of the atmosphere. As with *Impression, Sunrise*, Monet's pictures of trains show effects of the Industrial Revolution, indicating its potential for economic progress while at the same time indicating its adverse impact on the environment.

In the 1880s Monet moved away from modern life subjects toward a more decorative response to landscape. From 1883 to 1886, he painted a series of views of the Atlantic coast at Étretat, in which a sturdy rocky cliff in an arch-like formation juts out into the ocean. Here the artist juxtaposes the static character of the rock with the dynamic movement of the waves. Similar contrasts were created by Monet in his 1890s series of haystacks, which are shown from various angles, casting shadow effects that depend on the time of day and the season – whether in mist, sunlight, sunset, summer, or winter. When a shadow is cast on the snow, for example, Monet demonstrates the Impressionists' observation that there is no white in nature, breaking up the white into the component colors of the spectrum. He also illustrates the fact that shadows are not brown, black, or gray, as they had been represented before Impressionism; instead, he showed that their color depends on reflections of surrounding color. In a letter to a friend, written in 1890, Monet describes his aims in the haystack series: above all, he wrote, he sought "instantaneity," and was frustrated by the fact that he tried to capture a series of effects, but the sun goes down so fast that he had trouble following it.

Another series, dating from the 1890s, represents Rouen Cathedral, in northern France. In every case the Gothic building is cropped and shown in close-up view so that we see little of its setting. The cathedral recedes diagonally, which contributes to the fluid play of light and color that appears to be in constant motion as it would appear in reality. In *Rouen Cathedral, End of Day, Sunlight Effect* of 1894 (**figure 41**), for example, the surface

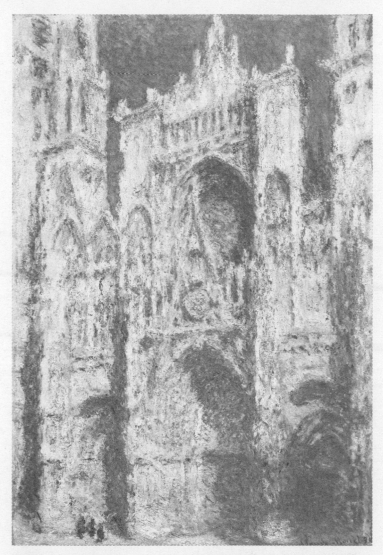

Figure 41 Claude Monet, *Rouen Cathedral, End of Day, Sunlight Effect*, 1894, oil on canvas, 39 3/8 x 25 5/8 in (100 x 65 cm). Musée Marmottan, Paris, France. (Source: Wikimedia Commons)

of the cathedral is bathed in a reddish-yellow light. The yellows mingle with grays, purples, and oranges and become darker where areas of the façade recede. Dabs of white seem to catch the remaining light as the day begins to wane, but the richness of the façade is retained and the sky is still a clear blue. Monet does not depict details of the Gothic sculpture, which have been replaced by prominent brushstrokes; the architecture has become an armature on which he structures light and color.

That same year, Monet painted another work in the series: *Rouen Cathedral, the West Portal and the Tour d'Albane, Harmony in Blue.* Here, as the title implies, the artist participates in the late-nineteenth-century vogue for harmonizing color, just as a musician harmonizes sound. The light in this work is more subdued than in *Sunlight Effect,* and the canvas is dominated by blues, grays, and purples. Where the façade recedes, there are passages of intense orange, especially in the central portal. In the rose window, on the other hand, a predominant darker purple has absorbed the blues and yellows. The sky is a soft blue-gray, which harmonizes with the colors of the cathedral.

In the series of Rouen Cathedral, the past is again merged with the present, though in a different way than in *Impression, Sunrise.* Not only does Monet show us the fugitive quality of light and color, but it is also significant that the subject is a Gothic cathedral. The fleeting effects of color, and of light and shadow, produce a contrast with the lasting character of the cathedral – a reminder of the medieval Catholic history of France. Monet's technique of applying paint is new and contemporary, contrasting with the static and unchanging nature of the building.

Monet struggled financially for much of his career. It was not until the 1890s that he could buy a house and some land at Giverny, in Normandy – thanks in large part to the efforts of Durand-Ruel. Giverny provided Monet with inspiration for his late work. Among the subjects that occupied him was his garden at Giverny with its small Japanese bridge over a water lily pond. From the dawn

of the twentieth century until his death in 1926, Monet's fortunes improved and his standard of living became increasingly comfortable.

Édouard Manet

Manet's upper-class family relieved him of the financial stress experienced by Monet and other Impressionists as they confronted a public and critics who disdained their work. Manet's mother came from a well-connected family of diplomats, and his father was a judge who assumed that their son would be a lawyer. But Manet insisted on a career in art, which he studied in Paris from 1850 to 1856, when he opened his own studio. He traveled to Holland, where he was impressed by the Dutch Baroque painter Frans Hals, as well as to Germany and Italy. In Spain, the artists who most influenced Manet – especially his early work – were Velázquez and Goya.

Having worked as a Realist during the 1860s (see **figure 27**), Manet expanded his color palette in the 1870s and developed an Impressionist style. In *The Railway* of 1872–1873 (**plate 8**), his subject, which also interested Monet, is the Gare Saint-Lazare. The Salon of 1874 accepted Manet's picture, though predictably some critics were puzzled by it. In the view of one critic, who apparently preferred the vapid and voluptuous nudes of the Academy, Manet's figures appeared "cut out of sheet-tin."[4] In this observation, the critic echoed Courbet's pronouncement that *Olympia* was too flat; it reminded him of a playing card (see p. 86).

The railway, a sign of changing times, of speed and travel, of mechanization and industry, had considerable appeal for the Impressionists interested in social and technological developments of the nineteenth century. Whereas Monet depicts trains chugging in or out of Saint-Lazare, Manet does not show us the train. Instead we see only its white steam filling the

background. In the foreground, a seated woman looks up from her book, as if just noticing the viewer. A young girl, possibly her daughter, stands with her back to us, gazing through an iron grille toward the steam. The figures are united partly by color (the buttons on the woman's jacket match the purple sash worn by the girl), partly by proximity to each other, and partly by staged contrasts. The woman's hair falls over her shoulders, her dress is a dark blue, red flowers adorn her hat, and a white dog rests against a closed red fan. The girl wears a white dress shaded in blue that is accented by a large purple sash, and her hair is tied up in a bun. By turning her back to us, she displays the color and silk texture of her dress, which echoes the white of the steam.

Manet juxtaposes sharp light–dark contrasts with the billowing steam and the soft textures of the figures. The bars create a pattern of dark verticals against light as the steam absorbs form and blocks our view. The woman is darkly dressed, whereas the young girl is mainly in white. Two generations are also juxtaposed, for the girl metaphorically turns her back on the present and stares, as if through confining prison bars, into a future of speed and mechanized travel embodied by the train.

Manet also painted erotically charged scenes of modern life in cafés and brothels, as well as performers such as actors, dancers, and musicians. In his *Corner of a Café-Concert* of 1879 (**plate 9**) he depicted a scene of modern leisure. His sketchy brushwork blurs the figures in the middle ground, creating the impression of movement. In the foreground, we confront the back of a man smoking a pipe and gazing at the highlighted dancer at the upper left. His blue smock identifies him as a laborer who has stopped by the café after work. His implied line of sight leads our eye to the gray bowler hat of a more elegantly dressed customer and contrasts with the gaze of the waitress. These three figures are linked by their pyramidal form, which is echoed by the triangles of the dancer's skirt and torso. The sharp diagonal of the

counter leads our eye past the heads of the two men to that of the waitress. She, in turn, informs us that something off to the right has caught her attention. In addition to these repeated juxtapositions of visual direction, Manet contrasts the fluid quality of the beer and its foam with the sharply silhouetted hatband and the flattened light of the ballerina. There is a lot of formal activity crowded into a confined picture space, just as the blurring and diagonals of the wind instruments, bows, and cello-player at the far right create a sense of musical rhythm.

Edgar Degas

Degas had a somewhat contentious personal relationship with Manet, but shared his wide range of subject matter and approach to paint application. Like Manet, Degas was well educated and came from a financially comfortable bourgeois family. His French father was a banker and his mother was a native Creole from New Orleans. Like Manet, Degas was expected by his father to study law, which he did after receiving his baccalauréat in literature. But, as with most artists, Degas' talent showed itself early and, by the age of eighteen, it was clear that his future lay with art. In 1855 he met Ingres, whom he greatly admired, and enrolled in art school. The following year Degas went to Italy and spent three years studying Renaissance art. Early in his career, Degas painted portraits, which he continued to produce until the end of his life, and historical subjects, which he soon renounced in favor of Impressionist scenes. He shared the Impressionist interest in Japanese prints (see box, p. 129), but not the practice of *plein air* painting, as he preferred to work indoors.

After the Franco-Prussian War, Degas visited relatives in New Orleans and produced a number of pictures inspired by what he saw there. In *A Cotton Office in New Orleans* of 1873, Degas shows

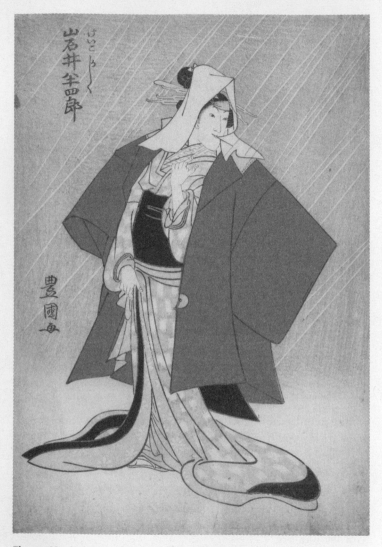

Figure 42 Utagawa Toyokuni, *The Kabuki Actor Iwai Hanshiro V as the Entertainer (Geiko) Kashiku*, 1808, 15 1/8 x 10 1/8 in (38.5 x 25.9 cm). Art Gallery of South Australia, Adelaide, Australia. (Source: Wikimedia Commons)

UKIYO-E: PICTURES OF THE FLOATING WORLD

Ukiyo-e refers to a genre of **woodblock prints** produced in Japan between the seventeenth and early twentieth centuries. The term literally means "the floating world," that is, a realm of evanescent, fleeting beauty and worldly pleasures. The subject matter of the prints consisted primarily of scenes of entertainment – festivals, theater, *kabuki* and *noh* actors, *geishas*, *oirans* (courtesans), tea houses, and brothels. Landscape became popular only in the nineteenth century with prints such as *The Great Wave* by Katsushika Hokusai (1760–1849) and Utagawa Hiroshige's (1797–1858) *Thirty-Six Views of Mount Fuji* and *100 Views of Edo*.

The golden age of Japanese print making occurred during the Edo Period (Edo being the old name for Tokyo), which lasted from the early seventeenth century to 1868. At this time, Japanese society was feudal and isolated from the rest of the world. Military and political power was controlled by the *shoguns*, warrior-dictators appointed by the emperor. In urban areas such as Edo, however, the mercantile class became interested in literature and the visual arts, a taste that was satisfied by woodblock printing. Publishers commissioned artists to create images which were then produced in multiples and sold to middle-class patrons.

With the opening up of trade with Japan and the exhibitions of woodblock prints in Europe, *ukiyo-e* prints became popular in the West. Following the Paris Universal Exposition of 1867, artifacts produced by non-Western cultures became more popular in Europe and increasingly influenced taste. The term *japonisme*, coined in 1872 by a French critic, reflected the increasing appeal of Japanese woodblocks, especially among artists and collectors. As a group, the Impressionists became interested in the woodblocks of the Edo period. Impressionist subject matter shared many features – such as entertainment scenes, silhouettes, varying weather conditions, and patterning – with *ukiyo-e*.

Woodblock printing was a complex process requiring years of training and precise workmanship. First, a master artist made an ink drawing, which an assistant traced onto a separate sheet of paper. The tracing was glued, face-down, onto a wood block and the areas where the paper was blank were cut away, leaving a relief print of the image in reverse. Then the block was inked and multiple copies of the original image were printed. At first the prints were **monochrome** (consisting of a single color), but by the seventeenth century **polychrome** prints could be made. The first polychrome prints were made using multiple blocks. The raised portions differed

from block to block and the final print was produced by sequentially pressing the blocks, each inked in a different color, onto the paper. If done properly, the contours of each block matched exactly, so that there was no overlapping or empty space.

Figure 42 by Utagawa Toyokuni (1769–1825) represents the Kabuki actor Iwai Hanshiro as the geisha (female entertainer) Kashiku. In addition to its content, the print shares with Impressionism an emphasis on silhouetted form, as seen in the hair and facial features as well as in the **calligraphy**. The diagonal tilt of the actor is stabilized by his dominating vertical and by the vertical arrangement of the Japanese characters at the left – an arrangement that is similar to the spatial construction of many Impressionist paintings. The crisp edges of the figure indicate the areas of separation between the individual blocks of color.

a group of workers in black suits silhouetted against the lighter background with cropped viewpoints. These features, as well as the slanted floor and partial space of the work room, suggest a candid photograph that has captured the figures unawares. All focus on what they are doing and seem oblivious to the viewer's gaze.

Degas' interest in photography is also evident in his *Vicomte Ludovic Lepic and His Daughters (Place de la Concorde)* of 1875 (**figure 43**), in which he took up the theme of the *flâneur*. Here we are at the Place de la Concorde, the wide square visible beyond Lepic and his daughters. Their poses are clearly staged, but at the same time they appear to be casually strolling through the open urban space. Lepic leans forward with his hands behind him, puffing on a cigar that tilts upward, emphasizing his aloof air, and carrying under his arm an umbrella that extends downward toward the girl at the right. She mirrors his haughty expression as she raises her chin very slightly and seems to be literally "looking down her nose" in the opposite direction. In the center foreground, her back to her father, Lepic's other daughter looks to the left, as does the family's well-groomed dog (Lepic was a breeder of dogs).

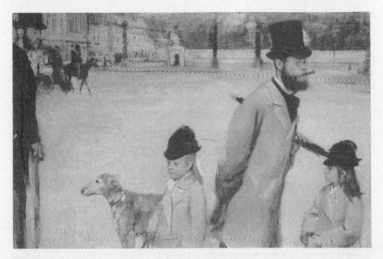

Figure 43 Edgar Degas, *Vicomte Ludovic Lepic and His Daughters (Place de la Concorde)*, 1875, oil on canvas, 31 x 46 1/4 in (78.7 x 117.6 cm). Hermitage Museum, St Petersburg, Russia. (Source: Wikimedia Commons)

The staging of these figures is formally calculated to suggest the back-and-forth movements of the city street. At the far left, the movement comes to an abrupt halt with the cropped man at the edge of the picture, whose vertical repeats that of the lamp posts across the square. Judging from his attire, he is not an aristocrat, but rather an ordinary pedestrian and thus distinct from Lepic the *flâneur*. In the distance, in contrast to the static pose of the cropped figure, is a horse-drawn carriage that is a visual echo of Lepic. The horse, one of Degas' favorite subjects, also seems to be strolling; its diagonal forelegs, which are placed firmly on the ground, tell us that its pace, like Lepic's, is a leisurely one.

Compared with Caillebotte's *Rainy Day*, Degas' *Lepic* is more Impressionist in its textured, though restrained, brushwork and seems more consciously staged. Both works exemplify the Impressionist theme of the *flâneur*; both make use of the cropped

viewpoint to suggest the spontaneous vision encapsulated in a candid camera-like image; and both contrast sharp, silhouetted edges with a more painterly depiction of atmosphere.

In addition to scenes of urban life, Degas was attracted to the contrast between form in motion and static form, and for this theme his most typical subjects were ballerinas, musicians and ballet masters, and horse races. In his paintings of horse races, Degas juxtaposed horses running, stopping, waiting impatiently to start, and turning abruptly, controlled to different degrees by their jockeys. In *Foyer de la danse à l'Opera de la rue Le Peletier* of 1872 (**figure 44**) Degas depicts a ballet master in a white suit and a seated musician with a group of ballerinas. The latter occupy a variety of poses, stretching, standing, walking, and sitting. The room itself is cropped with an open door at the left and a large

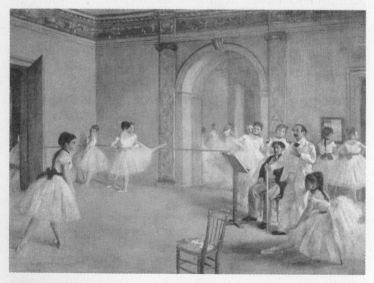

Figure 44 Edgar Degas, *Foyer de la danse à l'Opera de la rue Le Peletier*, 1872, oil on canvas, 12 7/8 x 18 1/4 in (32.7 x 46.3 cm). Musée d'Orsay, Paris, France. (Source: Wikimedia Commons)

mirror at the center that extends the space visually and reflects the dancers. Their softly textured white costumes stand out from the dark silhouettes of the coiffures and the coat of the seated musician. The sharpest color accents create a visual unity – for example, the oranges that are repeated in the sash at the far left, the barre, the fan on the chair, and in the signature of the artist himself. In the pink shoes worn by the dancers we see a combination of the whites of the costumes with the red barre, which further contributes to the chromatic unity of the work.

The cropped figures suggest a candid viewpoint, accentuating the tilting of the floor, as if the photographer (or the painter) has not taken the time to center and stabilize the composition. Another effect of the diagonal floor is the division of the picture space into two large trapezoids – the back wall and the floor. The potential instability of the image is anchored by the architectural verticals, echoed in the music stand and the cane of the ballet master. Also functioning as a stabilizing form is the cropped chair in the foreground that stands in place of the viewer observing the scene.

Degas painted many pictures of ballet dancers on and off stage, and spent long hours studying them from the wings of the theater. He made wax models of ballerinas, but exhibited only one bronze – during the 1880s. In these works, he retained the textured surface of unpolished bronze, which can be seen as a sculptural equivalent of Impressionist brushwork.

When Degas turned to intimate interiors of women bathing, his gaze became inseparable from his subjects. The intensity of his gaze transfers itself to the viewer, who is made to see as intently as he did. That focus became part of the meaning of his images. We can see this, for example, in the charcoal drawing *After the Bath, Woman Drying Her Hair* of around 1893 to 1898 (**figure 45**). A nude woman is shown in three-quarter view from the back, having just emerged from a bath. She sits on one towel and dries her hair with another. Her contours are well defined with

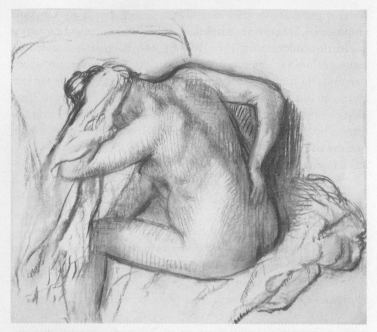

Figure 45 Edgar Degas, *After the Bath, Woman Drying her Hair*, c.1893-1898, charcoal on tracing paper, 24 3/8 x 27 1/4 in (62 x 69.3 cm). Kimbell Art Museum, Fort Worth, Texas. (Source: Wikimedia Commons)

hatching and cross-hatching lines, and areas of multiple outlining indicate her movements. The fact that we see her in such an intimate setting and that she does not see us affects the character of our gaze. We seem to be intruding on her space, uninvited, engaging in a kind of secret, even forbidden viewing that contains an element of voyeurism. By virtue of Degas' staged voyeurism, the viewer sees something sexually charged and is caught off guard. In *Foyer de la danse*, Degas plays with the theme of partial seeing and not seeing in the different viewpoints of the dancers, especially the partial figure glimpsed through the door on the left. In *After the Bath*, we see the back, but not the front of the figure.

By creating an iconography in which seeing and not seeing are emphasized, Degas reveals sexuality, while also keeping it a secret.

In the ballerinas and the bathers, Degas created a world of intimate looking that borders on being, but never becomes, perverse. He transforms voyeurism into art, and makes the viewer aware of the fine path he has trodden between the two. That Degas considered art itself an eroticized pursuit is clear from his often-cited statement in a letter published in 1879: "Art is vice; one doesn't marry it legitimately, one rapes it!" (*"L'art c'est le vice, on ne l'épouse pas légitiment, on le viole!"*).[5]

Camille Pissarro

Pissarro (1830–1903), who painted peasants in the countryside as well as views of Paris, was born in the Danish West Indies on the island of Saint Thomas (now part of the U.S. Virgin Islands). His father came from a Portuguese-Jewish family and his mother, like Degas', was a native Creole. Pissarro's father wanted him to make a career in business, but his attraction to art was inescapable. He spent a few years at school in Paris and then in 1847 returned home. At twenty-one, he went to Caracas, Venezuela, and worked as an artist there for two years before settling permanently in Paris in 1855. He studied, among others, with Corot, who influenced his interest in *plein air* landscape painting, especially of rural settings and peasants. Eventually, however, Pissarro's landscapes would become more typical of Impressionism in their range of bright color, and short, somewhat blurred dabs of paint that capture the fleeting qualities of nature.

During the Franco-Prussian War, Pissarro took his family to the village of Upper Norwood, outside London, where he met Durand-Ruel. Like Monet, Pissarro studied the landscapes of Turner and Constable. After the war, Pissarro returned to England several times, painting rural and urban scenes, which

were influenced by Turner and Constable as well as by Impressionist brushwork and new ideas about light and color. Pissarro became something of a father-figure to several contemporary artists, who revered him for his influence on their style as well as for his encouragement and advice. He was a driving force behind the Anonymous Society of Painters, Sculptors, Engravers, Etc. and showed his own work in all eight of the Impressionist exhibitions held in Paris between 1874 and 1886. But not everyone approved of Pissarro embracing Impressionist ideas. After the second Impressionist Exhibition in 1876, the art critic for the Paris newspaper *Le Figaro*, Albert Wolff, bemoaned the fact that Pissarro's trees were violet and his skies the color of butter.

Pissarro's *Gelée blanche, ancienne route d'Ennery, Pontoise* (*Hoarfrost, the Old Road to Ennery, Pontoise*) of 1873 represents a landscape near his home in Pontoise outside Paris. Shown at the First Impressionist Exhibition, the painting conveys Pissarro's Impressionist interest in the effects of nature. The scene is illuminated by a relatively clear sky spotted with scattered clouds shifting across the landscape. As was typical of the technique of some Impressionist painters, Pissarro painted with dabs of color, in this case oranges, greens, browns, whites, and blues. In different areas of the landscape, different colors predominate, though all are present throughout the canvas. Cutting across the entire field are shadows of tall tree trunks that change color according to the field's surface; the narrowness of the shadows indicates that the trees are poplars. Given that Pissarro was an anarchist, it is possible that the shadows are a veiled political allusion, for the poplar (*peuplier* in French) had been the "people's tree" during the French Revolution. (Monet, whose political sympathies lay with the republicans, frequently painted poplars as well.)

Pissarro, who was raised in the clear air of the Caribbean, was drawn to outdoor scenes and peasant themes. In the *Gelée blanche*, the only figure represented is a peasant endowed with the "romantic" quality of becoming one with nature. He is also a

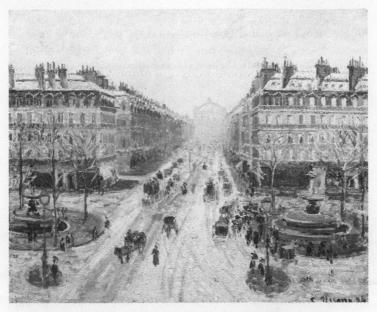

Figure 46 Camille Pissarro, *Avenue de l'Opera, Effect of Snow*, 1898, 21 1/4 x 25 1/2 in (54 x 65 cm). Private collection. (Source: Wikimedia Commons)

common worker, with whom the artist identified and to whom he gives no identity beside the fact that he trudges through the field carrying a load of wood.

Another theme that appealed to Pissarro was the grand view of a Paris boulevard. In *Avenue de l'Opera, Effect of Snow, Winter Morning* (**figure 46**), the viewpoint is elevated, offering an expansive view of the boulevard with Charles Garnier's Opera in the distance. Built in the Baroque style, the architecture of the Opera combined a lively façade with a ground floor arcade, second-story columns, and an ornate entablature. As a place of spectacles enjoyed by different classes of society, with entrances corresponding to each class of ticket-holder, the Opera exemplified the notion of modern life in nineteenth-century Paris. As

with Monet's Cathedrals, Pissarro does not depict the sculptural details of the Opera, and its structural elements are blurred by distance and early morning haze in the snow. The merging of brushstrokes simulates the effects of light and shadow and the repeated colors diminish in intensity as they recede into the distance. Animating the entire scene are the patterns of windows, of people and horse-drawn carriages, and the shadows that they cast. The buildings on either side of the street and the large circular fountains frame the thrust into the distance. Pissarro conveys the sense of hurrying crowds and a cold nip in the air. The figures, with their patterned effect, have no individual identity, like the peasant in the Pontoise landscape.

Both the cityscape and the landscape are consistent with Pissarro's advice to a young artist that nature should be his inspiration. He recommended that the subject be observed "more for shape and color than for drawing … Precise drawing," Pissarro said, "is dry and hampers the impression of the whole; it destroys all sensations. Do not define too closely the outlines of things; it is the brush stroke of the right value and color which should produce the drawing."[6] Pissarro further advised young artists to paint the essence of their subjects and not to be distracted by technique. Paint, he said, should be applied with small dabs of the brush and impressions placed immediately on the canvas. "Don't proceed according to rules and principles, but paint what you observe and feel … it is best not to lose the first impression … One must have only one master – nature; she is the one always to be consulted."[7]

Pierre-Auguste Renoir

Renoir began his career in Limoges, his native city, where as a boy he decorated porcelain objects. In 1862 he studied art at the École des Beaux-Arts in Paris; he met Monet and the two

artists became friends. In 1869, they worked together at La Grenouillère, a popular bathing area with a floating café outside Paris. Each artist produced a painting of the subject. As is characteristic of their respective styles, Renoir's version is composed of softer, blurrier brushstrokes, whereas Monet's are more distinct.

Renoir's poverty, like Monet's, made it difficult for him to buy paint supplies, despite showing his pictures in the Impressionist exhibitions. But by 1874 his fortunes had begun to improve, partly because of Durand-Ruel. In the early 1880s, inspired by his admiration for Delacroix, Renoir also went to Algeria. In Spain and Italy Renoir studied Velázquez, Raphael, and Titian. And like Monet, Renoir studied with Gleyre and joined the artists who met at the Café Guerbois.

Determined to convey accurately the character of light and color in nature, Renoir observed that "white does not exist in nature ... White and black are not colors." About the appearance of snow, he added that "you have a sky above that snow. The blue must show up in the snow ... no shadow is black. It always has a color. Nature knows only colors."[8] Renoir summed up his notion of the grammar of art in the term *irregularity*, which he applied to nature. An orange, he said, like the earth, is not perfectly round; no two leaves are identical; one period of history cannot repeat another one. As with all the Impressionists, he calls nature the real master of the artist – "never copy anything except nature."[9] Renoir recommended observing the way Japanese artists represent birds and fish; they watch their movements until they can finally depict them accurately.

Renoir's view of light and color is well illustrated in *The Swing* of 1876 (**plate 10**), which was shown in 1877 at the Third Impressionist Exhibition and is typical of the artist's style in its soft brushwork and largely pastel palette. The flickering shadows reflect Renoir's observation that nature is composed of color and devoid of black and white. As light filters through the foliage, purple-gray patches of shadow animate the surface of the ground.

Patterns are consciously created not only in the shadows, but also in the light patches on the man's suit and the ribbons on the woman's dress. In the background two couples are barely visible in the shadow of the trees.

Renoir's *Swing*, like Monet's *Impression, Sunrise* and Degas' erotic viewpoints, is a reminder of the significance of Impressionist content and the fact that it is often inseparable from an artist's technique. Renoir's *Swing* is filled with erotic tension, the power of the gaze, and emotional ambivalence. The tension inherent in the shifting color and light is echoed in the man and woman facing each other on either side of the swing. He looks at her; she looks away. His hand is just below hers on the left, but she seems to be pulling away from him to the right, while at the same time reaching in his direction to the left. The iconographic implication of the swing is the man's erotic intentions, to which the woman appears unsure how to respond. The motif of the swing, with its sexual allusions (compare "the swinging sixties"), both joins and separates them, while the presence of the little girl watching them reinforces the erotic gaze of the viewer. Renoir has added another layer of looking in the man on the other side of the tree; he looks out of the picture at the viewer, watching us as we watch them. The very blurring of form in this picture causes the viewer to try and focus on what may not be entirely clear at first glance. As a result, the technique of blurring merges with, and enhances, the content.

Although Renoir made his living mainly from portraiture, he was always interested in the volume and modeling of the female nude. In the nineteenth century, the Classical theme of the reclining nude was sometimes transformed into a harem girl or odalisque, as was the case with Ingres' *Grande Odalisque* (see **figure 8**) and Delacroix's North African odalisques. Taking a leaf from this vogue for Orientalism, in 1870 Renoir painted his young mistress, Lise Tréhot, as *A Woman of Algiers*. This picture is a swirl of exotic oriental patterns and warm color, with a still

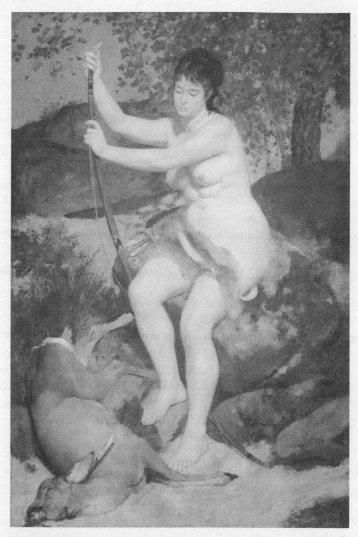

Figure 47 Auguste Renoir, *Diana*, 1867, oil on canvas, 77 1/2 x 52 in (199.5 x 129.5 cm). National Gallery, Washington, D.C. (Source: Wikimedia Commons)

life at the far left. The languid, seductive pose, parted red lips, half-closed eyes, and silky textures are calculated to beckon the viewer into an erotically charged space.

When the Salon rejected an 1867 nude portrait of Lise, Renoir altered the picture and transformed her into the moon goddess Diana (**figure 47**). Renoir posed Lise on a fur, which he draped across her legs, and added a bright pink ribbon. He gave her a bow, and at her feet he placed a dead deer – the deer being one of the goddess's attributes – with an arrow embedded in its neck. The choice of Diana the huntress reveals Lise's seductive power over the artist. In myth, Diana exacts revenge on men who see her nude; here she gazes wistfully at the deer she has just killed. The erotic ambivalence of *The Swing* and the seductive odalisques are thus repeated in mythological form in the *Diana*.

The critic Albert Wolff, who objected to the purple trees and butter-yellow skies of Pissarro, insulted Renoir's nudes by comparing their skin to decomposing flesh. Most likely it was Renoir's technique of breaking up the colors of the spectrum to depict the surfaces of their bodies rather than of applying a single flesh color that irritated Wolff. We can see this in the *Diana* by looking closely at her raised arm where there are patches of color visible on the surfaces of her arms and legs. Renoir's color thus literally "decomposes" so that the flesh is rendered as multiple individual colors rather than as what Wolff thought he perceived in nature as a single "flesh color."

Women as subjects and artists: Morisot and Cassatt

From the 1870s, more women were becoming professional artists. They had been, and still were, excluded from studying at the École des Beaux-Arts, on the grounds that men and women should not study nudes from life in the same classroom.

Nevertheless, for the first time in Paris, several teachers opened studios that admitted women together with men. But social interchange for upper-class women remained restricted, which seems to have influenced their subject matter more than their style. In general, works painted by women dealt primarily with domestic activities, women attending social events, women boating together, and women with children. Their male contemporaries painted a wider range of society – from prostitutes and peasants to doctors, lawyers, actors, politicians, and aristocrats. Berthe Morisot and Mary Cassatt, however, limited their subjects to the bourgeois classes, especially women, and often convey a sense of confined space, reflecting the social restrictions experienced by their subjects. It is clear from the paintings of Morisot and Cassatt that women painted by women were shown differently than when they were painted by men; both artists painted mothers with children throughout their careers.

Morisot was born in Bourges, in 1841, to a wealthy bourgeois family that moved to Paris when she was a child. There Morisot studied drawing privately, but exhibited with the Impressionists and in 1874 married Manet's brother; their daughter, Julie, became a frequent subject of Morisot's pictures. In *Au Bal (At the Ball)* of 1875, both the title and the formal attire of the woman indicate that she is out in the world of society. Wearing a low-cut dress and eyeing someone or something we do not see, she seems to be waiting for a dance partner. She peers out from behind a fan, denoting both modesty and seduction, for her fan may be open or closed, and can reveal or hide what is behind it. This particular fan is decorated with blurred forms that are difficult to make out, but in one section there appears to be a man seated on the bed of a nude woman. As with Renoir's *The Swing*, the very fact of blurring forces us to focus close attention on an ambiguous form, arousing our curiosity and inviting us to look at what might otherwise elude our attention. The fan seems calculated to express the ambivalence of the woman vis-à-vis her situation –

the woman shields herself with the fan, but also scans the scene before her. The slightly sullen expression and subdued color suggest displeasure with being socially circumscribed. Flowers in the background, on her hair, and on her dress, signify her sexual self; she is simultaneously on display and modestly posed. Since she is formally restricted within the space of the picture, we do not see her context, and she is constrained by the boundary of the painting as well as by social boundaries.

In Morisot's *Summer's Day*, of 1879, two women in a boat glide by a group of ducks in the Bois de Boulogne (**figure 48**). The style is typically Impressionist in the visibility of the brush-strokes, the reflections in the water, the cropped figures, and the fact that we see people leisurely strolling in the distance. The color relationships are tightly organized around greens and their component yellows and blues. The structure of the boat is equally tight; it forms a sharp triangle of space confining the women. Despite being outdoors, Morisot's women are limited by the space of the small boat. They are shown in close-up view; they are not rowing the boat and we do not see who is. The woman facing us emphasizes the fact of her confined space by a stiff-ened pose, suggesting that she is aware of being looked at. The other woman gazes wistfully at the ducks, which seem to have more freedom than she does. Morisot's women are not languid or seductive like the nineteenth-century odalisques, nor challenging like Manet's Olympia. They are fully and properly clothed, their posture and bearing conform to bourgeois propriety, and their activity is socially acceptable.

Mary Cassatt came from a wealthy family in the Pittsburgh suburb of Allegheny City. Her father was a stockbroker and her mother's family was in banking. As with most of the male Impres-sionists (but unlike Morisot, whose sister also became an artist), Cassatt's family objected to her choice of an artistic career. Her father insisted that she earn enough from her work to finance her own art supplies and study. Despite her father's resistance,

Figure 48 Berthe Morisot, *Summer's Day*, c.1879, oil on canvas, 18 x 29 5/8 in (45.7 x 75.2 cm). National Gallery, London, UK. (Source: Wikimedia Commons)

Cassatt continued to pursue her chosen path, first attending the Philadelphia Academy of Art and later studying in Paris. In 1874, after traveling around Europe, she made Paris her permanent home. She declined to study in an official French art academy, to which acceptance remained difficult for women. Instead, she obtained a permit to become a copyist at the Louvre and studied privately with several individual painters. Cassatt met Degas, who saw her work in 1874 at the Salon, and he invited her to show her work at the Fourth Impressionist Exhibition of 1879.

Attuned to the contemporary position of women in society and in the arts, Cassatt believed in suffrage for women. Her liberal views were reflected in her support for Dreyfus as well as in her feminist inclinations. She was well aware that women artists were more accepted in France than in the United States. "After all, give me France," she wrote in a letter to a friend. "Women do not have to fight for recognition here if they do serious work."[10] Cassatt's subject matter, like Morisot's, addresses

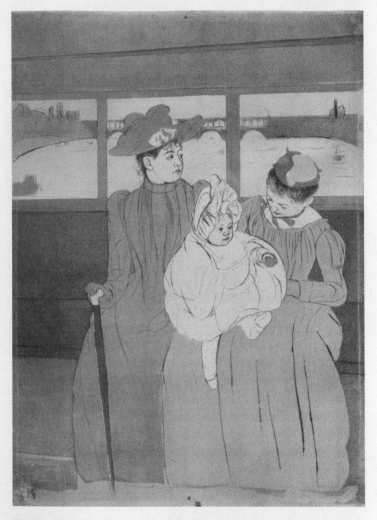

Figure 49 Mary Cassatt, *In the Omnibus*, 1890–1891, drypoint and aquatint on laid paper, 14 3/8 x 10 1/2 in (36.5 x 26.6 cm). National Gallery of Art, Washington, D.C. (Source: Wikimedia Commons)

the position of women in nineteenth-century Paris. One of her most pervasive subjects was women and children, though she herself was single and childless. A good example of this theme can be seen in her *In the Omnibus*, a lithograph of 1890 to 1891 (**figure 49**), which shows the influence of her good friend Degas and of Japanese woodblock prints. Like Degas, Cassatt devoted much of her artistic energy to pastels and prints, especially etchings. Here the image is composed of fine lines and flattened, unshaded color. The tight organization of the print suggests that even when women are out and about in Paris, a sense of restriction remains. Two women, framed (and visually confined) by the verticals of the windows, sit primly inside the bus as the city of Paris spreads out in the distance. The upright woman on the left gazes toward the right, her walking stick reinforcing the stiffness of her pose. The other woman attends to the infant girl on her lap, an example of the pervasive mother–child iconography in Cassatt's pictures. All three females are wrapped in coats, gloves, and hats, leaving only their faces visible. Even though they ride a modern bus, they appear to be imprisoned by their attire, as well as by the interior space of the bus.

Americans in and out of Paris

Paris drew a number of American artists to the Impressionist style. Mary Cassatt took up permanent residence there, as did Henry Ossawa Tanner (1859–1937), who studied art in Paris and exhibited with the Impressionists. James McNeill Whistler (1834–1903) spent time in Paris, but settled in London.

Tanner was drawn principally to two types of subject matter: the everyday life of African-Americans and biblical scenes, though he also painted landscapes and portraits. He shared the Impressionist interest in visible brushwork, chromatic harmony,

interior lighting, and blurred form, but his content draws on his African-American heritage. In the Paris Salon in 1894, he exhibited his *Banjo Lesson* of 1893 (**figure 50**), a genre painting that transcends genre by virtue of its spiritual quality and psychological insight. The sense of communication between the old man and the young boy echoes their emotional bond, which is accentuated by the diagonal of the banjo – a formal, psychological, and musical sense of union.

Tanner's figures are silhouetted against the white light on the back wall and tablecloth. Visible textures soften the forms and simulate the wood grain of the floor boards, the old shoes, and the casual attire. The slight blurring of the boy's hand on the banjo and the clarity of his face reveal his intense concentration as he strums the instrument. The slanted floor, a hallmark of Impressionist spatial construction, contrasts with the solidity of the old man, and also seems to impart a source of strength to the boy. The dark metal cans at the lower right corner anchor and stabilize the space, just as the verticals of Degas' ballet masters and their canes often stabilize the diagonals created by his ballerinas and his tilted floors.

James McNeill Whistler was born in Lowell, Massachusetts. He attended the United States Military Academy at West Point, but was expelled for, among other things, drawing on the walls. Much of his childhood was spent travelling in Europe; he accompanied his family to Russia, where his father was the engineer for the Moscow–St Petersburg railway. Whistler studied art in Paris, but made London his permanent home, where he supported himself mainly as a portrait painter.

Whistler was a flamboyant, dandified character, who made himself into an art form. He was known for wearing tight shoes with pink ribbons and complaining about having sore feet. He occasionally carried two umbrellas to protect himself from the English rain. He was also a biting wit, and his pamphlet *The Gentle Art of Making Enemies* was calculated to do just that.

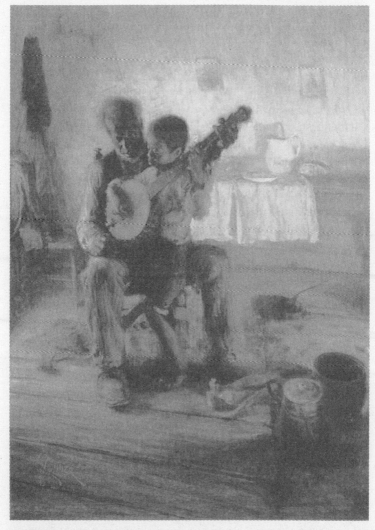

Figure 50 Henry Ossawa Tanner, *The Banjo Lesson*, 1893, oil on canvas, 49 x 35 1/2 in (124.5 x 90.2 cm). Hampton University Museum, Hampton, Virginia. (Source: Wikimedia Commons)

Whistler, like Degas, sexualized the art of painting, as is clear from his frequently quoted statement:

> Drawing, by God! Color is vice, although it can be one of the finest virtues. When controlled by a firm hand, well-guided by her master, Drawing, Color is then like a splendid woman with a mate worthy of her – her lover but also her master – the most magnificent mistress possible. But when united with uncertainty, with a weak drawing, timid, deficient, easily satisfied, Color becomes a bold whore, makes fun of her little fellow, isn't it so?[11]

To the extreme irritation of certain critics, Whistler often gave his works musical titles, such as "Arrangements," "Nocturnes," and "Symphonies," which emphasized their Impressionist quality. Although capable of precise drawing and clear form, as is evident from his etchings, Whistler shared the Impressionist interest in prominent brushwork, texture, and blurred form. But he also worked in a Realist style, especially early in his career when he was under the spell of Courbet. In an etching entitled *Rotherhithe* of 1860, for example, he shows two seamen from a cropped viewpoint engaged in conversation by the edge of a harbor. This work contains a series of blacks ranging from sharp silhouettes to textured surfaces, while the swirling lines in the sky create a slightly ominous mood and suggest the potential danger of the sea.

In *Symphony in White, No. 2: The Little White Girl* of 1864 (**plate 11**), Whistler gives form to Renoir's assertion that there is no white in nature. He infuses the white dress with yellows and blues that are repeated throughout the picture. The girl rests her arm on a mantel and tilts her head so that we see her face in three-quarter view in the mirror. Her red lips harmonize with the bright orange by her left hand, and with the pinks and oranges in the flowers and fan. The blues in the fan likewise harmonize with the blue and white Chinese porcelain vase of

the type Whistler collected. In his taste for Chinese porcelain, Whistler participated in the vogue for *chinoiserie* that, like the interest in *japonisme*, illustrated the growing awareness of non-Western cultures and art styles.

One of Whistler's self-portraits, *Arrangement in Grey: Portrait of the Painter* of 1872, appears rough, for, in addition to the visible textures, the artist has scratched through the paint in certain places. He shows himself as a painter, holding two brushes and peering intently out of the picture. The sharp silhouettes in the hat, tie, and surface behind his hand contrast with the sense of texture. His famous butterfly signature is prominently displayed above his hand, and he has added a scorpion's tail to it, infusing it with complex psychological meaning and creating an image of his divided character. The butterfly alludes to his dandified personality, while the scorpion tail is an echo of the biting wit exemplified in *The Gentle Art of Making Enemies*.

When Whistler exhibited his *Nocturne in Black and Gold: The Falling Rocket* at London's Grosvenor Gallery in 1877, Ruskin called him a Cockney coxcomb who had thrown a pot of paint in the face of the British public. Whistler sued for libel and the resulting trial became a microcosm of the wider conflict between conservative and avant-garde taste in the late nineteenth century. Echoing the French critics of Impressionism, Ruskin objected to the lack of "finish," to the musical titles, and their blurred form. He was convinced that Whistler's paintings were not only hastily and sloppily executed but also overpriced. Speaking for his client, Ruskin's counsel called the musical titles "fantastic conceits," which were "not worthy of the name of great works of art." When Ruskin's counsel asked Whistler to define the term *nocturne*, the artist replied, "I meant to indicate an artistic interest alone in the work ... I have chosen the word *nocturne* because it generalizes and simplifies the whole set of them" (that is, of night pictures).[12] Though Whistler won the case, he was awarded only a farthing in damages and the court costs bankrupted him.

Auguste Rodin

Auguste Rodin (1840–1917) was a prodigious artist and the first great sculptor to emerge among the avant-garde in late-nineteenth-century Paris. Difficult to fit into a neat stylistic category, Rodin has been labeled a Realist, a Naturalist, and, because of his spiritual qualities, a Symbolist (see box, p. 173). He came from a working-class Parisian family and began drawing at the age of ten. From fourteen to seventeen, Rodin attended a school that encouraged the study of art. The first twenty years of his career were spent as a craftsman, earning a living as an architectural decorator. He worked for a few years in Belgium, privately making sculpture that he could not afford to have cast in bronze. When he managed to save some money, he went to Italy, where he was most impressed by the Renaissance sculptors Donatello and Michelangelo. The latter would be a life long influence on Rodin's work, as he had been on Delacroix.

On two occasions the realism of Rodin's early sculpture – a nude male entitled *The Age of Bronze* of 1876 and *John the Baptist* of 1878 – led to accusations that he had cast them from life rather than from a preliminary version that he had modeled, which at the time would have been considered cheating. Critics also objected to Rodin's practice of making incomplete figures – for example, *Walking Man* of 1899 to 1900, which lacks arms and a head. But the German poet Rainer Maria Rilke, who corresponded with Rodin and wrote about his work, disagreed with conservative views of the incomplete figures. "Completeness," Rilke asserted, "is conveyed in all the armless statues of Rodin: nothing necessary is lacking. One stands before them as before something whole."[13] Rilke notes that Rodin's sculptures of single hands have character and life – "Hands that rise, irritated and in wrath; hands whose five bristling fingers seem to bark like the five jaws of a dog of Hell. Hands that walk, sleeping hands, and hands that are awakening."[14]

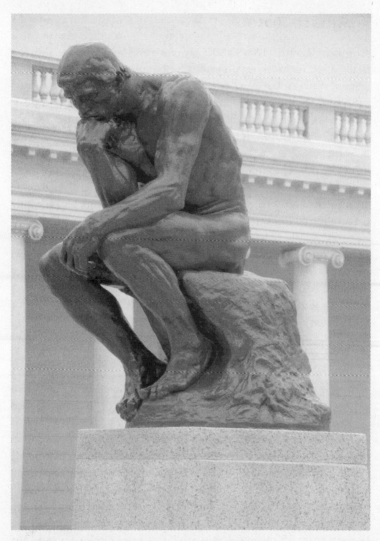

Figure 51 Auguste Rodin, *The Thinker*, 1902–1903, cast in bronze 1904, 72 x 38 x 54 in (182.9 x 96.5 x 137.2 cm). Legion of Honor, Fine Arts Museums of San Francisco, San Francisco, California. (Source: Wikimedia Commons)

Rodin's philosophy of art resembled that of the Impressionists, especially in his belief that nature is the best guide for an artist to follow. In his view, nature provides the "truth of an impression." Ugliness was considered an unfit subject for art, but Rodin argued that "What is commonly called *ugliness* in nature can in art become full of great beauty ... Let a great artist or a great writer make use of one or the other of the *uglinesses*, instantly it is transfigured: with a touch of his fairy wand he has turned it into beauty; it is alchemy; it is enchantment! ... There is nothing ugly in art except that which is without character, that is to say, that which offers no outer or inner truth."[15]

Rodin's early work was relatively naturalistic, generally made from life models, but later in his career he came to be associated with the Impressionist style insofar as he emphasized the surface texture of his sculptures. He made wax models and cast them in bronze; he also produced works in marble. His bronze figure of *The Thinker* of 1879–1889 shows a powerful nude, hunched over and brooding introspectively, as if on a deep philosophical problem (**figure 51**). The massive, muscular body, with its rippling form, is reminiscent of Michelangelo's prophets on the ceiling of the Sistine Chapel. It was the main figure in Rodin's *Gates of Hell*, on which he worked from 1880 to 1917, the year of his death. A commission from the French government, the work consists of a pair of doors destined for the Museum of Decorative Arts in Paris. Inspired by episodes from Dante's *Inferno*, *The Gates of Hell* is filled with contorted, writhing figures that recall the nudes in Michelangelo's *Last Judgment*. It is possible that *The Thinker* depicted Dante, although this is not certain; the figure could just as well be a mythic image of the power of abstract philosophical thought or a self-image of the artist. (Rodin himself referred to the sculpture as "the poet.") Another possible inspiration for the statue is Michelangelo's marble figure of Duke Lorenzo de' Medici (generally dated to the 1520s) in a similar thoughtful pose in the Medici Chapel, in the Church of San Lorenzo, in

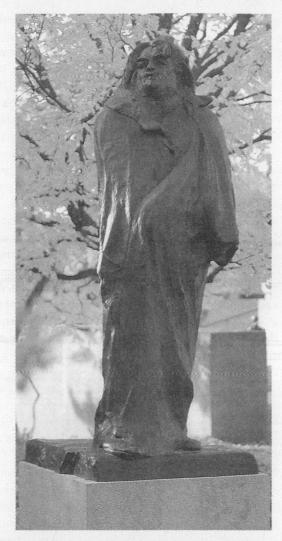

Figure 52 Auguste Rodin, *Monument to Honoré de Balzac*, 1898, cast in bronze 1935, 106 x 48 x 50 in (270 x 120.5 x 128 cm). Museé Rodin, Paris, France. (Source: Jeff Kubina/Wikimedia Commons)

Florence. Made for Lorenzo's tomb, the figure has been nick-named *Il Penseroso*, meaning "The Thoughtful One."

In 1891, the French Society of Men of Letters commissioned Rodin's most famous portrait (**figure 52**). It was a representation of the French author Honoré de Balzac (1799–1850) – first rendered in plaster and cast in bronze only after the artist's death. As with the sculptures of Degas, the *Balzac* has a textured surface that enhances and energizes the dynamic character of the portrait. In both the plaster and bronze versions of the *Balzac*, Rodin seems to have left the figure unfinished, as if it is in the process of being created. The *Balzac*'s head turns to one side, seemingly surveying modern life unfolding before him. The figure is enveloped by a heavy cloak, the monk's robe that Balzac typically wore while writing, to emphasize the solitary life of a novelist. The statue was described by one critic as a bathrobe with a mask for a head. Others declared that it resembled a penguin, a snowman, or a sack of flour. A giant of French literature, Balzac's *La Comédie humaine* described in ninety-one novels, stories, and essays the broad panorama of life in the Paris of his time. Like Rodin, Balzac adhered to Baudelaire's recommendation that art depict modernity.

5
Post-Impressionism

Post-Impressionism – a term coined in 1910 by the influential English artist and art critic Roger Fry (1866–1934) in the title of an exhibition of modern French painters (*Manet and the Post-Impressionists*) – literally means *After Impressionism*. It has come to refer to the work of the generation of artists who followed the Impressionists, but there is disagreement as to the precise application of the term *Post-Impressionist*. Fry saw the Post-Impressionists as more individualized than the Impressionists, not sharing a particular style as the Impressionists had. Today some art writers consider any art made in late nineteenth-century France to be Post-Impressionist, others include non-French artists, and still others take a more limited view, focusing mainly on van Gogh and Cézanne.

Post-Impressionist art is associated with subjectivity, expressive qualities, and imagination, foreshadowing twentieth-century abstraction. In the view of the Post-Impressionists, their Impressionist predecessors produced work that was too "realistic" and had not been sufficiently imaginative in their use of line and color to create moods. Still, the Post-Impressionists were drawn to Impressionist subject matter – entertainment, leisure, landscape, portraiture, the changing character of nineteenth-century society – and, like the Impressionists, they used prominent brushwork that gave texture to the surfaces of their paintings.

However, Post-Impressionist forms do not blend into each other as much as they do in Impressionism; distinctions between forms are maintained either by clear separations of areas of color or by outlines. Among the most significant artists who have been identified as Post-Impressionists, and who are the focus of this chapter, are Henri de Toulouse-Lautrec (1864–1901), Georges Seurat (1859–1891), Vincent van Gogh (1853–1890), Paul Gauguin (1848–1903), Paul Cézanne (1839–1906), and Edvard Munch (1863–1944). The latter is not usually included under the banner of Post-Impressionism, and he was born later than the others; nevertheless, Munch shared certain qualities with Post-Impressionists and, like them, influenced the development of abstraction in the early twentieth century.

Henri de Toulouse-Lautrec

Born near the town of Albi, in the Midi-Pyrénées in southern France, Toulouse-Lautrec came from a wealthy and aristocratic family descended from the counts of Toulouse and Lautrec and the viscounts of Montfa, all areas in southwestern France. He had a strained relationship with his father, who did not understand his importance as an artist, although his mother recognized his talent and tried to encourage his career. Around the age of thirteen Toulouse-Lautrec fell from a horse and, because his bones did not heal properly, he grew up with stunted legs and a normal torso. He studied art in the Montmartre quarter of Paris, lived a Bohemian life, and died from alcoholism at the age of thirty-six.

Toulouse-Lautrec frequented Paris night-life, and painted scenes from the popular nightclubs, cabarets, and brothels. His pictures were influenced by the tilted viewpoints, cropped forms, and silhouettes of Degas. Partly as a result of the lasting effects of his own accident, he, like Degas, depicted jockeys and the movements of horses in space, as well as popular dancers of the

period. He also painted portraits, landscapes, workers, prostitutes, public spectacles, intimate scenes, and crowds. Toulouse-Lautrec exhibited at the Society of Independent Artists, a successor to the *Salon des Refusés*, established in 1884 to eliminate juries from deciding who could and could not be admitted to show their work.

By the late nineteenth century, posters made by the process of lithography had become a popular way of advertising events. One of Toulouse-Lautrec's major contributions to late-nineteenth-century art was his large production of lithograph posters advertising cabarets; contemporary dance-hall stars such as La Goulue at the Moulin Rouge, Jane Avril at the Café du Divan Japonais, and Yvette Guilbert; the singer Aristide Bruant, who performed in Montmartre, the American dancers May Milton and Loie Fuller; the Irish singer May Belfort, and others.

In his poster *Le Divan Japonais* (**figure 53**), whose title and composition reflect the taste for *japonisme*, Toulouse-Lautrec shows Jane Avril in the foreground, with Yvette Guilbert, partially cropped in the background at the upper left. Guilbert wears her signature long gloves, which, like Avril's hat and fan, are black silhouettes. At the far right, also cropped, is a contemporary writer in a top hat seated next to Avril. A light gray monochrome defines the bar, the partial instruments from the orchestra pit, and the conductor. Highlights of color appear in Avril's red lips and orange hair, and in the pink lips and yellow beard of the man. The clearly defined edges typical of woodblock prints are used here as an allusion to *ukiyo-e* prints. The lettering, like the calligraphy in many Japanese woodblocks (see **figure 42**), is part of the design: the words *Divan Japonais* are printed in white letters outlined in black, the address – *75 Rue Des Martyres* – appears in cursive script at the top right, and *Ed Fournier*, the director (*directeur*), is at the lower left. The *THLautrec* monogram signature is at the lower right in black, corresponding to the predominance of black accents and silhouettes in the overall design.

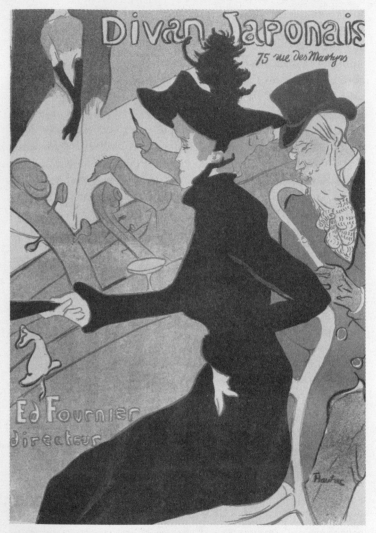

Figure 53 Henri de Toulouse-Lautrec, *Le Divan Japonais*, c.1892–1893, colored lithograph poster, 31 3/4 x 23 3/4 in (80.8 x 60.8 cm). Private collection. (Source: Wikimedia Commons)

Toulouse-Lautrec's paintings, unlike his posters, are typically composed of sketchy brushwork, through which one can often make out the surface underneath. Whereas his posters tend to consist of strong flattened forms, his paintings have a sense of modeling, creating illusions of textured materials such as silk costumes, fur collars, feathered hats, and wood-grain floors. This adds to the impression of dynamic, rapid movement, not only in the dancers, but also in the shifting lights, darks, and colors.

During his short lifetime Toulouse-Lautrec produced nearly a thousand oils and watercolors, over five thousand drawings, and over three hundred posters and prints, but he struggled for critical recognition. After his death, Toulouse-Lautrec's mother, together with his dealer, tried to promote his reputation. She was instrumental in establishing the Toulouse-Lautrec Museum in Albi, which has an impressive collection of his work.

Georges Seurat

Georges Seurat's family lived a comfortable life in Paris, where he studied at the École des Beaux-Arts from 1878 to 1879. In 1880, after a year in the military, he returned to Paris and moved first into a studio with two friends and then into his own studio. He was something of a loner and lived with his model, by whom he had a son; but he introduced them to his parents only two days before his sudden death of uncertain causes at the age of thirty-one. His earliest large-scale painting, *Bathers at Asnières* of 1884, was rejected by the Salon. He then helped to form the Society of Independent Artists, where he met other like-minded painters. Seurat, like fellow Society member Toulouse-Lautrec, was attracted to scenes of entertainment such as circuses, dancers, musicians, and other types of spectacles enjoyed by the French public. His pictures are imbued with a sense of geometric structure and are depicted with clear edges.

Seurat's large painting – over six-and-a-half by ten feet – *Sunday Afternoon on the Island of the Grande Jatte* (**plate 12**) created enormous controversy when first shown in 1886 at the Eighth (and last) Impressionist Exhibition. The artist depicts a range of social classes – from workers, including prostitutes, to the bourgeoisie – enjoying a few hours of leisure on an island in the Seine where Parisians often went to relax on Sundays. The left foreground is occupied by a sleeveless worker next to a well-dressed woman and a man with a cane wearing a top hat. At the center, in the middle ground, a woman in a red jacket accompanies a little girl in a white dress whom she seems to be minding, while behind her and to her left another girl in red skips across the grass. At the right, a couple with a silhouetted umbrella strolls with two pets, a dog and a monkey. Their gazes lead ours to the opposite side of the picture, a gaze that is countered by shadows moving diagonally from left to right. All the human figures (of which there are over forty) are arranged in groups of two or three; but despite their movement, they have an unusually static quality, because of their geometric, mainly cylindrical, character, which is echoed in the vertical tree trunks.

Seurat created a distinctive style of Post-Impressionism in which he applied dots of color to build up form. He is sometimes called a Neo-Impressionist, but terms such as *Pointillism* or *Divisionism* (which the artist preferred) seem more suited to his technique. He followed contemporary theories of color relationships, perception, and emotion, about which several scientists were writing at the time. Seurat employed complementary colors – that is, pairs of colors which, when combined in the right proportions, produce a neutral color (white, gray or black). He believed that if two complementary colors were adjacent to each other, from a distance the eye would read them as their combined color – thus a series of red dots next to a series of yellows would be perceived as orange – an example of optical color mixing rather than mixing pigments on the palette. In addition, the

colors resulting from optical mixing would be far more intense than those mixed on the palette. Seurat also believed that artists could use colors to create emotion and harmony in art.

Another characteristic of Seurat was his habit of painting his own frames, especially those framing works painted in oils. In the *Grande Jatte*, the frame is predominantly composed of purple dots, which repeat the purples of dots arranged throughout the main space of the picture. Since purple is one of the darker colors he uses, Seurat gives the frame a stable, structured appearance that anchors the work through its color. The purple is made by mixing primary red and blue hues and is arranged throughout the main image. Its repetition thus creates a unity of color that ties the main image to the frame.

As we have seen, the shadows in the *Grande Jatte* reflect one of the discoveries made by Impressionist artists – namely, that they are not gray or black, but rather a darker version of their surface color influenced by surrounding reflective light and color. A shadow on light green grass would be a darker green, just as the reflections in the Seine are darker blues; like the shadows, they are not a solid color, but retain dots that are the same color as the objects being reflected. Like Monet's "broken color" in the reflection of the sun in *Impression, Sunrise* (see **plate 7**), in which the orange brushstrokes are separated by those depicting the water, Seurat's reflections pull apart the dots of color to indicate the slow motion of the flowing river. His painting also shares with Monet's *Impression, Sunrise* the theme of changing times, in this case by juxtaposing sailboats and rowboats at the upper left with a suggestion of factory buildings on the distant shore.

The critic Félix Fénéon, a supporter of the Post-Impressionists, particularly admired Seurat's *Grande Jatte*. In 1866 he wrote that on Seurat's canvas:

> you will find on each inch of its surface, in a whirling host of tiny spots, all the elements which make up the tone … Only

two elements come together to produce the grass in the sun: green and orange tinted light, any interaction being impossible under the furious beating of the sun's rays. Black being a non-light, the black dog is colored by the reactions of the grass; its dominant color is therefore deep purple; but it is also attacked by the dark blue arising from neighboring spaces of light. The monkey on a leash is dotted with yellow ... and flecked with purple and ultramarine.[1]

The color relationships created by Seurat result in a harmonious combination of individual elements and dots arranged into a whole, coherent image. This coherence, in which the individual dots are both distinct and part of a greater compositional idea, illustrates the artist's notion that art is harmony and reflects the role of music in Impressionism and Post-Impressionism. Seurat maintained his pointillist dots of color in his drawings as well as in his oil paintings. He enhanced their effect by using conté crayons (named for Nicolas-Jacques Conté, who invented them in 1795 to compensate for a graphite shortage during the Napoleonic Wars). The crayons are made of compressed powdered graphite or charcoal mixed with wax or clay, and they are typically used on textured paper for drawing studies. The rough surfaces of the paper Seurat used increase the pointillist effect of the drawings. In addition to twenty-eight oil-on-panel and three canvas studies, he made over twenty-eight conté crayon studies for the *Grande Jatte*, including several of the monkey walking with the couple at the right.

Vincent van Gogh

Van Gogh spent only a few years of his short life painting, but he was one of the most prolific artists in the history of Western art. In ten years he painted over 800 oils and produced 1,300 prints,

drawings, and watercolors. He was born in Zundert, in Holland, in 1853 to a mother depressed by the stillbirth of a brother, also called Vincent, who died a year before the birth of Vincent the artist. Five siblings followed, but van Gogh had the most intense relationship with his brother Theodorus, known as Theo, who became an art dealer in Paris. Their stern father, a minister in the Dutch Reformed Church, did little to relieve the depressive atmosphere of the household, and he and Vincent had a strained relationship for most of the artist's life.

Van Gogh's uncle hired him to work at Goupil et Cie, an art dealership with branches in The Hague, Paris, and London. By the age of twenty, van Gogh had become successful enough to be promoted to a position at the London branch of the firm. While in London, he fell in love with the daughter of his land-lady, who rejected him; this sent him into the first of several bouts of depression. It was also the first of many failed attempts to forge relationships with unsuitable or unavailable women. By January 1876 it was evident that van Gogh might never return to his old self and he was dismissed from his uncle's firm. After his dismissal from Goupil's, he taught at a boarding school in London, and turned to religion; he became a fanatic, indulged in fervent, masochistic behavior, and worked as a missionary with coal miners in the Borinage, a region in the Walloon province of southern Belgium. His odd behavior and failure to pass the necessary exams prevented him from being ordained as a minister, which thwarted his efforts to identify with his father.

Although van Gogh had made sketches as a child, living in the Borinage inspired his first major oil painting, *The Potato Eaters* of 1885. In that work van Gogh represented a family of peas-ants seated around a wooden table, in a circular configuration, illuminated from the center by a single lamp hanging from the ceiling. The poverty of the family is clear from the simple cloth-ing and the rustic character of the house and its furnishings. The

family members are united by the lamp's glow and the poses and gestures linking them to each other. Van Gogh's identification with the family, particularly the young man at the left, is evident from the signature on his wooden chair. Typical of the artist's early pictures, *The Potato Eaters* is painted in dark colors, mainly greens and blacks. Alluding to van Gogh's sense of Christian harmony, the yellow emanating from the lamp casts a glow over the figures that suggests a divine warmth pervading the space of the painting and further unifying the family.

After leaving the Borinage, van Gogh decided on a career as an artist. He spent time in several Dutch cities, studying briefly with various individual artists, until 1886, when he moved to Paris to live with Theo, who also worked for Goupil's and to whom van Gogh wrote many letters detailing his struggles as a painter, his life in general, and his views on art. In Paris he met the Impressionists and expanded his range of color, developing from a dark, Realist palette to bright, prismatic color (the seven colors of the spectrum seen when light passes through a prism). In 1887 van Gogh wrote from Paris to an English painter that, although he was not yet a member of the Impressionist "club," he admired the nude figures of Degas and the landscapes of Monet.[2] Van Gogh's subjects included landscapes, portraits (when he could find a sitter), thirty-seven self-portraits, still lifes, café scenes, pictures based directly on Japanese woodblock prints (which he collected), and workers and peasants (with whom he identified). As with many of the Impressionists and Post-Impressionists, van Gogh sometimes depicted society changing from a rural lifestyle to an industrial one. He used two kinds of brushstrokes in his major paintings – generally either impasto (thickly applied paint) or spiraling strokes that sweep across a picture's surface, animating it while maintaining clear edges of form.

In 1887 van Gogh met the French artist Paul Gauguin, with whom he would have one of his most significant and stormy relationships. The following year van Gogh went to live in Arles,

THE LETTERS OF VINCENT VAN GOGH

Van Gogh's letters, addressed to his younger brother as "Dear Theo," like Delacroix's journal, comprise a revealing literary self-portrait. He describes his struggle to learn to paint and become an artist, his constant poverty, conflicts with his father, problems with women, and his mental breakdowns. He complains about the cost of paint supplies and repeatedly asks Theo for financial support. He details his influences, including that of Delacroix, of whose pictures van Gogh made several copies, and Millet and Daumier, who, like him, were drawn to workers. A prodigious reader in several languages, van Gogh admired Realist and Naturalist authors such as Zola, Dickens, Balzac, and Hugo, and identified with Jean Valjean, the persecuted hero of Hugo's *Les Misérables.* Van Gogh's many references to Harriet Beecher Stowe's *Uncle Tom's Cabin* in the letters also indicate his sympathy with the downtrodden members of society.

A letter to Theo of May 31, 1876, from Ramsgate, a seaside town in the south of England, shows van Gogh's close attention to nature while watching a storm: "The sea was yellowish, especially near the shore; on the horizon a strip of light, and above it immense dark gray clouds from which the rain poured down in slanting streaks. The wind blew the dust from the little white path on the rocks into the sea and bent the blooming hawthorn bushes and wallflowers that grow on the rocks."[3]

In June 1879, van Gogh wrote from the Belgian village of Wasmes, offering his definition of art: "man added to nature – nature, reality, truth, but with a significance, a conception, a character, which the artist brings out in it, and to which he gives expression ... which he disentangles, sets free and, interprets."[4]

From The Hague, in Holland, on July 31, 1882, he considered the nature of color: "There are only three fundamental colors – red, yellow and blue; 'composites' are orange, green and purple. By adding black and some white one gets the endless varieties of grays ... The colorist is the man who knows at once how to analyze a color, when he sees it in nature, and can say, for instance: that green-gray is yellow with black and blue, etc. In other words, the man who knows how to find nature's grays on his palette."[5]

Van Gogh also had strong views on representing figures. In April 1885, he wrote from the Dutch town of Nuenen: "In drawing ... that question of drawing the figure starting with the circle – that is to say, using the elliptical planes as a foundation. A thing which the ancient Greeks already knew, and which will remain valid till the end of the world."[6]

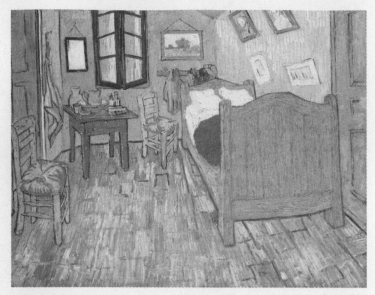

Figure 54 Vincent van Gogh, *Bedroom at Arles*, 1889, oil on canvas, 22 5/8 x 29 1/8 in (57.5 x 74 cm). Musée d'Orsay, Paris, France. (Source: Wikimedia Commons)

in the south of France, where he hoped to establish a utopian art community. He was eager that Gauguin join him and awaited his arrival with anxious anticipation. Van Gogh moved into the so-called Yellow House, which he depicted in the bright colors and forceful brushstrokes that were typical of his works during that period. He made a painting of his bedroom in the Yellow House, which is devoid of people but filled with light and prismatic color (**figure 54**). Two doors and the back wall are painted in a darker blue than the wall beside the orange bed. Two portraits and two etchings hang on that wall. The bed is covered with a bright red blanket and two pillows; blue work clothes and an orange hat hang on the wall at the head of the bed; two chairs

and a small desk echo the color of the bed and occupy the other side of the cramped space. On the back wall there is a mirror, a landscape painting, and a window whose dark frame is silhouetted against the yellow panes of glass. The personal character of the bedroom is a reflection of van Gogh's autobiographical iconography and the sense of his own presence in much of his imagery.

Gauguin finally arrived in Arles in October 1888, and for a few weeks the two artists painted together. Van Gogh painted still lifes of the chairs used by the two artists – his own chair was a kind of displaced self-portrait and Gauguin's a psychological portrait of his companion. The biographical underpinnings of the two "portraits," which have been much discussed by scholars, are clear: van Gogh's chair is plain, wooden, and yellow, a color with which he identified. The seat holds a pipe and some tobacco, and the box signed *Vincent* in the background contains two onions with double sprouts that refer to the artist's wish for twinship – temporarily with Gauguin and with Theo throughout his life. Gauguin's chair, on the other hand, is elegantly carved, curvilinear, and has an upholstered seat. It holds a lighted candle and two books. The yellow chair and the onions suggest van Gogh's self-image as a man of the people, a worker tied to the earth. The elegant chair implies van Gogh's view of Gauguin as educated and having more refined, urban tastes. The former work has more spatial depth, with its tilted, roughly tiled floor and cropped features. The latter has a flatter space, emphasized by the patterned carpet, which reflects the influence of *japonisme*.[7]

After little more than two months, it was clear that van Gogh and Gauguin could not get along and, following a heated argument, Gauguin announced that he was leaving Arles. According to Gauguin's account, which we have only second-hand in a letter from another artist to a critic, it was this

announcement that precipitated the famous incident in which van Gogh cut off his own earlobe and presented it to a prostitute.[8] Van Gogh memorialized the ear cutting in his *Self-Portrait with Bandaged Ear, Arles, January 1889* (**plate 13**). He painted this picture after his release from the hospital at Arles, using colorful impasto brushwork that enlivens the picture surface and imparts an intense character to the figure of the artist. The face is composed of a variety of bright colors – oranges, greens, and whites; the bandage is blue and white; the green coat contains black brushstrokes, with a black outline defining its edge. The whites of the eyes are the same green as the coat, and the neck is composed of a deep rich orange and a lighter orange that also recur in the face. The light green wall and the blue door echo the green of the coat, of which blue and yellow are component colors.

Van Gogh collected Japanese prints, and he produced several pictures based on *ukiyo-e* woodblocks. *Japonisme* is evident in the shape at the top of the easel that resembles a Japanese character and in the print on the wall depicting Japanese figures with Mount Fuji in the background. The thickly painted yellows and reds in the sky over Mount Fuji are component colors of the oranges in van Gogh's face. By repeating the colors in the Japanese print – yellow, red, orange, green, blue, and white – van Gogh reveals his identification with it. In a letter to Theo, sent from Arles on September 26, 1888, the artist expressed his admiration for Japanese clarity: "It is never tedious, and never seems to be done too hurriedly. Their work is as simple as breathing, and they do a figure in a few sure strokes with the same ease as if it were as simple as buttoning your coat."[9]

After Gauguin left Arles, van Gogh returned to the Yellow House. Continued bouts of delusional thinking and depression resulted in his spending more time in mental hospitals. In 1889

he committed himself to a hospital in Saint-Rémy, also in the south of France, where he painted his famous *Starry Night*, in which the entire picture surface is animated by vigorous swirls of color, especially blues and violets. Despite several relapses, van Gogh continued to paint during most of his hospital stays. In May 1890, he moved to Auvers, northwest of Paris, residing at an inn near the home of Paul Gachet, a doctor who treated several Impressionist artists and of whom van Gogh painted several portraits. There he painted *Wheatfield with Crows*, whose darkening sky seems to be descending over the landscape as if to herald his own death. On July 27, 1890, van Gogh shot himself and died two days later.

In 1892, two years after van Gogh's death, the Symbolist critic (see box, p. 173) G.-Albert Aurier called van Gogh's color "unbelievably dazzling." For Aurier, van Gogh was the only painter to perceive "the coloring of things with such intensity ... He maneuvers his brush with enormous impasto touches of very pure color in curved pathways broken by rectangular strokes ... in sometimes awkward heaps of shining masonry, and this gives some of his canvases the solid appearance of dazzling walls made of crystal and sun."[10] Aurier characterized the artist's work as excessive in its strength, agitation, and violent expressiveness: "he is a fanatic, an enemy of bourgeois sobriety and of pettiness, a kind of drunken giant, better at shaking up mountains than handling delicate knick knacks, a brain at the boiling point."[11]

A diagnosis of van Gogh's mental instability has never been definitively established to everyone's satisfaction, and numerous theories have been posited as to its origin, from the possible to the ridiculous – everything from his mother's depression to breathing in toxic, paint-related chemicals. What there can be no doubt about is van Gogh's genius, his intellectual power, and his mental and physical control of an original artistic style.

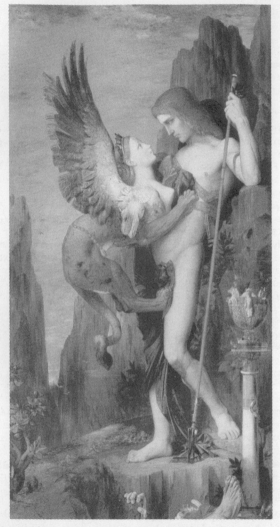

Figure 55 Gustave Moreau, *Oedipus and the Sphinx*, 1864, oil on canvas, 81 1/4 x 41 1/4 in (206.4 x 104.8 cm). Metropolitan Museum of Art, New York, USA. (Source: Wikimedia Commons)

THE SYMBOLIST MOVEMENT

Symbolism began as a literary movement; its seeds can be found in the poetry of Charles Baudelaire, especially *Les Fleurs du mal* (*The Flowers of Evil*) of 1857, and it was espoused in the second half of the nineteenth century by French poets such as Paul Verlaine and Stéphane Mallarmé, and by the Swedish playwright August Strindberg. Symbolists were interested in spirituality, mysticism, subjectivity, and the world of imagination and dreams; Symbolism sought to portray ideas, feelings, and inner, often erotic, psychological states rather than social and political reality. In 1886 the Greek-born French poet Jean Moréas (1856–1910) published the *Symbolist Manifesto* in the Paris newspaper *Le Figaro*, in part to defend Symbolism against accusations of decadence.

Symbolism was taken up by visual artists who rejected Realist ideals and were more in tune with the personal expression advocated by the Romantics. The artists achieved Symbolist aims largely through their use of intense, mood-creating color and their choice of surreal imagery, rather than by depicting the external appearance of the world around them. As with Romanticism, Symbolism does not comprise a single identifiable style, but is rather an approach to themes and images often based on biblical, mythological, or other literary narratives (Rodin's *Gates of Hell* can in this way be considered Symbolist). A major work of Symbolism in the visual arts is *Oedipus and the Sphinx* (**figure 55**), by the French painter Gustave Moreau (1826–1898); he painted it in 1864, one year after Manet submitted *Luncheon on the Grass* to the Salon. Like many of Moreau's paintings, *Oedipus and the Sphinx* is based on a literary theme – in this case, the myth in which Oedipus solves the riddle of the sphinx and is rewarded with marriage to Jocasta, queen of Thebes, who turns out to be his mother. The power of this myth, which formed the core concept of Freud's theory of psychoanalysis, is apparent in its widespread influence on art and literature in the late nineteenth and early twentieth centuries.

Moreau depicts an episode in the narrative that suggests its hidden, unconscious meaning. He shows the intense confrontation between Oedipus and his monstrous adversary, who kills all those who fail to solve her riddle: "What walks on four legs in the morning, two legs in the afternoon, and three legs in the evening?" The answer – Man (who first crawls on all fours, then walks upright on two feet, and walks with a cane in old age) – conveys the universal psychology of the myth. At the bottom of the painting we can see a hand and foot that belonged to one of the sphinx's victims; the

prominence of the foot alludes to the very name *Oedipus*, which is derived from Greek words meaning *swollen foot*.

The perverse nature of the confrontation between Moreau's Oedipus and the sphinx is shown in their locked gazes, the sphinx's physical contact with the nude body of Oedipus, and her bizarre combination of human flesh, a lion's body, and soft, colorful wings. That her approach is sexual is clear from the position of her rear right paw and Oedipus's recoiling pose. His head tilts forward, and his gaze penetrates that of the sphinx, whose destruction is foreshadowed by her position in space. She can only fall, whereas Oedipus stands on solid rock and steadies himself with a spear. Moreau's sphinx is a mythic version of the nineteenth-century *femme fatale* – beautiful, seductive, terrifying, dangerous to men, and a recurring theme in Symbolist work. She is a nineteenth-century version of a deadly Medusa, as well as Keats's "belle dame sans merci" and, for the moment, she has Oedipus "in thrall."

While Courbet did not want to paint an angel without having seen one, Moreau believed that what he could feel and imagine was more powerful, and thus more "real," than what he could actually see. In his personal notebooks, Moreau wrote: "I believe neither in what I touch nor what I see. I only believe what I do not see, and solely in what I feel ... Photographic truth is merely a source of information."[12]

Paul Gauguin

Gauguin was born in Paris in 1848. His father was a French journalist and his mother came from a Peruvian socialist family. Partly because his father was an anti-Bonapartist republican, all three, along with his sister, sailed for Peru when Gauguin was eighteen months old; his father died on the way. After around five years in Peru, Gauguin returned to France and attended school until he was seventeen, when he joined the merchant marine. Two years later he returned again to Paris and for eleven years had a successful career as a stockbroker at the Bourse. In 1873 he married Mette-Sophie Gad, a Dane by whom he had five children. They lived for a time in Denmark, but separated when Gauguin decided to become a full-time artist and moved back to

France. Thereafter he lived peripatetically, and painted portraits, self-portraits, landscapes, still lifes, and many scenes inspired by his time spent in Tahiti. In addition to paintings and drawings, Gauguin made sculptures, especially wood carvings. He moved through a number of styles over the course of his artistic career, embracing formal aspects of Impressionism and Symbolism.

In France, Gauguin met Cézanne, eventually owning six of his paintings, and became good friends with Pissarro, who influenced his attraction to the Impressionist style. From 1881 to 1882, Gauguin exhibited with the Impressionists in Paris, sharing their taste for Japanese woodblock prints. His Impressionist works also show the influence of Degas, especially in the use of cropped form, but he soon moved beyond Impressionism.

At the end of 1886, Gauguin went to Pont-Aven, in Brittany, where living costs were lower than in Paris. Pont-Aven also appealed to Gauguin's search for a pre-industrial, "primitive" energy that would fuel his pictures and, while he was there, he painted Breton figures in traditional costume. His works painted in Brittany are generally characterized as Symbolist because of their flat planes of color, which show the influence on Gauguin of *ukiyo-e* prints, stained glass, and the flat designs of cloisonné enamel, as well as the paintings of the critic and artist Émile Bernard (1868–1941), all of which had an abstract geometric flavor. The spiritual quality of Symbolism is shown in Gauguin's titles. In 1891, the critic Aurier hailed Gauguin as a Symbolist, admiring in particular *Vision after the Sermon (Jacob Wrestling with the Angel)* of 1888 (**figure 56**). Its flattened perspective and unshaded, tilted red floor create an unreal, imaginary space consistent with the idea that a group of religious Breton women wearing the local white caps are envisioning the biblical scene before them. Cutting across the picture plane in a strong diagonal silhouette is the trunk of an apple tree, alluding to the Fall of Man. The struggle between Jacob and the angel, an event described in Genesis, is shown in a greater variety of color than

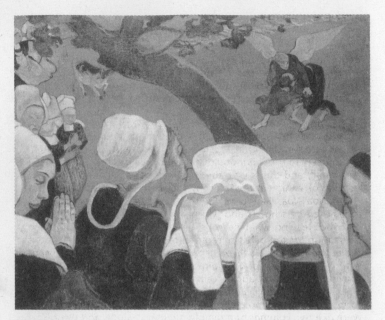

Figure 56 Paul Gauguin, *Vision after the Sermon*, 1888, oil on canvas, 28 3/8 x 35 7/8 in (72.2 x 91 cm). National Gallery of Scotland, Edinburgh, UK. (Source: WikiPaintings)

the women observing them. But the colors, like the scene itself, are unnatural and herald twentieth-century abstraction.

The artist's stay in Brittany produced another famous Symbolist work, namely the *Yellow Christ* – a good example, as the title indicates, of non-local, imagined color. It depicts the Crucifixion set in a landscape composed of red trees and yellow-green hills.

Pissarro disliked Gauguin's religious pictures, on the grounds that they avoided the anarchist concern with society in the real world. The Impressionists, Pissarro believed, had taken a stance in favor of "truth" – that is, an honest art driven by sensations. Accordingly, he criticized what he considered Gauguin's escape into idealism, symbolism, mysticism, and a taste for the occult.

GAUGUIN AND TAHITI

Beginning with the eighteenth-century voyages of Captain Cook to the South Sea Islands in the Pacific, Western collectors became interested in Oceanic art and in descriptions and drawings of the islanders brought back by explorers. By the second half of the nineteenth century, Oceanic art had joined the vogues for *chinoiserie* and *japonisme* that had infiltrated Western taste. When asked in an interview why he went to Tahiti, Gauguin replied that he wanted to produce something new, which requires returning to the original source, "to the childhood of mankind. Eve, as I see her, is almost an animal; and this is why she is chaste, though naked. All those Venuses on exhibit at the Salon are indecent, hatefully lascivious."[13]

In *Noa Noa*, Gauguin's Tahitian Journal – the date of which is disputed by scholars and which some consider inauthentic – he describes leaving what he considered the corruption of Western civilization for the paradise represented by Oceania. Doubts about the authenticity of *Noa Noa* notwithstanding, its text is consistent with what is known of Gauguin's views on art and nature. On first arriving in Oceania, Gauguin calls himself "still blind" to the beauty of a Tahitian woman. But later, he notes "the majestic sculptural form of her race, ample and at the same time gracious. The arms were like two columns of a temple, simple, straight; and the whole bodily form with the long horizontal line of the shoulder, and the vast height terminating above in a point, inevitably made me think of the Trinity."[14]

He writes that the landscape was simple to paint as he saw things without the inhibitions of Western civilization: "to put without special calculation a red close to a blue. Golden figures in the brooks and on the seashore enchanted me. Why did I hesitate to put all this glory of the sun on my canvas? ... Oh! the old European traditions! The timidities of expression of degenerate races!"[15]

At home in his new world, he wrote that "Civilization is falling from me little by little ... I have escaped everything that is artificial, conventional, customary. I am entering into the truth, into nature."[16]

In 1891, after stints in Panama and Martinique, the peripatetic Gauguin made the first of two trips to French Polynesia, which appealed to his taste for pre-industrial, "primitive" cultures and

his rejection of the so-called corrupt civilization of Western society. In 1895 he traveled back to France, before returning to Oceania, where he contracted syphilis. He died in 1903 at the age of fifty-four.

We can see the merger of Tahitian with Western iconography in Gauguin's *Te Arii Vahine* (*The Noble Woman*) of 1896 (**plate 14**), which was exhibited in 1898. Here Gauguin uses imaginative, mood-evoking color reminiscent of his Symbolist phase. A faint dark outline is visible around the figure. The softly textured, velvety paint surface is characteristic of Gauguin – his paint surfaces are smoother than either Seurat's dots of color or van Gogh's swirling and impasto brushwork. Gauguin described his reclining nude as a queen by a large tree guarded by a black dog. She lies on a green rug that echoes the foreground grass and the distant hills. The orange of the trees at the right, the red surface under the tree in front of them, and the red of the fan are repeated in the mangoes at the lower left. Two figures converse above and behind the woman's head, and two white doves appear at the far right of the canvas. In the distance a mysterious dark blue sea with white surf is visible.

The pose, and the white cloth, which contrasts sharply with the dark brown surface of the figure, are clear allusions to Manet's *Olympia* (see **figure 27**), with which Gauguin was familiar. The noble Tahitian tilts her head slightly to the left, parting her lips seductively and gazing at something not seen on the canvas. The open red fan, in contrast to the white cloth, creates a tension between seduction and modesty that is also present in *Olympia*, but is more ambiguous in this case. That the mangoes echo the color of the fan, as does the red patch under the tree beside the doves, reinforces the erotic implications of the woman. The lush vegetation and the serpentine form coiled around the tree imply that the figure was associated in the artist's mind with Eve. The modest gesture, based on Western prototypes, and the erotic elements in the iconography further suggest that this represents Eve after the Fall.

In a series of notes, which have been dated to anywhere from 1884 to 1890, Gauguin comments on the use of color and proposes a theory based on his observations of nature:

> We are criticized for using colors without mixing them, placing them next to each other. On that ground we are necessarily the winners, being mightily helped by nature, which proceeds in just the same way. A green next to a red does not yield a reddish brown as would the mixture of the two [as Seurat believed], but gives two vibrant notes instead. Next to that put a chrome yellow; you have three notes each enriched by the others and increasing the intensity of the first tone, the green. Instead of the yellow put a blue and you'll find three different tones but all vibrating because of each color. Instead of the blue put a purple, and you'll be back in a single composite tone, merging into the reds.[17]

The notes also emphasize the artist's interest in the relation of music to color, which caused so much controversy in the case of Whistler's musical titles. Gauguin compared art to music in the arrangement of lines and colors to create symphonies and harmonies. According to Gauguin, the purpose of these arrangements was "to make you think the way music is supposed to make you think, unaided by ideas or images, simply through the mysterious affinities that exist between our brains and such arrangements of colors and lines."[18] In a letter from Tahiti written in March 1899, Gauguin asks the reader to think of "the musical role color will henceforth play in modern painting. Color, which is vibration just as music is, is able to attain what is most universal yet at the same time most elusive in nature: its inner force."[19]

Gauguin also had strong views about his artistic predecessors and their relationship to the avant-garde. Of the Old Masters, he notes that the greatest of them "deformed nature"; no two great artists are ever the same. To a critic who called him a "revolutionary,"

THE FRENCH AVANT-GARDE IN RUSSIA

Gauguin, like van Gogh, died penniless. But after his death his reputation improved, as did the prices paid for his work. By 1914 the Russian businessman Sergei Ivanovich Shchukin (1854–1936) owned sixteen of Gauguin's Tahitian pictures, along with works by Monet, Renoir, Cézanne, and van Gogh. Shchukin's friend and competitor, Ivan Morozov (1871–1921), began collecting similar work around the same time. Both men opened their houses to the public so they could enjoy the collections.

Following the Communist revolution of 1917, the state confiscated the art collections of both men and their homes became museums. In the 1930s, the pictures were divided between the Pushkin Museum in Moscow and the Hermitage in Leningrad. However, deemed inconsistent with Stalin's cultural policy, they were relegated to storage; the public would have to wait until the 1960s to see the collections again.

Gauguin responded that such an idea was ridiculous, because all innovative artists differ from past artists. He cites Manet and Delacroix, noting that they were originally reviled by critics and the public – "people laughed their heads off over Delacroix's purple horse." He continues: "But that's the way the public is … If I did what has already been done, I would be a plagiarist … so I do something different and people call me a scoundrel. I'd rather be a scoundrel than a plagiarist!"[20]

Paul Cézanne

By the end of the nineteenth century, two artists had emerged who would have a major impact on the twentieth-century avant-garde, namely Paul Cézanne and Edvard Munch.

Cézanne was born in 1839 in Aix-en-Provence in the south of France. His father was a successful banker, which made it possible for his son to pursue a career in art without having to

struggle financially. He studied drawing beginning in 1857, but acceded to his father's wish that he attend law school. Cézanne's mother, like Toulouse-Lautrec's, was more amenable to her son's interest in art. In elementary school Cézanne met Zola, and the two became close friends until Zola depicted Cézanne in his novel *L'Oeuvre* as a painter who failed to fulfill his promise. Their break was reinforced by the Dreyfus affair, with Cézanne, politically conservative and a devout Catholic, on the side of the anti-Dreyfusards.

Cézanne's early paintings are characterized by the predominance of the color black and violent subjects, such as murder and rape. He was known as the Black Painter, but, after moving to Paris in 1861 and meeting Pissarro and the Impressionists, his palette changed and he turned to brighter color and patchy, crystalline brushstrokes that create contrast as well as harmony between colors. To Émile Bernard, Cézanne wrote that there is no distinction between drawing and color, that form is fullest when color is richest, and that when color and line are arranged harmoniously next to each other, drawing achieves precision.

By 1866, Cézanne had decided that pictures painted outdoors were superior to those painted in a studio, as had been the traditional Academic practice, and this accorded with his view that artists should study directly from nature. The Louvre, he said in 1904, was a good place to consult works of art, but it was not as good as the study of nature herself, which trains the eye. The study of nature was a significant aspect of Cézanne's formative friendship with Pissarro, as the two artists often painted outdoor landscapes together.

In addition to the shift in his palette, Cézanne's iconography also changed under Pissarro's influence, and, by the height of his career, he had renounced explicitly violent subject matter in favor of landscapes, portraits, bathers, and still lifes – especially apples. It was Cézanne's ambition to "astonish Paris with an apple," a pun on his wish to achieve fame in the city of Paris that alluded

to the Greek myth in which the Trojan prince Paris awards a golden apple to Aphrodite, proclaiming her the most beautiful of three goddesses: herself, Hera, and Athena (see p. 16). Cézanne exhibited at the *Salon des Refusés*, since every work he submitted to the official Salon between 1864 and 1872 – with one exception – was rejected. It was not until 1895 that he had a one-man show at the gallery of Ambroise Vollard, a dealer in Paris who supported the avant-garde.

Beginning in the 1880s Cézanne worked mainly in Provence, where he developed his unique approach to space, creating patchwork brushstrokes, bright color, and shifting perspectives. From his studio, Cézanne had a view of Mont Sainte-Victoire, an imposing, triangular mountain made of limestone. The artist painted the mountain many times over the course of his career. According to the German poet Rainer Maria Rilke, commenting to a contemporary in front of a painting of the mountain, "Not since Moses has anyone seen a mountain so greatly."[21]

Living and working in the south of France, away from the immediate influence of the Impressionists, Cézanne added a new sense of geometric structure to his work. Like most of the Impressionists and Post-Impressionists, he believed that artists should study nature. In a letter of 1904 to Émile Bernard he recommended treating "nature by the cylinder, the sphere, the cone, everything in proper perspective so that each side of an object or a plane is directed toward a central point. Lines parallel to the horizon give breadth … Lines perpendicular to the horizon give depth."[22] Although at first glance the natural contour of an apple resembles a sphere, apples are, in fact – as Renoir said of oranges – irregular in shape. When painted by Cézanne, apples are composed of rectangular patches of color, giving them the appearance of having been constructed of solid geometric forms.

In the first decade of the twentieth century Cézanne painted the *Large Bathers* (**plate 15**), in which many of his ideas on art are evident. His complex technique consisted of building up

solid areas of color to achieve form. The crystalline brushstrokes correspond to Cézanne's view of the components of nature as geometric – the cylinder, sphere, and cone, and, one could add, the cube.

The *Large Bathers* is his biggest canvas, over six by eight feet, and its space is filled with a combination of nude female figures and landscape arranged as an architectural structure. The foreground trees form a pointed arch, whose upward thrust is echoed in the background verticals. They frame a spatial triangle that has a three-dimensional quality, mirroring the solid forms throughout the picture. Two of the women – at the far left and right – are aligned with the trees, one striding in profile and the other facing the viewer. The other figures occupy various poses; most are seated. One at the right is prone, facing away from the viewer and overlapping another figure, also with her back to us, whose head merges with a distant pointed tree. These figures carry our gaze beyond a river toward the background, where we see the backs of two tiny undefined figures apparently heading for the space between the distant pointed tree and church tower. In this work, Cézanne exemplifies his view that lines parallel and perpendicular to the horizon give an image breadth and depth, respectively.

The patches of color, mostly blue, in the sky that towers above the landscape resemble solid forms and are defined by individual areas of structured paint. The range of color is relatively narrow, the predominant blues varied with patches of green, yellow, light browns, a few lavenders (in the sky), and white spaces. By placing areas of blue and green in the trees and areas of green and light brown in the sky, Cézanne disrupts the expected relationship of foreground, middle-ground, and background, and creates a continual shifting of space.

The figures in the *Large Bathers* are anonymous (although some have been described as based on Classical sculpture), as is the setting, which directs our attention to the relationships in nature and to the abstract geometry of the figures. They were

most likely taken from earlier studies, as Cézanne preferred not to paint directly from nude models and noted that it would be difficult to find women who, like himself, were middle-aged (and most likely conservative) to pose in the nude. Some of the figures merge into the diagonal trees and reinforce their triangular configuration, just as the church spire echoes the vertical trees. In such arrangements, Cézanne produces a harmonious image in which human form, nature, and architecture correspond to each other. In the *Large Bathers*, therefore, the artist created a metaphor expressing his conviction that the study of nature underlies the work of art.

In 1894, summing up his view of Cézanne as an artist, the critic Gustave Geffroy described his isolation, focus, and commitment to art: "Surely this man has lived and lives a beautiful interior novel, and the demon of art dwells within him."[23]

Edvard Munch

Munch's early work was influenced by Realism and Impressionism, and later, as a mature artist, he painted in an exuberant expressionist style that shared features with works of the Symbolist Movement and that looked forward to developments at the beginning of the twentieth century.

Munch was born in 1863 in Løten, Norway. His father was an army physician, whose modest income made it difficult to support his family. His mother's family were seafarers and, like his father, she was not particularly intellectual or interested in the arts. With five children – Edvard, three sisters, and one brother – Munch's father was forced to move his family from one inexpensive apartment to another. In 1864, they moved to Oslo (then called Christiania). Munch's childhood was dreary, and the atmosphere in his home was fraught with depression and illness. His mother died of tuberculosis in 1868 when Munch was

five, and his aunt took her place in raising the family. His sister Johanne Sophie died eleven years later; she was a year older than Munch and his favorite sister. Munch memorialized her death in some twenty paintings entitled *The Sick Child*.

The first version of *The Sick Child* (**figure 57**), according to Munch, signaled his break with Realism and Impressionism. It depicts a red-haired girl propped up in bed; she turns to an old woman leaning over at her side. The girl's whitened face, seen in profile, is pale, but we do not see the face of the old woman. A glass of water at the lower right and a bottle resting on a table at the left are consistent with the setting being a sick room. The paint is thin and seems to have been scratched into the canvas, creating an overall sense of nervous texture that reflects the agitation felt by Munch when dealing with this personal subject. The direct representation of sickness and death in this picture, as well as sexual imagery in other works, and the unfinished appearance of the paint surfaces, caused an enormous amount of controversy among critics. In 1889 Munch wrote that this picture offended many viewers in Norway – one Naturalist painter yelled "Humbug Painter" at him as he left the gallery where it was being exhibited.[24]

Another sister suffered from psychosis, and Munch himself was frequently sick as a child, forcing him to miss a lot of school. He was tutored at home, where he often turned to drawing. In 1879, he set out to become an engineer, but by 1880 he had changed his mind and decided to become an artist. Munch's father, who was fervently religious, considered art an immoral profession. His father's attitude pervaded the household, creating an atmosphere of depression with constant talk of death and damnation.

Like van Gogh, Munch was an explicitly autobiographical painter whose themes of anxiety, death, and despair were directly related to his experiences as a child. Although he suffered from mental health problems throughout his life, Munch never lost

Figure 57 Edvard Munch *The Sick Child*, 1885–1886, oil on canvas, 47 x 46 5/8 in (119.5 x 118.5 cm). National Gallery, Oslo, Norway. (Source: Wikimedia Commons)

control of his artistic genius. Sometime around 1880 he began keeping a diary, which provides us with a view into his art, as well as his childhood memories, and some of the major events of his adult life. An entry in his diary dated November, 1880, when he was seventeen, records his decision to be an artist.

In 1881, Munch studied at the Oslo Academy of Drawing, where he painted mainly figures; his early pictures include portraits, self-portraits, and nudes. He experimented with different

styles, notably Impressionism and Seurat's Pointillism, but moved beyond these to forge new, highly personal approaches to painting. Much of his time was spent with Bohemian intellectuals and artists, further angering his father. Like most of the avant-garde, Munch's work was denigrated by both his father and his contemporaries.

In 1882, Munch shared a studio in Oslo with a group of painters, including Christian Krohg, a prominent Norwegian Naturalist, who influenced him and other members of the group. For the next few years Munch traveled, and exhibited his work in Norway, in Paris, and at the Antwerp World's Fair of 1885. In 1889, he studied figure drawing at the Paris studio of the popular French Realist Léon Bonnat and visited museums and galleries. That same year, he had his first solo exhibition in Oslo, which consisted of 110 works. His father died in November, an event that had a lifelong impact on the artist. The year 1889 also saw the Universal Exhibition (World's Fair) in Paris, which exposed him to new developments in industry and cultural displays from around the world.

In 1892 Munch exhibited in Berlin at the Berlin Artists' Association, but controversy caused the show to close after a week. The reaction to his exhibition only increased his notoriety, and the work was subsequently shown in other German cities and Copenhagen. In Berlin, Munch became involved with a group of international artists, including August Strindberg, whose portrait he painted. All in all, Munch spent four years in Berlin, where his ideas for his most important work, *The Frieze of Life – a Poem about Life, Love and Death*, began to take shape. The works that comprised the *Frieze* expressed his view that art is a mirror of an artist's life. It consisted of a cycle of pictures dealing with themes that continually preoccupied him – life and death, loneliness and jealousy, melancholy and anxiety, terror and sickness.

Munch's 1893 Berlin exhibition included six paintings which launched the group of works he would call *The Frieze of Life*.

THE UNIVERSAL EXHIBITION (*EXPOSITION UNIVERSELLE*) OF 1889

In 1889, the centennial of the storming of the Bastille and of the beginning of the French Revolution, Paris mounted a world's fair, lasting from May 6 to October 31 and attended by over 32 million visitors from France and abroad. The Eiffel Tower was one of the main exhibits, along with the "Galerie des Machines," both built specifically for the exhibition. The *Galerie* featured steam engines and other steel constructions and inventions developed as a result of the Industrial Revolution. Other exhibits such as music and dance came from non-Western cultures as well as from Russia and the United States. Buffalo Bill came with his sharpshooter, Annie Oakley. There were also art exhibits from around the world; but they did not include the Impressionists or Post-Impressionists, whose significance was yet to be recognized by the general public. However, Munch's painting of 1884 entitled *Morning* (originally *A Servant Girl*), which shows a young girl seated on her bed, looking through a window at a sun-filled day, was on view at the Norwegian pavilion.

The entire group, however, was not completed until well into the twentieth century, when it was exhibited at Blomqvist's Gallery in Oslo in 1918. In 1918, Munch wrote that the *Frieze* was a series of pictures depicting life, but that it was not a single work because he used different techniques and different images inspired by different periods of his life.

Reflecting both the Symbolist moods and expressionist energy that Munch strove to achieve, he wrote on the origins of *The Frieze*: "I painted impressions from my childhood – the blurred colors of days gone by. By painting colors and lines and shapes that I had seen in an emotional mood, I wanted to make the emotional mood ring out again as happens on a gramophone. This is how the pictures of *The Frieze of Life* came into being."[25]

The Frieze of Life exemplifies the connection between Munch's ideas on art and nature. In 1890 he wrote:

> I do not paint from nature – I take from it – or help myself
> generously from its riches.
> I do not paint what I see – but what I saw,
> The camera cannot compete with the brush and palette –
> as long as it cannot be used in heaven or hell.[26]

In 1907–1908 he wrote on art and nature:

> Art is the antithesis of nature.
> A work of art can only come from within a man.
> …
> Nature is the single, great realm upon which art feeds.
> Nature is not only that which is visible to the eye – it also
> Presents the inner pictures of the soul – the picture on the
> reverse side of the eye.[27]

The Frieze included Munch's most famous painting, indeed one of the most famous paintings we know today – *The Scream* (**plate 16**). He made four unique versions of *The Scream* (two oils and two pastels between 1893 and 1910) and several lithographs of the work; all depict a figure representing the artist crossing the bridge that spans the Christianiafjord in Oslo. The vivid colors convey the intensity of Munch's connection with nature. He stops on the bridge and places his hands on the side of his head, pushing it inwards so that it resembles a skull; he screams in response to a scream he hears tearing through nature: "I felt as though a scream went through nature – I thought I heard a scream – I painted this picture – painted the clouds like real blood. The colors were screaming."[28] The fact that he painted four versions of the picture indicates the importance of its theme for him.

The Scream mirrors the artist's state of mind by creating a mood of terror and mental dissolution. Its mood-creating quality, prominent, loose brushwork, and Symbolist use of color are

characteristic of Munch's expressionist style; they are also aspects of Post-Impressionism. Energetic bright reds and oranges fill the sky, and pinks swirl through the dark blue water of the Christian-iafjord. Two figures on the bridge behind Munch create a sense of paranoia as they approach, unseen by the artist but sensed by him nevertheless. They are represented as staunch verticals, making them seem more determined than the artist, whose swaying form echoes the curves of the water and sky. The bridge divides the picture into two trapezoids, producing a tilt and the suggestion of a candid viewpoint, echoing the influence of photography on late nineteenth-century imagery.

From 1896 to 1898, Munch lived in Paris, frequenting a group of artists and musicians. He produced lithographs and made posters for Norwegian plays – Ibsen's *Peer Gynt* and *John Gabriel Borkman* – being performed at the Théâtre de l'Oeuvre in the rue de Clichy, which catered to Symbolists and other avant-garde playwrights. During this period, Munch met several Impressionists, and painted some of his most significant work. He had a number of exhibitions, though critics continued to find his work difficult. By 1899, however, he had saved enough to buy a country house in Norway, where he spent his summers. At the turn of the twentieth century, his critical reception had improved. In 1927 he had a retrospective of over 200 works at the National Galleries of Oslo and Berlin, and in 1929 a major exhibition of graphics in Stockholm at the National Museum. In 1936 he exhibited in England, but the following year the Nazis removed his work from display in Germany on the grounds that it, like all avant-garde art, was degenerate. Most of the work was sold off. Nevertheless, with an increasing number of exhibitions, including his first in America in 1942, and as his originality and influence on the twentieth-century avant-garde became evident, his prices escalated. He continued to travel and exhibit his work until his death in 1944.

Conclusion

The critical and financial fortunes of the nineteenth-century avant-garde artists changed radically in the twentieth and twenty-first centuries, when many became household names, with their work hanging in the world's most famous museums and selling for astronomical prices (see box, p. 192). What had seemed new and shocking to nineteenth-century viewers became accepted, even highly valued, as with the $120 million sale of a version of Munch's *The Scream* in 2012.

Just as developments in the eighteenth century had produced the arts of the nineteenth, so the nineteenth century formed a basis for the avant-garde of the twentieth century. The mature styles of Cézanne and Munch, for example, defined two trends that would lead to new explorations by subsequent generations of avant-garde artists. The new approach to representing three-dimensional space on a flat surface that was spearheaded by the patchy brushwork and geometric view of nature in the work of Cézanne led to Cubism and the technique of collage invented by Georges Braque (1882–1963) and Pablo Picasso (1881–1973), working together in Paris. Munch's vivid use of mood-creating color and line prefigured the moods of Picasso's Blue and Rose Periods, the non-figurative work of Wassily Kandinsky (1866–1944) in Russia, German Expressionism, and the bright color of Fauvism and Henri Matisse (1869–1954) in France. Rodin's partial figures exerted a significant influence on the development of abstraction, as artists sought to break with the idealized Classical approach to human form. The Romanian-born modernist sculptor Constantin Brancusi (1876–1957) studied

RISING FORTUNES

- In 1990, a small version of Renoir's *Moulin de la Galette* of 1876 was purchased at auction by a Japanese buyer for over $78 million, making it one of the world's most expensive paintings at the time.
- In 1996, a Cassatt painting sold at Christie's for $3,700,000 and in 2010 a pastel sold for nearly one million dollars. Her famous painting entitled *The Boating Party* was used on a United States postage stamp.
- Of the van Gogh paintings that eventually found their way onto the market, several achieved record prices. In 1987, *Vase with Fifteen Sunflowers* sold for $39.9 million and *Irises* for $53.9 million; in 1989, *Portrait of Joseph Roulin* (the postman) sold for $58 million; in 1990, *Portrait of Dr. Gachet* sold for $82.5 million; in 1993, *Wheatfield with Cypresses* sold for $57 million; and in 1998, *Self-Portrait without a Beard* sold for $71.5 million.
- In 2000, *Man on a Balcony* by Caillebotte sold at a New York auction for over $14 million and in 2011 his *Le Pont d'Argenteuil et la Seine* sold at Sotheby's for over $18 million.
- In 2005, Degas's painting of c.1886–1887 entitled *The Laundress* sold at Christie's for a record $22.4 million.
- In 2009, Pissarro's *Le Pont Boieldieu et la Gare d'Orleans, Rouen, Soleil* of 1898 was sold at a Sotheby's auction by the heirs of Durand-Ruel for over $7 million.
- In 2012, a 1905 painting from Monet's famous series of water lilies sold at Christie's in New York for over $43 million.
- In 2012, a version of *The Scream* sold in New York for nearly $120 million, becoming the world's most expensive work of art ever to sell at auction up to that time.

with Rodin for a while and also made partial figures. The nine-teenth-century focus on brushwork, notably in Impressionism and Post-Impressionism, led to the non-figurative imagery and energetic paint handling of the Abstract Expressionists, including the American artist Jackson Pollock (1912–1956).

The notion of the manifesto in the arts that had begun in the nineteenth century, with Courbet's Realist Manifesto in

1855 and Moréas's Symbolist Manifesto in 1886, was taken up by twentieth-century artists. The Futurist Manifesto of 1909 by Filippo Marinetti (1876–1944) in Italy went further than the nineteenth-century artists who had challenged the rules of the Academy. Futurism advocated a complete break with the past, including the destruction of museums and libraries linked to traditional knowledge. This was followed in 1924 by the first of two Surrealist manifestos by the French poet André Breton (1896–1966), who argued for the importance of the unconscious and dream reality based on the psychoanalytic theories of Sigmund Freud (1856–1939) and previously expressed to some degree in nineteenth-century Symbolism and Romanticism.

Glossary

aesthetic the formal properties of art, especially those intended to convey beauty

altar (a) any flat structure used for religious sacrifice or worship; (b) in a Christian church, a table-like structure where the Eucharist is celebrated

apse a section, usually semicircular, projecting from a building (especially a church)

aquatint a print made from a metal plate on which certain areas have been painted with an acid-resistant varnish to prevent the action of the acid

attic in architecture, a low story above the main *entablature*

avant-garde literally, "the advance guard" of an army; also used to denote non-traditional or innovative qualities in a particular field

calligraphy handwriting intended to be beautiful; literally, "beautiful writing"

calotype a photograph made by projecting an image onto sensitized paper, chemically *fixing* it as a negative, which was then used to make a positive print on another sensitized surface

cloisonné enamel an ancient type of *enamel* work fusing threads of metal to frame a design made of enamel paste

colonnade a series of columns arranged at regular intervals, usually to support arches or an *entablature*

conté crayon a non-greasy stick of powdered graphite and clay mixed with soot, red ochre, or other substance and used for drawing

Corinthian order the most ornate of the three main *orders* of Classical Greek architecture, characterized by slender *fluted* columns, a base, and capitals decorated with acanthus leaves

cornice a projecting horizontal unit at the top of an arch or wall; the topmost element of a Classical *entablature*

cromlech a Neolithic monument consisting of a circle of monoliths (large blocks of uncut stone)

cross-hatching a second set of parallel lines set at an angle to *hatching* lines

daguerreotype a photograph developed by Louis Daguerre in the mid-nineteenth century by fixing positive images on silver-coated plates

dome a vaulted roof or ceiling (often hemispherical and erected on a circular or square base)

Doric order the oldest and simplest of the three main orders of Classical Greek architecture, characterized by heavy fluted columns with plain capitals and no base

enamel a baked protective coating on metal, glass, or ceramic

entablature the part of a Classical order that appears above the capital of a column

etching (a) a process in which a print or impression is taken from a metal plate on which an image has been eaten away by acid; (b) a print made by such a process

façade the front or face of a building

fix in photography, to make an image more permanent by using a chemical process

fluted having a series of decorative vertical grooves

frieze (a) a horizontal band decorated with pictures or relief sculpture; (b) in the Classical *orders*, the central horizontal section of the *entablature*

genre painting a category of art representing scenes of everyday life

glaze in oil painting, a layer of translucent paint or varnish, usually applied over another color and through which light is reflected back by the lower surface

hatching close parallel lines used to create an effect of shading or shadow (and thus three-dimensionality) in drawings or prints. See *cross-hatching*

hierarchy of genres the ranking of categories, especially by the French Academy – in descending order of importance, religious painting, history painting, portraiture, genre, landscape, and still life

hue a pure spectrum color, usually referred to by the 'color names', e.g. red, green, blue, etc.

iconography the way an image is written, including the layers of meaning in the work such as symbolism and allegory, etc.

impasto the thick application of paint

Ionic order the second Greek *order* of architecture, having *fluted* columns, a round base, and volute scrolls decorating the capital

linear perspective a mathematical system developed in the Renaissance to create the illusion of depth in a two-dimensional image. In one-point linear perspective, orthogonals (lines perpendicular to the picture plane) converge at a single point

lithography a printmaking process in which an image is drawn on a smooth stone or plate with a crayon or other oily substance

medium (pl. **media**) (a) the material of which a work of art is made (e.g. oil on canvas); (b) the liquid in which pigment is suspended

metope the square area between the *triglyphs* of a *Doric frieze*, often decorated with *relief sculpture*

mimesis Greek for "imitation"

monochrome consisting of tones of a single color

order in Classical architecture, one of the elevation systems (*Doric, Ionic, Corinthian*) used by the Greeks and Romans in post-and-lintel construction. See *Doric, Ionic,* and *Corinthian orders*

painterly in painting, using the quality of color and texture, rather than line, to define form

pediment (a) in Classical architecture, the triangular element at the top of the *cornice* on the short ends of a Greek or Roman temple; (b) a triangular element over a door or window

peristyle a *colonnade* surrounding a structure

pilaster a shallow, rectangular version of a column, sometimes load-bearing, but often purely decorative

plein air **painting** painting executed outdoors, rather than in a studio

podium (a) the base of a temple; (b) a raised platform or pedestal

polychrome (**polychromy**) consisting of more than one color

portico (a) a *colonnade*; (b) a porch with a roof supported by columns, usually at the entrance to a building

prefabrication making the parts of a structure before assembling it at its permanent site

primary colors in painting the three pure hues (red, blue, yellow), from which all other colors can theoretically be mixed

prismatic color the seven colors of the visible spectrum

quadriga a chariot, usually ancient Roman, drawn by four horses

relief a mode of sculpture in which an image is carved outward (low or high relief) or inward (sunken relief) from the plane of the material

rusticate to give a rustic appearance to masonry blocks by leaving their surfaces rough or beveling their edges so that their joints are recessed

silhouette the outline of a figure, usually filled in with a uniform, unshaded color

suspension bridge as built in the nineteenth century, a bridge whose roadway is suspended from two or more steel cables anchored at either end

symmetry a form of balance in which two sides of an image, arranged around an axis or central line, correspond to each other in one or more respects (e.g. shape, color, and size)

terracotta (a) an earthenware material consisting of baked clay; (b) an object made of baked clay

triglyphs in a *Doric* frieze, the carved, grooved verticals between the *metopes*

trompe l'oeil an illusionistic technique that "fools the eye" by imitating reality

truss construction an architectural system in which bars, beams, or other members are joined, often in triangular elements, to form a rigid framework

woodblock print an image printed on paper from a wooden block, on whose surface a design is drawn and then cut away, color by color, to create the final image

Notes

Chapter 1

[1]See Nochlin, *Women, Art and Power*.
[2]Delécluze, cited in Eitner, *Neoclassicism and Romanticism* (1970), p. 18.
[3]Ingres, cited in Eitner, ed., *Neoclassicism and Romanticism* (1989), p. 295.
[4]Ingres, cited in ibid., p. 136.
[5]Ingres cited in ibid., p. 291.
[6]Gautier, cited in ibid., p. 139.

Chapter 2

[1]See Eisenman, ed., *Nineteenth-Century Art*, p. 107.
[2]Adams, *Art and Psychoanalysis*, ch. 9.
[3]Blake, cited in Eitner, ed., *Neoclassicism and Romanticism* (1989), p. 19.
[4]Friedrich, cited in ibid., p. 55.
[5]John Ruskin, *Modern Painters*, vol. I, cited in Eitner, ed., *Neoclassicism and Romanticism* (1989), p. 238.
[6]Thackeray, cited in Rosenberg, *The Darkening Glass*, p. 9.
[7]John Ruskin, *Modern Painters*, vol. I, cited in Eitner, ed., *Neoclassicism and Romanticism* (1989), p. 239.
[8]Constable, cited in ibid., p. 64.
[9]Constable, cited in ibid., p. 63.
[10]Cole, cited in Novak, *American Painting*, p. 71.

[11]See Meiss, "Masaccio and the Early Renaissance."

[12]For the relationship of the fragment to modernity, see Nochlin, *The Body in Pieces*.

[13]Géricault, cited in Eitner, ed., *Neoclassicism and Romanticism* (1989), p. 148.

[14]On this dynamic, see Lacan, *The Four Fundamental Concepts*, pp. 115–116.

[15]Delacroix, *Journal*, p. 1.

[16]Ibid., pp. 181–182.

[17]Ibid., p. 182.

[18]Heine, cited in Eitner, ed., *Neoclassicism and Romanticism* (1989), p. 152.

[19]Delacroix, *Journal*, February 21, 1832, p. 51.

[20]Ibid., January 29, 1832, p. 49.

[21]Baudelaire, cited in Eitner, ed., *Neoclassicism and Romanticism* (1989), p. 127.

Chapter 3

[1]Courbet, cited in Victor Fournel, *Les Artistes*, p. 366. For this reference I am grateful to Petra ten-Doesschate Chu.

[2]Jules Antoine Castagnary, *1863: The Triumph of Naturalism*, cited in Nochlin, ed., *Realism and Tradition*, pp. 63–66.

[3]Corot, cited in Andrews, *Landscape and Western Art*, p. 191.

[4]Zola, cited in Nochlin, ed., *Realism and Tradition*, p. 75.

[5]Ernest Chesneau, the art critic and historian, cited in ibid., p. 82.

[6]Jules Claretie, the author, critic, dramatist, and member of the French Academy, cited in ibid., p. 83.

[7]Charles Dickens, cited in Chu, *Nineteenth-Century European Art*, p. 327.

[8]William Sidney Mount, cited in Novak, *American Painting*, p. 151.

Chapter 4

[1]Louis Leroy, cited in Nochlin, ed., *Impressionism and Post-Impressionism*, p. 13.
[2]Théodore Duret, cited in ibid., p. 30.
[3]Marc-Charles-Gabriel Gleyre, cited in ibid., p. 40.
[4]Cited in Rewald, *History of Impressionism*, p. 326, note 30.
[5]Lemoisne, *Degas et son oeuvre*, vol. 1, p. 119.
[6]Pissarro, cited in Nochlin, ed., *Impressionism and Post-Impressionism*, p. 60.
[7]Pissarro, cited in ibid.
[8]Renoir, cited in Rewald, *History of Impressionism*, p. 210, note 28.
[9]Renoir, cited in Nochlin, ed., *Impressionism and Post-Impressionism*, pp. 48–51.
[10]Cassatt, cited in Eisenman, ed., *Nineteenth-Century Art*, p. 272.
[11]Whistler, cited in Weintraub, *Whistler*, p. 124.
[12]Cited in Adams, *Art on Trial*, pp. 17–19.
[13]Rilke, cited in Nochlin, ed., *Impressionism and Post-Impressionism*, p. 75.
[14]Rilke, cited in ibid.
[15]Rodin, cited in ibid., pp. 70–72.

Chapter 5

[1]Félix Fénéon, cited in Nochlin, ed., *Impressionism and Post-Impressionism*, pp. 108–109.
[2]Van Gogh, *Letters*, p. 279.
[3]Ibid., p. 36.
[4]Ibid., p. 50.
[5]Ibid., p. 95.
[6]Ibid., p. 234.

[7]For a more extensive analysis of the chairs and their psychological meanings see Collins, *Van Gogh and Gauguin*, especially the chapter entitled "Eclectic Arguments."

[8]For a more complete account of these events, see ibid., p. 178.

[9]Van Gogh, *Letters*, p. 334.

[10]G.-Albert Aurier, cited in Nochlin, ed., *Impressionism and Post-Impressionism*, p. 138.

[11]Aurier, cited in ibid., pp. 135–136.

[12]Gustave Moreau, cited in ibid., p. 199.

[13]Interview with Eugène Tardieu, in Gauguin, *The Writings of a Savage*, p. 110.

[14]Gauguin, *Noa Noa*, p. 3.

[15]Ibid., p. 12.

[16]Ibid., p. 17.

[17]Gauguin, *The Writings of a Savage*, pp. 9–10.

[18]Ibid., p. 109.

[19]Gauguin, cited in Nochlin, ed., *Impressionism and Post-Impressionism*, p. 178.

[20]Gauguin, *The Writings of a Savage*, p. 110.

[21]Rilke, *Letters on Cézanne*, p. viii.

[22]Cézanne, letter of 1904 to Émile Bernard, cited in Nochlin, ed., *Impressionism and Post-Impressionism*, pp. 91–92.

[23]Geffroy, cited in ibid., p. 107.

[24]Wood, ed., *Edvard Munch*, p. 13.

[25]Munch, cited in Nochlin, ed., *Impressionism and Post-Impressionism*, p. 207.

[26]Munch, cited in Wood, ed., *Edvard Munch*, p. 11.

[27]Munch, cited in Nochlin, ed., *Impressionism and Post-Impressionism*, p. 209.

[28]Munch, cited in Eggum, *Symbols and Images*, p. 391.

Bibliography

Works cited

Adams, Laurie, *Art on Trial, from Whistler to Rothko* (New York: Walker and Co., 1976).

Adams, Laurie Schneider, *Art and Psychoanalysis* (New York: HarperCollins, Icon Edition, 1993).

Andrews, Malcolm, *Landscape and Western Art* (Oxford: Oxford University Press, 1999).

Chu, Petra ten-Doesschate, *Nineteenth-Century European Art* (New York: Harry N. Abrams, 2003).

Collins, Bradley, *Van Gogh and Gauguin* (Boulder, CO: Westview Press, 2001).

Delacroix, Eugène, *The Journal of Eugène Delacroix*, ed. Hubert Wellington, translated by Lucy Norton (Ithaca, NY: Cornell University Press, 1980).

Eggum, Arne, *Symbols and Images*, Exhibition Catalogue (Washington, DC: National Gallery of Art, 1978).

Eisenman, Stephen F., ed., *Nineteenth-Century Art: A Critical History* (New York: Thames and Hudson, 1998).

Eitner, Lorenz, *Neoclassicism and Romanticism 1750–1850*, vol. II, *Sources and Documents*, ed. H. W. Janson (Englewood Cliffs, NJ: Prentice Hall, 1970).

Eitner, Lorenz, ed., *Neoclassicism and Romanticism 1750–1850, An Anthology of Sources and Documents* (New York: Harper and Row, Icon Edition, 1989).

Fournel, Victor, *Les Artistes Français Contemporains* (Tours: Alfred Mame et Fils, 1885).

Gauguin, Paul, *Noa Noa, The Tahitian Journal*, translated by O.F. Theis (New York: Dover Publications, 1985).

Gauguin, Paul, *The Writings of a Savage*, ed. Daniel Guérin, translated by Eleanor Levieux (New York: Paragon House, Tesoro Books, 1978).

Gogh, Vincent van, *Van Gogh: A Self Portrait: Letters Revealing His Life as a Painter*, selected by W.H. Auden (New York: Tesoro Books, Paragon House, 1989).

Lacan, Jacques, *The Four Fundamental Concepts of Psychoanalysis* (New York: W.W. Norton, 1978).

Lemoisne, Paul-André, *Degas et son oeuvre*, 4 vols. (1946–1949; reprint, New York and London: Garland, 1984). Supplement, accompanying reprint, by Philippe Brame and Theodore Reff.

Meiss, Millard, "Masaccio and the Early Renaissance: The Circular Plan," in *The Painter's Choice* (New York: Harper and Row, Icon Edition, 1976), pp. 63–81.

Nochlin, Linda, *Realism and Tradition in Art 1848–1900,* Sources and Documents in the History of Art series, ed. H.W. Janson (Englewood Cliffs, NJ: Prentice Hall, 1966).

Nochlin, Linda, *Impressionism and Post-Impressionism 1874–1904*, Sources and Documents in the History of Art series, ed. H.W. Janson (Englewood Cliffs, NJ: Prentice Hall, 1966).

Nochlin, Linda, *Women, Art and Power and Other Essays* (New York: Harper and Row, Icon Edition, 1988).

Nochlin, Linda, *The Body in Pieces: The Fragment as a Metaphor of Modernity* (London: Thames and Hudson, 1994).

Novak, Barbara, *American Painting of the Nineteenth Century* (New York: Harper and Row, Icon Edition, 1979).

Rewald, John, *The History of Impressionism* (New York: The Museum of Modern Art, 1973).

Rilke, Rainer Maria, *Letters on Cézanne*, translated by Joel Agee, foreword by Heinrich Wiegand Petzer (New York: Fromm International Publishing Corporation, 1985).

Rosenberg, John D., *The Darkening Glass*, *A Portrait of Ruskin's Genius* (New York and London: Columbia University Press, 1961).

Weintraub, Stanley, *Whistler* (New York: Weybright and Talley, 1974).

Wood, Mara-Helen, ed., *Edvard Munch: The Frieze of Life* (London: National Gallery Publications, Nov. 12, 1992–Feb. 7, 1993).

Further reading

General

Bell, Quentin, *Ruskin* (New York: Braziller, 1978).

Bryson, Norman, *Tradition and Desire: From David to Delacroix* (New York: Cambridge University Press, 1984).

Burke, Edmund, *A Philosophical Enquiry into the Origin of Our Ideas of the Sublime and Beautiful*, ed. Adam Philips (Oxford: Oxford University Press, 1990).

Carrier, David, *High Art: Charles Baudelaire and the Origins of Modernist Painting* (University Park, PA: Penn State University Press, 1996).

Champa, Kermit, ed., *The Rise of Landscape Painting in France* (Manchester, NH: The Currier Gallery of Art, 1991).

Derrida, Jacques, *The Truth in Painting*, translated by Geoff Bennington and Ian McCleod (Chicago: University of Chicago Press, 1987).

Eitner, Lorenz, *Nineteenth-Century European Painting: David to Cézanne* (New York: Westview Press, Icon Edition, 2002).

Errington, Lindsay, *Social and Religious Themes in English Art, 1840–1860* (London: Garland, 1984).

Fer, Briony et al., *Modernity and Modernism: French Painting in the Nineteenth Century* (New Haven: Yale University Press, 1993).

Friedlander, Walter, *David to Delacroix*, translated by Robert Goldwater (Cambridge, MA: Harvard University Press, 1975).

Harrison, Charles, Wood, Paul, and Gaiger, Jason, eds., *Art in Theory, 1815–1900: An Anthology of Changing Ideas* (Oxford: Blackwell, 1988).

Hobsbawm, Eric J., *Industry and Empire: The Birth of the Industrial Revolution* (New York: New Press, 1999).

Loyer, François, *Paris Nineteenth Century: Architecture and Urbanism*, translated by Charles Lynn Clark (New York: Abbeville Press, 1988).

Mainardi, Patricia, *The End of the Salon* (Cambridge: Cambridge University Press, 1993).

Milner, John, *The Studios of Paris: The Capital of Art in the Late Nineteenth Century* (New Haven: Yale, 1988).

Rosen, Charles, and Zerner, Henri, *Romanticism and Realism: The Mythology of French 19th-Century Art* (New York: Viking Press, 1984).

Rosenblum, Robert, and Janson, H. W., *Art of the Nineteenth Century* (New York: Harry N. Abrams, 1984).

Rosenthal, Michael, *British Landscape Painting* (Ithaca, NY: Cornell University Press, 1982).

Taylor, J. C., *Nineteenth-Century Theories of Art* (Berkeley, CA: University of California Press, 1987).

Tomlinson, Janis, *Readings in Nineteenth-Century Art* (Upper Saddle River, NJ: Prentice-Hall, 1996).

Winckelmann, Johann Joachim, *Writings on Art*, ed. David Irwin (London: Phaidon, 1972).

Chapter 1: Neoclassicism

Boime, Albert, *Art in an Age of Revolution, 1750–1800* (Chicago: University of Chicago Press, 1987).

Boime, Albert, *Art in an Age of Bonapartism, 1800–1815* (Chicago: University of Chicago Press, 1993).

Brookner, Anita, *Jacques-Louis David* (London: Thames and Hudson, 1980).

Haskell, Francis, and Penny, Nicholas, *Taste and the Antique: The Lure of Classical Sculpture* (New Haven, CT: Yale University Press, 1981).

Honour, Hugh, *Neo-Classicism* (New York: Penguin Books, 1977).

Irwin, David, *Neoclassicism (Art and Ideas)* (London: Phaidon, 1997).

Lee, Simon, *David* (London: Phaidon, 1999).

Palmer, Allison Lee, *Historical Dictionary of Neoclassical Art and Architecture* (Lanham, MD: Scarecrow Press, 2011).

Porterfield, Todd, *The Allure of Empire in the Service of French Imperialism, 1798–1836* (Princeton: Princeton University Press, 1998).

Powell, Nicolas, *Fuseli: The Nightmare* (London: Penguin, 1973).

Rosenblum, Robert, *Ingres* (New York: Harry N. Abrams, 1990).

Toman, Rolf, ed., *Neoclassicism and Romanticism: Architecture, Sculpture, Painting, Drawing* (Potsdam: H.F. Ullmann, 2011).

Tomory, Peter, *The Life and Art of Henry Fuseli* (New York: Praeger, 1972).

Vaughan, William, and Weston, Helen, eds., *David's The Death of Marat* (Cambridge: Cambridge University Press, 2000).

Chapter 2: Romanticism

Bailey, Anthony, *Standing in the Sun: A Life of J.M.W. Turner* (New York: HarperCollins, 1997).

Brown, David Blayney, *Romanticism* (New York and London: Phaidon, 2001).

Clark, Kenneth, *The Romantic Rebellion* (New York: Harper and Row, 1973).

Eitner, Lorenz, *Géricault's "Raft of the Medusa"* (London: Phaidon, 1972).

Ferber, Michael, *Romanticism: A Very Short Introduction* (Oxford: Oxford University Press, 2011).

Hofmann, Werner, *Caspar David Friedrich*, translated by Mary Whittall (London: Thames and Hudson, 2000).

Honour, Hugh, *Romanticism* (New York: Harper and Row, Icon Edition, 1979).

Jullian, Philippe, *The Orientalists: European Painters of Eastern Scenes*, translated by Helga and Dinah Harrison (Oxford: Phaidon, 1977).

Koerner, Joseph Leo, *Caspar David Friedrich and the Subject of Landscape* (New Haven: Yale University Press, 1990).

Licht, Fred, *Goya: The Origins of the Modern Temper in Art* (New York: Harper and Row, 1983).

Parkinson, Ronald, *John Constable: The Man and His Art* (London: V & A Publications, 1998).

Paulson, Ronald, *Literary Landscape: Turner and Constable* (New Haven: Yale University Press, 1982).

Praz, Mario, *The Romantic Agony*, translated by Angus Davidson (Oxford: Oxford University Press, 1970).

Rodner, William S., *J.M.W. Turner: Romantic Painter of the Industrial Revolution* (Berkeley, CA: University of California Press, 1997).

Rosenblum, Robert, *Modern Painting and the Northern Romantic Tradition* (New York: Harper & Row, 1975).

Schmied, Wieland, *Caspar David Friedrich*, translated by Sarah Twohig (New York: Harry N. Abrams, 1995).

Symmons, Sarah, *Goya* (London: Phaidon, 1998).

Thomas, Hugh, *Goya: The Third of May* (London: Penguin, 1972).

Tomlinson, Janis, *Goya in the Twilight of Enlightenment* (New Haven: Yale University Press, 1992).

Vaughan, William, *German Romantic Painting* (New Haven: Yale University Press, 1980).

Walker, John, *John Constable* (New York: Abrams, 1991).

Wilton, Andrew, *Turner and the Sublime* (Chicago: University of Chicago Press, 1980).

Chapter 3: Realism

Barringer, Tim, *Reading the Pre-Raphaelites* (New Haven, CT: Yale University Press, 1999).

Barthes, Roland, *Camera Lucida*, translated by Richard Howard (New York: Hill and Wang, 1971).

Bouret, Jean, *The Barbizon School and 19th-Century French Landscape Painting* (Greenwich, CT: New York Graphic Society, 1973).

Chu, Petra ten-Doesschate, ed. and trans., *The Letters of Gustave Courbet* (Chicago: University of Chicago Press, 1992).

Clark, T.J., *The Painting of Modern Life: Paris in the Art of Manet and His Followers* (Princeton: Princeton University Press, 1999).

Clark, T.J., *Image of the People: Gustave Courbet and the 1848 Revolution* (Berkeley, CA: University of California Press, 1999).

Clark, T.J., *The Absolute Bourgeois: Artists and Politics in France 1848–1851* (Berkeley, CA: University of California Press, 1999).

Hilton, Timothy, *The Pre-Raphaelites* (New York: Abrams, 1971).

Laughton, Bruce, *Daumier* (New Haven: Yale University Press, 1996).

Mainardi, Patricia, *Art and Politics of the Second Empire* (New Haven: Yale University Press, 1987).

Needham, Gerald, *19th-Century Realist Art* (New York: Harper & Row, 1988).

Newhall, Beaumont, *The History of Photography: From 1839 to the Present* (New York: Museum of Modern Art, 1999).

Nochlin, Linda, *Realism* (New York: Penguin Books, 1971).

Nochlin, Linda, *Courbet* (New York: Thames and Hudson, 2007).

Passeron, Roger, *Daumier*, translated by Helga Harrison (New York: Rizzoli, 1981).

Prettejohn, Elizabeth, *The Art of the Pre-Raphaelites* (London: Tate Publishing, 2000).

Reff, Theodore, *Manet: Olympia* (New York: Viking Press, 1977).

Rubin, James H., *Courbet* (New York and London: Phaidon, 1997).

Tucker, Paul Hayes, ed., *Manet's Le Déjeuner sur l'Herbe* (Cambridge: Cambridge University Press, 1998).

Chapter 4: Impressionism

Adams, Steven, *The Barbizon School and the Origins of Impressionism* (London: Phaidon, 1994).

Armstrong, Carol, *Odd Man Out, Readings of the Work and Reputation of Edgar Degas* (Chicago: University of Chicago Press, 1991).

Collins, Bradford R., ed., *12 Views of Manet's Bar* (Princeton: Princeton University Press, 1996).

Elsen, Albert E., *Rodin* (New York: Museum of Modern Art, 1963).

Guth, Christine, *Art of Edo Japan* (New York: Henry N. Abrams, 1996).

Herbert, Robert L., *Impressionism: Art, Leisure, and Parisian Society* (New Haven: Yale University Press, 1988).

Kendall, Richard, *Degas: Beyond Impressionism* (London: National Gallery Publications, 1996).

King, Ross, *The Judgment of Paris: The Revolutionary Decade that Gave the World Impressionism* (New York: Walker & Co., 2009).

Lewis, Mary Thompkins, ed., *Critical Readings in Impressionism and Post-Impressionism* (Berkeley, CA: University of California Press, 2007).

Locke, Nancy, *Manet and the Family Romance* (Princeton: Princeton University Press, 2001).

Mathews, Nancy Mowll, *Mary Cassatt* (New York: Abrams, 1987).

Merrill, Linda, *A Pot of Paint: Aesthetics on Trial in Whistler v. Ruskin* (Washington, DC: Smithsonian Institution, 1992).

Pissarro, Joachim, *Camille Pissarro* (New York: Abrams, 1993).

Roos, Jane Mayo, *Early Impressionism and the French State (1866–1874)* (New York: Cambridge University Press, 1996).

Rubin, James H., *Impressionism* (New York and London: Phaidon, 1999).

Schapiro, Meyer, *Impressionism: Reflections and Perceptions* (New York: George Braziller, 1997).

Smith II, Henry D., and Poster, Amy, et al., *Hiroshige: One Hundred Famous Views of Edo* (New York: Braziller and The Brooklyn Museum of Art, 1986).

Smith, Paul, *Impressionism: Beneath the Surface* (New York: Abrams, 1995).

Tucker, Paul Hayes, *Claude Monet: Life and Art* (New Haven: Yale University Press, 1995).

Chapter 5: Post-Impressionism

Dorra, Henri, *The Symbolism of Paul Gauguin* (Berkeley, CA: University of California Press, 2007).

Geist, Sidney, *Interpreting Cézanne* (Cambridge, MA, and London: Harvard University Press, 1988).

Gibson, Michael F., *Symbolism* (New York: Taschen, 1999).

Heller, Reinhold, *Edvard Munch: The Scream* (New York: Viking Press, 1972).

Herbert, Robert L., ed., *Georges Seurat, 1859–1891* (New York: Metropolitan Museum of Art, 1991).

Herbert, Robert L., ed., *Seurat and the Making of La Grande Jatte* (Chicago and Berkeley: Art Institute of Chicago in association with UCLA Press, 2004).

Holland, J. Gill, ed. and trans., *The Private Journals of Edvard Munch* (Madison, WI: University of Wisconsin Press, 2005).

Jullian, Philippe, *The Symbolists* (London: Phaidon, 1973).

Loran, Erle, *Cézanne's Composition* (Berkeley, CA: University of California Press, 2006).

Lubin, Albert J., *Stranger on the Earth: A Psychological Biography of Vincent Van Gogh* (New York: Da Capo Press, 1996).

Lucie-Smith, Edward, *Symbolist Art* (London: Thames & Hudson, 1985).

Rewald, John, *Post-Impressionism: From Van Gogh to Gauguin* (New York: Museum of Modern Art, 1986).

Schapiro, Meyer, *Vincent Van Gogh* (New York: Abrams, 2003).

Schapiro, Meyer, *Paul Cézanne* (New York: Abrams, 2004).

Shiff, Richard, *Cézanne and the End of Impressionism* (Chicago: University of Chicago Press, 1984).

Smith, Paul, *Seurat and the Avant-Garde* (New Haven: Yale University Press, 1997).

Sweetman, David, *Paul Gauguin: A Life* (New York: Simon and Schuster, 1996).

Thompson, Belinda, *Gauguin* (New York: Thames and Hudson, 1987).

Thompson, Belinda, ed., *Gauguin: Maker of Myth* (Princeton: Princeton University Press, 2010).

Thomson, Richard, et al., *Toulouse-Lautrec* (New Haven: Yale University Press, 1991).

List of artists and works

Listed below are all the artists and works mentioned in this text. Dates and present locations of works are also included.

Adam, Robert (1728–1792)
Augustus of Prima Porta
Bierstadt, Albert (1830–1902)
 Sunrise, Yosemite Valley, c.1870, Amon Carter Museum, Fort Worth, Texas
Blake, William (1757–1827)
 Frontispiece for *Jerusalem: The Emanation of the Giant Albion*, 1804–1820
 Nebuchadnezzar, 1795
Bonheur, Rosa (1822–1899)
 Plowing in the Nivernais: The Dressing of the Vines, 1849, Musée National du Château de Fontainebleau, Fontainebleau, France
Bouguereau, William-Adolphe (1825–1905)
Boyle, Richard (Earl of Burlington) (1694–1753)
 Chiswick House, 1725–1729, London, UK
Brady, Mathew (1822–1896)
Brown, Ford Madox (1821–1893)
 The Last of England, 1852–1855, Birmingham Museum and Art Gallery, Birmingham, UK
 Work, 1852–1865, Manchester Art Gallery, Manchester, UK
Caillebotte, Gustave (1848–1894)
 Rue de Paris: Temps de Pluie (Paris Street: a Rainy Day), 1877, Art Institute of Chicago, Chicago, Illinois

Canova, Antonio (1757–1822)
Venus Victrix, 1805–1808, Borghese Gallery, Rome, Italy
Cassatt, Mary (1844–1926)
In the Omnibus, 1890–1891, National Gallery of Art, Washington, D.C.
The Boating Party, 1893–1894, National Gallery of Art, Washington, D.C.
Cézanne, Paul (1839–1906)
Large Bathers, *c*.1905–1906, Philadelphia Museum of Art, Philadelphia, Pennsylvania
Cole, Thomas (1801–1848)
The Course of Empire, 1833–1836, New York Historical Society, New York
Desolation, 1836, New York Historical Society, New York
Constable, John (1776–1837)
The Hay Wain, 1821, National Gallery, London, UK
Corot, Jean-Baptiste-Camille (1796–1875)
Ville d'Avray, *c*.1867, National Gallery of Art, Washington, D.C.
Courbet, Gustave (1819–1877)
A Burial at Ornans, 1849, Musée d'Orsay, Paris, France
The Stonebreakers, 1849–1850, destroyed during World War II, formerly in the Gemäldegalerie, Dresden, Germany
Daguerre, Louis (1787–1851)
Daumier, Honoré (1808–1879)
Rue Transnonain, April 15, 1834, 1834, private collection
David, Jacques-Louis (1748–1825)
Coronation of Napoleon, 1806, Musée du Louvre, Paris, France
The Death of Marat, 1793, Royal Museums of Fine Arts, Brussels, Belgium
The Oath of the Horatii, 1784, Musée du Louvre, Paris, France
The Tennis Court Oath, 1789–1791, Musée du Louvre, Paris, France
Degas, Edgas (1834–1917)
A Cotton Office in New Orleans, 1873, Musée des Beaux-Arts, Pau, France

After the Bath, Woman Drying Her Hair, c.1893–1898, Kimbell Art
 Museum, Fort Worth, Texas
Alexander and Bucephalus, 1859–1861, National Gallery of Canada,
 Ottawa, Canada
Foyer de la danse à l'Opera de la rue Le Peletier, 1872, Musée d'Orsay,
 Paris, France
Semiramis Building Babylon, 1860, Musée d'Orsay, Paris, France
Young Spartans Exercising, 1860, The National Gallery, London, UK
Vicomte Ludovic Lepic and His Daughters (Place de la Concorde), 1875,
 Hermitage Museum, St Petersburg, Russia
Delacroix, Eugène (1798–1863)
Bark of Dante, 1822, Musée du Louvre, Paris, France
Death of Sardanapalus, 1827, Musée du Louvre, Paris, France
Jewish Woman of Tangier, 1832, Musée Delacroix, Paris, France
Liberty Leading the People, 1830, Musée du Louvre, Paris, France
Lion of the Atlas, c.1829, Brooklyn Museum, New York
Massacre at Chios, 1824, Musée du Louvre, Paris, France
Durand, Asher Brown (1796–1886)
Kindred Spirits, 1849, Crystal Bridges Museum of American Art,
 Bentonville, Arkansas
Eakins, Thomas (1844–1916)
The Gross Clinic, 1875, Philadelphia Museum of Art, Philadelphia,
 Pennsylvania
Eiffel, Alexandre-Gustave (1832–1923)
Eiffel Tower, 1887–1889, Paris, France
Friedrich, Caspar David (1774–1840)
The Stages of Life, 1834–1835, Museum der bildenden Künste,
 Leipzig, Germany
Fry, Roger (1866–1934)
Fuseli, Henry (1741–1825)
The Nightmare, 1781, Detroit Institute of Arts, Detroit, Michigan
Garnier, Charles (1825–1898) Paris Opera, 1860–1875, Paris, France
Gauguin, Paul (1848–1903)
Te Arii Vahine (The Noble Woman), 1896, Pushkin State Museum of
 Fine Arts, Moscow, Russia

Vision after the Sermon (Jacob Wrestling with the Angel), 1888, National Gallery of Scotland, Edinburgh, UK

The Yellow Christ, 1889, Albright-Knox Art Gallery, Buffalo, New York

Géricault, Théodore (1791–1824)

Portrait of a Kleptomaniac, c.1822, Ghent Museum, Ghent, Belgium

The Raft of the Medusa, 1818–1819, Musée du Louvre, Paris, France

Goya, Francisco (1746–1828)

Y son fieras (*And They Are Wild Beasts*) from *Disasters of War*, 1810–1820, Museum of Fine Arts, Boston, Massachusetts

The Disasters of War, 1810–1820

Duendecitos (*Hobgoblins*) from *Los Caprichos*, 1797–1798, Metropolitan Museum of Art, New York

The Executions of May 3, 1808, 1814, Prado, Madrid, Spain

Los Caprichos, 1797–1798

Haussmann, Georges-Eugène (1809–1891)

Hokusai, Katsushika (1760–1849)

The Great Wave, c.1829–1832

Homer, Winslow (1836–1910)

Prisoners from the Front, 1866, Metropolitan Museum of Art, New York

Hunt, William Holman (1827–1910)

The Awakening Conscience, 1853–1854, Tate Britain, London, UK

Ingres, Jean-Auguste-Dominique (1780–1867)

The Apotheosis of Homer, 1827, Musée du Louvre, Paris, France

La Grande Odalisque, 1814, Musée du Louvre, Paris, France

Louis-François Bertin, 1832, Musée du Louvre, Paris, France

Jefferson, Thomas (1743–1826)

Virginia State Capitol, 1788, Richmond, Virginia

Jenney, William Le Baron (1832–1907)

Home Insurance Building, 1884, Chicago

Kilburn, William Edward (1818–1891)

The Great Chartist Meeting on Kennington Common, April 10, 1848, 1848, Windsor Castle, Windsor, UK

Langhans, Carl (1732–1808)

Brandenburg Gate, 1791, Berlin, Germany

Leibl, Wilhelm (1844–1900)

Village Politicians, 1876–1877, Museum Oskar Reinhart am Stadt-garten, Winterthur, Switzerland

Lorrain, Claude (*c.* 1600–1682)

Manet, Édouard (1832–1883)

Corner of a Café-Concert, 1879, National Gallery, London, UK

Luncheon on the Grass, 1863, Musée d'Orsay, Paris, France

Olympia, 1865, Musée d'Orsay, Paris, France

The Railway, 1872–1873, National Gallery of Art, Washington, D.C.

Mantegna, Andrea (c.1431–1506)

The Dead Christ, c.1475–1501, Pinacoteca di Brera, Milan, Italy

Meissonier, Jean-Louis-Ernest (1815–1891)

Memory of Civil War (also known as *The Barricade, Rue de la Mortel-lerie, June 1848*), *c.*1848–1850, Musée du Louvre, Paris, France

The Ruins of the Tuileries Palace after the Commune of 1871, 1877, Musée Antoine Vivenel, Compiègne, France

Michelangelo (1475–1564)

Millais, John Everett (1829–1896)

Christ in the House of His Parents, 1850, Tate Britain, London, UK

Millet, Jean-François (1814–1875)

The Gleaners, 1857, Musée d'Orsay, Paris, France

Monet, Claude (1840–1926)

Gare Saint Lazare, 1877, Musée d'Orsay, Paris, France

Impression, Sunrise, 1872, Musée Marmottan, Paris, France

Rouen Cathedral, End of Day, Sunlight Effect, 1894, Musée Marmot-tan, Paris, France

Rouen Cathedral, the West Portal and the Tour d'Albane, Harmony in Blue, 1894, Musée d'Orsay, Paris, France

Moreau, Gustave (1826–1898)

Oedipus and the Sphinx, 1864, Metropolitan Museum of Art, New York

Morisot, Berthe (1841–1895)

Au Bal (At the Ball), 1875, Musée Marmottan, Paris, France

Summer's Day, *c.*1879, National Gallery, London, UK

Morris, William (1834–1896)

Mount, William Sidney (1807–1868)

California News, 1850, Long Island Museum, Stony Brook, New York

Munch, Edvard (1863–1944)

Morning (originally titled *A Servant Girl*), 1884, Bergen Kunstmuseum, Bergen, Norway

The Frieze of Life, 1893–1902

The Scream, 1893, National Gallery, Oslo, Norway

The Sick Child, 1885–1886, National Gallery, Oslo, Norway

Nash, John (1752–1835)

Royal Pavilion, 1823, Brighton, UK

Niépce, Joseph Nicéphore (1765–1833)

Paxton, Joseph (1803–1865)

Crystal Palace, 1851, London, UK

Pissarro, Camille (1830–1903)

Avenue de l'Opéra, Effect of Snow, 1898, Musée des Beaux Arts, Reims, France

Gelée Blanche, Ancienne Route d'Ennery, Pontoise (*Hoarfrost, the Old Road to Ennery, Pontoise*), 1873, Musée d'Orsay, Paris, France

Poussin, Nicolas (1594–1665)

Pugin, Augustus (1812–1852)

Houses of Parliament, 1840–1870, London, UK

Raphael (1483–1520)

The School of Athens, 1509-1510, The Vatican Museum, Vatican City State

Raimondi, Marcantonio (*c.*1480–1534)

Rembrandt (1606–1669) *The Anatomy Lesson of Dr. Nicolaes Tulp*, 1632, Mauritshuis, The Hague, the Netherlands

Renoir, Pierre-Auguste (1841–1919)

Diana, 1867, National Gallery of Art, Washington, D.C.

The Swing, 1876, Musée d'Orsay, Paris, France

A Woman of Algiers, 1870, National Gallery of Art, Washington, D.C.

Riis, Jacob (1849–1914)

*Bandits' Roost, Mulberry Street, New York, c.*1888, Museum of the City of New York, New York

Rimmer, William (1816–1879)

Dying Centaur, 1871, Metropolitan Museum of Art, New York

Rodin, Auguste (1840–1917)

The Age of Bronze, 1876

Gates of Hell, 1880–1917

John the Baptist, 1878

Monument to Honoré de Balzac, 1898, cast in bronze 1904, Musée Rodin, Paris, France

The Thinker, 1902–1903, cast in bronze 1904, Legion of Honor, Fine Arts Museums of San Francisco, San Francisco, California

*Walking Man, c.*1900

Roebling, John Augustus (1806–1869)

Brooklyn Bridge, 1869–1883, New York

Rossetti, Dante Gabriel (1828–1882)

Seurat, Georges (1859–1891)

Bathers at Asnières, 1884, National Gallery, London, UK

Sunday Afternoon on the Island of the Grande Jatte, 1884–1886, Art Institute of Chicago, Chicago, Illinois

Soufflot, Jacques Germain (1713–1780)

Church of Sainte-Geneviève (the Pantheon), 1758–1790, Paris, France

Sullivan, Louis (1856–1924)

Wainwright Building, 1890–1891, St Louis, Missouri

Talbot, William Henry Fox (1800–1877)

Tanner, Henry Ossawa (1859–1937)

The Banjo Lesson, 1893, Hampton University Museum, Hampton, Virginia

Titian, (*c.*1488–1576)

*Venus of Urbino, c.*1538, Galleria degli Uffizi, Florence, Italy

Toulouse-Lautrec, Henri de (1864–1901)

Le Divan Japonais, 1892–1893

Tournachon, Gaspard-Félix (Nadar) (1820–1910)

Turner, Joseph Mallord William (1775–1851)

The Fighting Temeraire Tugged to Her Last Berth to Be Broken Up, 1838, 1838, National Gallery, London, UK

Utagawa, Hiroshige (1797–1858)
One Hundred Famous Views of Edo, 1856–1858
Thirty-Six Views of Mount Fuji, 1852 and 1858

Toyokuni, Utagawa (1769–1825)
The Kabuki Actor Iwai Hanshiro V as the Entertainer (Geiko) Kashiku, 1808, Art Gallery of South Australia, Adelaide, Australia

Van Gogh, Vincent (1853–1890)
Bedroom at Arles, 1889, Musée d'Orsay, Paris, France
The Potato Eaters, 1885, Van Gogh Museum, Amsterdam, Netherlands
Self-Portrait with Bandaged Ear, Arles, January 1889, 1889, private collection
Starry Night, 1889, Museum of Modern Art, New York
Wheatfield with Crows, 1890, Van Gogh Museum, Amsterdam, Netherlands

Velázquez, Diego (1599–1660)
Whistler, James McNeill (1834–1903)
Arrangement in Grey: Portrait of the Painter, 1872, Detroit Institute of Arts, Detroit, Michigan
Nocturne in Black and Gold: The Falling Rocket, 1875, Detroit Institute of Arts, Detroit, Michigan
Rotherhithe, 1860
Symphony in White, No. 2: The Little White Girl, 1864, Tate Britain, London, UK

Index

Illustrations are indicated by page numbers or Plate numbers in bold. Glossary entries are not included.